The Metaphoric Body

Guide to Expressive Therapy through Images and Archetypes

> 'Metaphor is at the bottom of being alive'
>
> Gregory Bateson

I am a Wheel

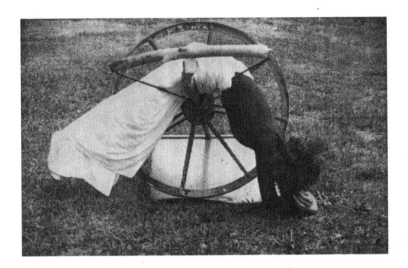

In the above photograph, the woman identifies herself with the wheel. This identification is a metaphor, and the relationship between the woman and the wheel is a metaphor for her feelings.

We use metaphor as a tool for change and transformation, allowing analogy or symbol to manifest in a specific image. Similarly, the human mind is able to visualise in abstract form the most intricate relationships and consequently transform them into concrete or material representation.

This process of change evokes feelings, senses, situations, experiences and memories, that serve to mediate between the conscious and the unconscious – bridging what is hidden with that which is familiar. In other words, the mediatory or reflective role is active between two states of realities: the tangible, identified as day-to-day existence or temporal-historical life; and the non-tangible, defined by the eternal realm of myths and archetypes.

The Metaphoric Body
Guide to Expressive Therapy through Images and Archetypes

Leah Bartal • Nira Ne'eman

Foreword by Harris Chaiklin
Appendix by Alon Shapira

Jessica Kingsley Publishers
London and Philadelphia

Acknowledgement to publishers

We would like to thank the following Publishers for the permission to quote:

Faber and Faber (London) / Doubleday (New York) – Extracts from *Seneca's 'Oedipus'* by Ted Hughes

The Feldenkrais Foundation – Extracts from *Awareness Through Movement* and *The Elusive Obvious* by Moske Feldenkrais

Gateway Books – Extracts from *Earth's Embrace* by Alan Bleakley

Menashe Kadishman – Sculpture: *Spiral.* Avraham Hay - photograph

Inner City Books – Extracts from *The Scapergoat Complex* by Sylvia Brinton Perera

Israel Museum – Copy of *Statuette of Aphrodite*

Samuel Weiser – Extracts from *The Hebraic Tongue Restored* by Fabre D'Olivet

Thames and Hudson – For the words by Dore Hoyer in *The Mystic Spiral* by Jill Purce

Diagram and text of the Swastika in *An Illustrated Encyclopedia of Traditional Symbols* by J.C. Cooper

Zeus Press – Extract from 'Tarot for Today' by Mayananda as found in *Jung and the Tarot* by Sallie Nichols

Harper Collins – Extracts from *Innana* by Diane Wolkstein and Samuel Noah Kramer

Schoken Books – Copy of 'Diagram of the Supreme Ultimate' in *T'ai Chi Ch'uan and Meditation* by Da Liu

Manna Media Publications – Extracts from *The Golden Needle* by Gerda Geddes

First published in the United Kingdom in 1993 by
by Jessica Kingsley Publishers
116 Pentonville Road
London N1 9JB, UK
and
400 Market Street, Suite 400
Philadelphia, PA 19106, USA
www.jkp.com

British Library Cataloguing in Publication Data
Available from British Library on request

ISBN-13: 978 1 85302 152 7
ISBN-10: 1 85302 152 0

Contents

Dedication

Dedicated with love to Nira's husband Mecky, their children and family:
Tali, Yoram, Yuval, Hemdah and Ziv
and to Leah's son Alon,
for their devotion and ongoing support during
the long journey of this book.

Acknowledgements

We wish to express our gratitude to the many persons whose generosity has contributed significantly to this book: The late Mary Capy, Sharon Chaiklin, Yardenah Cohen, Frank Connolly, Noah Eshkol, Moshe Feldenkrais, Gerda Geddes, Mick Horn, Sue Jameson, Chuck Schwartz...who opened many gates on our journey and became friends and colleagues.

The numerous friends and colleagues who were available when needed, provided insights, warm support, and who encouraged us throughout the years: Naomi Adler, Hemda Arad-Ne'eman, Lynn Barbour, Hazel Carey, Professor Harris Chaiklin, Evelyn Cibula, Davida Cohen, Patrizia Diaz, Kate D. Donahue, Lois Giffen, Marsha Halkin, Phyllis Heft, Patricia Hilaire, Vivian Hirshen, Dawn Horowitz, Sally Jenkins, Richard Koren, Ada Levitt, Yonah Libai, Chere Mah, Nurit Musson, Jean Nandi, Tali Ne'eman-Sabo, Yuval Ne'eman, Ziv Ne'eman, Joan Reynolds, Pam Stowell, the late Shirley Toms and Anna Wolf.

The students and clients who inspired us, followed us where we dared to go – sharing pain and joy in discovering new ways of being: Reuth Belzer, Veronica Burtt, Bernadine Evaristo, Hanna Glasser, Judith Goldfarb, Helen Griffiths, Nancy Gurian, the late Ruthy Hafsadi, Rita Kuhn, Shoshanah Lederman, Evi Rote, Miriam Santuria, Bob Sherwood, David Threlfall.

We are deeply grateful to the students and colleagues of the Oranim School of Education of the Kibbutz Movement, Israel; Lesley College Graduate School, Expressive art Therapy Department, Tel Aviv and Boston USA; Manchester Polytechnic School of Theatre, England; the Rose Bruford College of Speech and Drama, England.

Special thanks to Ziv Ne'eman and Tali Ne'eman-Sabo – for their assistance with the layout and graphic designs.

To Mecky (Eliyahu Ne'eman) we are deeply grateful for his constant presence, involvment and caring.

Special gratitude to Alon Eliezer Shapira – for his involvement with the book, and as its editor: with the patient skills of an Ancient midwife helping us to give birth to our creation following a long gestation.

We are deeply indebted to our publisher, Jessica Kingsley, and to Helen Skelton and Anna French for editing and for their understanding, sensitivity and co-operation.

Photographs and illustrations by Avinoam Alon • Naomi Adler • Aharon Amit • Veronica Burtt • Da Liu • Patrizia Diaz • Avraham Hay • Eliyahu 'Mecky' Ne'eman • Tal Ne'eman-Sabo • Ziv Ne'eman • Evi Rote • Alicia Sclovich • Shirley Toms • Yeheskel Yardeni • Yolande Yacoby

Foreword

One element in life is the continuous struggle to attain inner peace. Few attempts to reach this ever-receding goal have been more imaginative than that which is revealed in Nira Ne'eman and Leah Bartal's *The Metaphoric Body*. They creatively build on the idea that through our bodies we can achieve a sense of wholeness. The body is a metaphor for all that we were, are, or might be. Our bodies reflect our common humanity. To paraphrase Kipling's famous lines in *The Ballad of East and West*, 'Oh, East is East, and West is West, and always the twain shall meet' – in our body.

Their chosen vehicle is philosophy and in a *tour de force* they show how the common elements in Greek myths, the Bible and Eastern philosophies point to a synthesis through the basic elements which constitute the universe – *wood, fire earth, metal* and *water*. This is not a lofty and empty intellectual enterprise. The integration leads to a series of exquisite exercises which translate the philosophical ideas into practical and clearly understood directives for activities that are immediately experienced in the body.

In a sense, this volume sums up Ne'eman and Bartal's experience. They were among the early Western students of Tai Chi. Throughout their careers they have combined study with practice in dance, theatre, the visual arts and therapy. In turn, these activities have been expressed in educating others and in a range of creative therapies. All of this learning and experience is honed into a volume that reflects what the philosopher Whitehead called 'elegant simplicity'.

Imaginative ideas which are clear and easily understood sometimes have a difficult path. Having observed the development of *The Metaphoric Body* at various stages of its maturation and through several metamorphoses, I can attest both to the great effort and intellectual power brought to bear in creating these concepts and to the thousands of hours spent in refining the exercises. Those who use this book will be grateful that Ne'eman and Bartal have persisted in their efforts. This work is useful to anyone engaged in education, the creative arts and the art therapies. It is useful for all ages and all people and for all time. In a word, this volume is practical. Dear reader, you are about to embark on an exciting adventure.

Harris Chaiklin
Professor of Social Work
University of Maryland

Genesis

We are teachers, therapists, and artists, who work with people through movement, metaphor, and consciousness; our aim is to help them experience themselves, and to expand through dance, poetry, and visual arts, in order to express their being, find and utilise their own individual and collective symbols, which govern their internal and external lives.

We grew up in Israel, in a Western-style civilization. Our culture is a conglomerate of about seventy nationalities. By the nature of our social environment we had to become synthesizers. There were many beginnings and struggles; we became imaginative and inventive. Thus many seeds had to be sown in hard ground. The country was barren. The need to survive gave great motivation.

Curious about life, humanity and natural environment, we had to assimilate, integrate and create links – links with each other, and links with our past – in order to create a possible future. From early youth we have danced and choreographed extensively – folk dances or dramatic events, often based on Biblical stories.

During our quest we have explored many ways and came across many people. Inspiration in the field of psychophysical perception came in the 1950s, first from Moshe Feldenkrais, the pioneer philosopher of body and mind, who embraced scientific Western Knowledge and Eastern Wisdom. He maintained that unity of mind and body is an objective reality; one feels with one's body, and one's behaviour patterns determine one's feelings. Noah Eshkol gave us a deep understanding of movement and its notation. We experienced work with Gerda Alexander, who invented the term and concept 'Eutony'; and with various teachers of the Mathias Alexander technique, as well as expanding in creativity and inspiration with Yardena Cohen, Gertrud Kraus, Katya Michaeli.

In the early 1970s we were introduced by Gerda (Pytt) Geddes to T'ai Chi Ch'uan and Chinese philosophy. Since then we have integrated Eastern and Western ways of thought as a way to understand better the inner world of humanity. The T'ai Chi philosophy and the understanding of the concepts of Yin and Yang have brought us in touch with the environment, the general feeling of the universe, with what is called Tao, The Way, and the Five Elements: *wood, fire, earth, metal* and *water.*

In the late 1970s we moved into a psychological phase to explore creative art and dance therapy, Jungian analysis, transpersonal psychology, and psychosynthesis, to deepen our understanding of ourselves, to make our unconscious

motives conscious. *Symbols, metaphor,* and *archetypal images* are the *threads* of our lives.

We would like to share with you some of our experiences in our search for meaning and self-direction. We all need creative expression and fulfilment. We need to understand ourselves in order to be able to communicate with our environment. We need to belong and to be included. We learn to be aware of our strengths and weaknesses, to discover the positive and the negative influences on us. We see the value of challenge in negative experiences such as depression, accidents, loss and bereavement. These processes become magnified in migrant populations, coming from mixed cultural backgrounds, that consist of different customs, rituals, and social interaction. Often the non-verbal is a very immediate way of communicating.

Biblical stories were always part of our lives in teaching and choreography. In ancient Greece the gods were part of people's lives. In the age of mass communication and high technology, many people have lost the direct communication with the sacred. Through our work in theatre and education we rediscovered the symbolic values of stories and myths to live by.

Life and work in the kibbutz movement for over twenty years brought us in contact with people from kindergarten to grand-parents of seventy and older. They were all participating in celebrations of the community, performing as actors, dancers and folkdancers from many backgrounds. They came together in the social melting pot of Israel.

We encountered women from the Middle and Far East who were suddenly exposed to a change of culture, their bodies asked to perform different tasks, coping with modern technological 'advances', which had profound effect on their bodily and mental outlook. Devising theatre in London brought us in contact with various community groups, including women from Asian and West Indian backgrounds.

We are on a continuous path of moving towards becoming integrated individuals with open hearts, surviving in the complexities of life in the twentieth century: so full of contradictions, upheavals and new discoveries.

Our paths have crossed with students in universities; with children; visual artists; actors; psychologists; dance therapists; 'normal neurotics'; chronic depressives and schizophrenics; people with disabilities, and 'minority' communities. Since 1984 this book has grown, with us together and apart. It reflects our ways of becoming – a gradual process of exploration and deepening understanding of life, physical structure, environment and our ancestors. It has been written across three continents, deserts, and oceans. It was written in Haifa, Israel, where Nira lives; in London, England, where Leah lives; and in Berkeley, California... Many writing meetings needed careful balancing of timetables and locations, between work, family, endless telephone calls and crises. We shared experiences and new ideas, always in an air of celebration. We inspired each other into new avenues and shared each other's friendship, and the love of our friends.

Writing the book was like undergoing the Tasks of Psyche, from her early confusion, working like the ants that helped her, when she was asked by Aphrodite to sort out a room full of poppy seeds, chick peas, lentils, and barley. Our tables were always full of books, manuscripts, and the feedback of our participants, along with dictionaries, coloured crayons – and not forgetting the scissors. Gradually, through the process of the Tasks – Sifting, Patience, Overview, and Delving into the Deep – we have come out with the beautiful gift of Persephone, which we want to share with you in body, mind, spirit and reality.

Introduction

The feeling of being alive relates to the awareness of growing to be oneself.
Moshe Feldenkrais

The Metaphoric Body is a resource book based on practical and spiritual awareness, which allows readers directly to experience transformation. As a guide book it offers suggestions, ideas, exercises and a way of working to enhance personal growth and the therapeutic process.

Jung viewed the desire to create and transform as 'the basic instinct of civilization'. Goethe more joyously expresses it: 'Transformation and again transformation, the eternal entertainment of the eternal spirit'. We thus define our work as 'serious play', encouraging the child within us all to break through the complex layers of adulthood, once more to respond as children do, with a lack of inhibition.

Winnicott (1971) commenting on this theme, states: 'on the basis of playing is built the whole of man's existence'. Likewise Sutherland (1980): 'It is only in playing that the individual – child or adult – uses his whole personality in creative activity, and it is only in creative activity that he discovers his self'.

The book's title conveys our belief that the exploration of the body through archetypal symbols transforms and facilitates changes in people's lives. As Jung stated: 'Fantasy is the archetypal activity of the psyche...it is never merely mentally subjective, but is always being en-acted and embodied'.

The work we do can be expressed in a nutshell, by the Greek Delphic Oracle's call 'know thyself'. The Call of Awakening in Hebrew, 'lech lecha', literally translates as 'go to there' – and in a metaphoric sense, implies 'go to thyself'.[1]

We identify the *mythic* as the *internal process* and the *metaphoric* as the *external expression*. Therefore, what we mean by 'go to thyself' relates to a mythic internal perception, which is made visible through the senses and can be called the 'negative' of a photograph. In order to develop the negative one needs to activate the senses. This process we identify with 'go to there', which is the metaphoric expression.

We link the body to the psychological process, employing the tools of artistic expression to gain personal insights – to open new channels in the brain, the mind's eye. Such undertaking has the potential to influence the

quality of emotional perception, as a necessary grounding and preparation of the body for the spiritual dimension.

In the past 15 years, participation in the expressive arts, with their transformative emphasis, has expanded into an international field. Since the publication of our first book *Movement Awareness, and Creativity,* body awareness, T'ai Chi Ch'uan, and mythological consciousness have become much more widely known and appreciated modes of working with people.

Much of the work of dance movement and other expressive art modes remains unknown to professionals in medical, psychological, educational, social, and ecclesiastic fields. However, individuals are looking for ways to become more integrated in body, mind and spirit. We feel that in the next decade the arts in transformation will become even more significant.

The recent 're-discovery' of Joseph Campbell's work, the growth of areas such as consciousness studies and transpersonal psychology, and the current interest in shamanism which uses ritual, rhythm, music, movement and symbols, signal that the time is right to bring the mythic dimension back into life. This search cannot be coincidental, since wherever one looks there are people disconnected from themselves and from each other, trying to find a sense of purpose and community. This kind of work is also popular with migrant populations from mixed cultural backgrounds, who seek new ways of relating in an unfamiliar environment.

As international pioneers who have worked in the fields of movement, dance, dance therapy, drama and art since the early 1950s, we want to share our experiences, inspire our readers to move into new avenues of creative thinking and to enrich the imagination. The arts in general, movement and dance in particular, offer a way to bring metaphoric and mythic thinking into the body, where we all live.

We emphasise a holistic practice, which goes beyond a purely cognitive and verbal psychological approach. Our aim is to heal emotions, body, and spirit, using the body and soul rather than only the mind, as both the instrument of this process and its vessel of receptivity.

The nature of our work is to nurture the creative seed that lies hidden deep in everyone's soul – the Tao Te-Ching's notion of returning 'to the uncarved block'. In nurturing this we foster growth of the inner power.

This process of cultivation can best be likened to a metaphoric stone thrown into a pond, creating circles of dynamic motion. The ripples stimulate the world of feelings, memories and knowledge, stirring the unconscious into consciousness, making the invisible visible in a receptive and nonjudgemental environment. Joy arises from having a sense of

wholeness and integration, when what we do is consistent with who we are, balanced between the personal and social 'I'.

The quest for wholeness reflects the integration of polarity. The Yin-Yang archetypal pair derived from Taoist philosophy form the complementary and opposing poles of Nature and human nature: shadow/light, positive/negative, male/female. Acceptance of both dualities is essential for the development of courage, trust, and confidence to face the unknown, or 'unseen' world. It is in this 'unseen' realm that each person follows his or her own labyrinthine path, and where all motives for actions can be found. Our task can be viewed as Ariadne's, offering the thread to those searching to confront their own Minotaur within their own labyrinth; in other words, to guide those who wish to come face to face with their own deepest fears, and to confront and conquer the powers they feel inhibit and constrict them.

We live in an ongoing spirit of exploration which we direct and channel for ourselves and our clients. It is our path to become integrated, to discover and understand the parts of ourselves we are unaware of or have repressed. Our students and readers come to recognise the deeper layers of their personalities, which unknowingly affect their lives, by tackling such issues as love and hate, independence and dependence, insecurity and assertiveness, aimlessness and feeling of being rooted. We weave a tapestry, relating and understanding the events of our lives and our times.

We all need creative expression and fulfillment, as well as a sense of belonging to a greater whole. We need to be aware of our strengths and weaknesses, to see the reasons behind and the value of the challenges that arise from such negative experiences as depression, accidents, loss and bereavement.

The non-verbal is the immediate way of communicating and discovering the many layers of individuals, some confident and constructive, others shaky and destructive. Without words, reality and fantasy more readily intertwine, unfolding many layers of individual and cultural traits. We find the non-verbal to be a practical method that cuts across many barriers, stimulating the senses and leading to invigorating exchanges of physical communication, forming a body language that is beyond speech. Thus the prime source of learning is rooted in the body-felt experience.

In all cultures, humanity's earliest attempts to communicate occurred on the preverbal level. Gesture and body expression are the vehicle in any attempt to share experience. Non-verbal expression through movement, dance, visual arts, and music, enables one to think in images, to respond spontaneously and creatively in the here and now. Hence the dance of

body/mind/spirit becomes the metaphor for transformation – its most potent guide – on the journey of inner and outer growth.

Let the play begin...

Stepping Stones: Sources and Wisdom from East and West

> *According to a Tibetan parable, a man without awareness is like a carriage driven by a sleeping coachman. Its passengers are the desires seeking different destinations, its horses are the muscles pulling in different ways, whilst the carriage itself is the skeleton. But when the coachman is wide awake and holds the reins the horses will pull the carriage to bring every passenger to their proper destination.*

Much is being written nowadays by practitioners of body disciplines and by psychologists. Our philosophy is one of integration, treading the fine line, the cutting edge between physical manifestation, expression of feelings and the creative-artistic dimension. The thinking that emerges has a sparkling quality.

We try to transcend physical boundaries and, in the wake of Moshe Feldenkrais, explore primal qualities. In our method the personal and interpersonal aspects are related in a meaningful way: we include the environment with the human aspect. The ontological Self is identified and made whole through an imaginative journey rooted in the sensory perception. We followed Feldenkrais's dictum to be 'deliberately spontaneous'. Our book is meant to enhance personal growth and assist in the therapeutic process.

> Each one of us speaks, moves, thinks and feels in a different way, each according to the image of himself that he has built up over the years. In order to change our mode of action we must change the image of ourselves that we carry within us. (Feldenkrais, 1972)

In the early 1950s Moshe Feldenkrais opened our minds to the understanding of body/mind interrelatedness. We had danced without real body awareness. For the first time we experienced lessons in awareness through movement. We were fascinated by the way he treated every lesson as one unit, working on one theme, exploring its many facets with inventive variations. We came out of these lessons with a new consciousness and a new concept of thinking and sensing body and mind. He also introduced us to the reality of Eastern philosophy through our newly awakened bodies.

Feldenkrais (1972) believed 'our self-image consists of four components that are involved in every action: movement, sensation, feeling and thought'. Detailed attention to any of these components will influence the others, hence the whole person. Unity of mind and body is an objective reality, we feel with our bodies, our behaviour patterns determine feelings. Maximum efficiency should be achieved by a minimum of effort,

not through increased muscular strength but through increased consciousness of how the body works.

As water changes its density, so the human body changes as it moves. The body can be soft, slow, and weak; or it can become stronger, faster, and more vigorous until it is like a stormy sea with giant waves flooding its shore. The body can be as rigid as ice or turn into vapour or become pure spirit.

In the early 1970s, we started studying T'ai Chi Ch'uan in London with Gerda (Pytt) Geddes, the first woman to bring T'ai Chi Ch'uan to Europe. She began as a modern dancer, became a psychoanalyst, and then lived in China for ten years with her family. We were greatly influenced by her knowledge of Chinese philosophy and the symbolism of T'ai Chi Ch'uan. Her humanity and modesty became a model for us.

Geddes fell in love with the beauty of T'ai Chi Ch'uan at first sight, but, as a foreigner and a woman, she had to pursue an old master for a whole year, bringing him presents, such as a special leaf or stone or poem, until he agreed to let her into the secrets of ancient Chinese knowledge.

At the heart of ancient Chinese wisdom is the T'ai Chi circle symbol of the Yin-Yang, depicting balance and harmony of two primary and supreme forces in the Universe. The unification of these two great forces expresses paradox and polarity. Jung stressed that the Chinese have always recognised paradox and polarity as an integral part of whatever is alive or moving.

> Where there is day, there must be night
> and where there is night, there must be day.
> Day is Yang, night is Yin.
> Yin and Yang are complementary
> Opposites which unite to form a whole. (Tsung Hwa, 1980)

Jung (1962) further notes that, according to the Chinese, 'to be one-sided was considered barbaric, although they recognised it could give momentum'. The Chinese believed that always, when a situation moved to an extreme, it would reach a point of reversal to become its opposite. In times of distress, this philosophy has afforded courage and perseverance; in times of success it has invited caution and a modest response, in knowing that the polarity would surely exert itself. As the ancient text, *The Secret of the Golden Flower* (1962) points out, it was a sign of high culture that opposites always balance one another:

> When Yang has reached its greatest strength the dark power of Yin is born within its depths, for night begins at midday when Yang breaks up and begins to change to Yin.

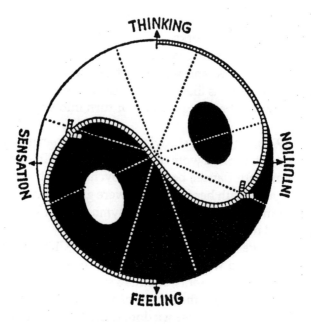

Yin-Yang diagram in relationship to Jungian thought

Balance, according to Jung, was a virtue sought by the inner psyche of the individual, as well as by an entire culture. In a commentary written in 1962, he states that the West was beginning to achieve more balance by celebrating feeling or intuition, rather than upholding only the intellect. He believed that such a shift towards favouring the intuitive was 'a mark of cultural advance, a widening of consciousness beyond the too narrow limits of a tyrannical intellect'.

Self-knowledge involves discovering the polarities of one's inner world. Mary Starks Whitehouse (1979), the dance therapist, following the principles developed by Jung, used dance therapy as a way to bring polarities into awareness, and to facilitate the interaction of the unconscious and the conscious. Polarity is contained in the physical as well as the psychological body – seen by the Chinese as two sides of the same principle. The ideal paradox occurs when the opposites are united, each becoming the other. In Taoist words 'action through non-action'. The experience of a balance between action and non-action allows one to evolve by way of a keener perception. Something new is attained when the poles interact, enabling a third quality of awareness to manifest itself in a sense of wholeness.

Dance therapist Trudi Schoop (1979) believes that each individual contains the complete range and polarity of every feeling, action and

thought. To become fully human is to experience every nuance of one's being, whereby thoughts and feelings are embodied in the physical being.

> Change can be brought about through changing either the mind or the body...the ideal approach is to work with both aspects of one's being at the same time.

The Yin-Yang's eternal and universal quality can be reviewed in the following figure of Jung's perception of the 'Four functions': thinking, feeling, sensation, intuition, mapped onto the ancient Chinese symbol of Yin-Yang, weaving Eastern and Western patterns onto one tapestry (Jacoby, 1973).

The four functions fall into two main areas of differentiation: the light and dark areas of the Yin-Yang. The light represents the differentiated, auxiliary, and directed part of consciousness; and the dark, the unconscious – the 'unseen' – part.

Studying T'ai Chi Ch'uan and the five elements, we came across the source of Chinese philosophy. We were drawn towards the thought of Chou Tun-Yi, found in *A History of Chinese Philosophy, Vol. 2* by Fung Yu-Lan (1953). Tun-Yi, a philosopher of the Sung period, developed the ideas found in the Appendices of the *I-Ching (The Book of Changes)*, and synthesised them into his own figure, which he named the 'Supreme Ultimate'. We came across the following figures, depicting the 'Supreme Ultimate' in the works of Da Liu (1974, 1986) and our adaptation of Dora Kalff's (1980) which hint at and develop the parallel between ancient Chinese analogy and Jung's concept of the individuation process, expressing the maturation of the self (see Figures 3a and 3b).

Having explored both Eastern and Western modes of body movement and paths of creativity, we realised that the two poles of seeming extremes – different techniques and philosophies – at their heart aim towards a common purpose of understanding and expression.

However, differences exist in the traditions which lie behind their development. In the West, body consciousness as the root of all manifestation has been buried and forgotten until this century, along with all the ancient wisdom it contains. Instead, the West has focused on the mind processes, and so been cut off at its physical 'earthbound' roots. Nevertheless, the gains made by Western traditions in the way of scientific knowledge attest to a more dynamic material-external transformation than the slower evolving Eastern process was able to achieve. Both traditions, then, contain within themselves the polarities of the other's strengths and weaknesses. In this age of mass communication and transportation, the two cultures have come face to face.[2]

The spiritual crisis at the root of the tragic wars of this century, has led many Westerners in a 'migration of souls' toward the earthbound philos-

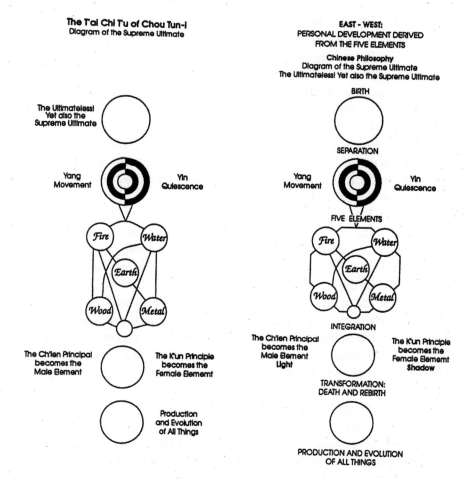

The T'ai Chi T'u of Chou Tun-i
Diagram of the Supreme Ultimate

The Ultimateless!
Yet also the
Supreme Ultimate

Yang
Movement

Yin
Quiescence

Fire Water

Earth

Wood Metal

The Ch'ien Principal
becomes the
Male Element

The K'un Principle
becomes the
Female Element

Production
and Evolution
of All Things

EAST - WEST:
PERSONAL DEVELOPMENT DERIVED
FROM THE FIVE ELEMENTS

Chinese Philosophy
Diagram of the Supreme Ultimate
The Ultimateless! Yet also the Supreme Ultimate

BIRTH

SEPARATION

Yang
Movement

Yin
Quiescence

FIVE ELEMENTS

Fire Water

Earth

Wood Metal

INTEGRATION

The Ch'ien Principal
becomes the
Male Element
Light

The K'un Principle
becomes the
Female Element
Shadow

TRANSFORMATION:
DEATH AND REBIRTH

PRODUCTION AND EVOLUTION
OF ALL THINGS

Source: a – Fung Yu-lan, A History of Chinese Philosophy, vol. 2
(Princeton, N.J.: Princeton University Press, 1953), p.436
Da Liu, T'ai Chi Ch'un and Meditation (1986)
b – Adapted from Dora Kalff (drawing by Tali Ne'eman–Sabo)

Supreme ultimate

ophies of the East. However, in our journey of discovery, we have come to believe that the West contains within itself the same traditions of wisdom and understanding which many believe is to be found uniquely in the East. Through our exploration of The Five Elements on the one hand, and Bible stories and Greek myths on the other, we encourage the discovery of these complementary modes of expression.

We thus express a humane belief that those of us in the West need only 'unearth' our own lost traditions to get in touch with our own self, and ultimately the universal consciousness, which contains all dualities under one roof, and, below its 'structure', in the roots of the Earth. [3]

Searching for our roots brought us in contact with Biblical stories that emit mythologic vibrations, opening the doorway to intuitive awareness. Our spiral path winds towards a sense of individual and collective consciousness beyond the boundaries of one's life experience, transcending limitations of time and space.

Feedback from our sessions came in diverse ways. One of our clients acted the figure of Medea from the Greek mythology in a private session – she relished the vision, brought it to life, expressing how much she had learnt about herself by identifying with the mythical figure. This led to further exploration of the goddesses as a source of knowledge and human experience. We asked how we become a creator of our own lives and not a victim of the environment. We explored the three virgin goddesses: Artemis, Athena, and Hestia, who represent fearlessness, wisdom, and focus on the inner spiritual centre; and the three vulnerable goddesses: Hera, Demeter, and Persephone, who represent the traditional roles of wife, mother, and daughter: the relationship-orientated archetypes. We decided to focus on Aphrodite, goddess of love and beauty, who does not belong to either category. She allows the power of transformation to manifest itself, evolving qualities which enable her to become mistress of her own existence.

We share the exploration and development of the quest towards this existence, of becoming mistresses and masters of one's life process, with all comers.

The Creative Process

> In the symbol the particular represents the general,
> not as a dream, not as a shadow,
> but as a living and momentary revelation of the inscrutable.
>
> *W. Goethe*

Symbols, metaphors and archetypal images have become the threads of our lives; they mediate between the conscious and the unconscious, bridging what is hidden and that which is visible. They are expressed in

the words of thinkers throughout the ages and across many cultures. Jung described them as 'living psychic forces', affecting the soul or our inner life in the way organs do the body. As such they mediate and reflect the entire landscape of one's psychic and emotional being, with the potential to evoke new behavioural responses. The human psyche is able to visualise in abstract form the most intricate relationships, and subsequently transform them into concrete or material representation. Primarily, they are always represented in some pictorial form or image. Arieti (1976) explains: 'the image not only re-evokes what is not present; it also enables a human being to retain an emotional disposition towards an absent object'. Thus a symbol can appear in dreams or be expressed through visual arts, dance, music, literature and play. It serves in a mediatory or reflective role, between two states of reality – the tangible, identified as day-to-day existence or temporal and historical life; and the intangible, defined by the eternal realm of myths and archetypes.

Marie-Louise von Franz (1972) highlights the borderline where the two realities merge: 'Whenever known reality stops, where we touch the unknown, there, we project an archetypal image'. Lao Tzu and Confucius express the view that every event in the visible world is the effect of an 'image' that is, of an idea in the unseen world. Accordingly, everything that happens on earth is only a reproduction, as it were, of an event in the world beyond our sense perception (*I Ching*). Cooper (1972) adds: 'In Taoist art there was nothing that was not symbolic and every symbol was a window onto a realm that is greater than the symbol itself and greater than the man who perceives it'.

Hence, it is in this 'unseen world' where we encounter the personification of symbols as the link between the physical and metaphoric bodies. As such, Suares (1985a) states that humans are a composite or conjunction of a 'double reality' or 'two realities' perceived as being equally alive – the metaphoric as much as the physical, since we are more than mere blood, skin and bones.

To deny or negate such comprehension is ultimately to sow weeds, draining the vitality of the mysterious enigmatic spirit that inhabits all life at its roots, the consequence of which leads to disease – disease with one's self, one's beloved, and the environment.

THE POWER OF POLARITY

The concept of polarity has gained prominence in psychology. According to Jung, every aspect of the structure of the psyche takes into account the law of opposites, based on complementary or compensatory factors, as depicted in the Yin-Yang diagram.

Polarity is important to Erikson (1963) as a recurring theme within the stages of the life cycle, affirming that man does not live alone and recognising a struggle in the process of reaching a balance between man and nature, as well as between the individual and society. Erikson describes this within his own theory as the 'Eight Stages of Man', which is also related to Chinese philosophy contained in the *I-Ching*.

Suares, as Jung, offers further distinctions, stressing that a symbol needs to be viewed as a dynamic and not a static entity, and in its mediatory role defines 'two poles of energy (essence-appearance, spirit-matter)'. And that these 'two sides of one vital energy', whether they be in relation to 'masculine and feminine', 'good' and 'evil', 'life and death', are nevertheless always 'in motion' (Suares, 1985a). In the context of our work, we say that a continuous ongoing interaction exists between our sensual and emotional faculties and those of the psyche – thus linking one's physical and metaphoric bodies.

HUMAN RELATIONSHIP TO SYMBOL AND METAPHOR

Symbols are the tools and we the vehicle of the psychic transformation of energy. According to Jacobi (1974): 'the psyche, as a mirror and expression of the outward and inward world, creates symbols and transmits them from soul to soul'.

However, symbols and metaphors cannot act by themselves, but need to be acted upon in order to impregnate our psyche, so as to effect a change upon our whole being. Sharon Chaiklin (1975) bases her dance movement therapy on her strong belief in the psychic-physical relationship and use of movement and arts as the medium of change.

We like to define the human being as a musical instrument strung by strings of varying qualities – thick, thin, taut, loose. And in order to harmonise we need subtle tuning. To achieve such harmony we need initially to undertake the work of body-mind-spirit consciousness, in order to get in touch with the self's deepest recesses. Then our relationships can be like a silk thread, soft, precious, beautiful and very strong.

THE SYMBOLIC OR METAPHORIC JOURNEY

In our work we begin with the physical body – the skin, muscles, blood and bones. We explore the body on many levels – sensate, emotional, symbolic, and mythological. Wherever we journey, we stay centred in the reality of the physical body. We draw our sources of inspiration from the natural enviroment, universal forces, the Five Elements, Biblical heroes and heroines, and from Greek mythology.

To undertake the necessary journey to the deepest recesses of one's being, we have developed a creative art and movement therapy approach – both verbal and nonverbal – in order to facilitate the growth and

understanding of the participant. We aim to establish an objective under-
standing of subjective processes and to develop the inner 'eye's' relation-
ship to the outer 'eye', to build a bridge between the 'seen' and 'unseen'
worlds of consciousness and the unconscious.*

> **The Seed**
> The seed of the self;
> The positive seed, the value of the shell.
> Find tools to open the shells –
> the soft skin,
> the round and slippery shell.
> A rugged, rough and thorny shell –
> each one needs a different touch;
> an acceptance, holding and letting go,
> taking risks.

APPLICATION OF CREATIVE PROCESS

We lay out below a structure of our model. Working from the initial idea
– a seed thought is sown – it gives rise to a variety of possibilities that are
pared down. Once a choice of a theme is made, it is explored in an
experiential way, through several variations. A concept grows, containing
both the positive and negative aspects and their interactions. We conclude
with verbal feedback: 'sharing' to contextualize the process and place it
in the real life experience.

* See Note 1 in chapter *'Dionysus and Ariadne'*.

Structure for Spontaneity

1	**Seed Thought –** Initial Idea	Verbal and nonverbal brainstorming, which evokes free associations, and gives birth to images from the environment and the inner self.
2	**Choosing –** The Power of Limits	From the free associations a choice of one or two themes is made.
3	**Exploring –** Themes and Variations	The theme is experienced through: movement and dance, visual art expression, sound and voice, musical expression, creative writing and poetry.
4	**Focusing –** Experience on the Symbolic Level	Focusing narrows down and sharpens feelings and images. Emphasis is put on the polarity of dark and light, yin and yang, negative and positive, unconscious and conscious perception.
5	**Contextual ising –** Meaning and Value	Verbalising the creative process and understanding its meaning in relation to real life situations. Integration of feeling and symbolic levels.

The process is open-ended and will continue to be part of the dancing body/mind/spirit.

Experiential Model

1 **Seed Thought –
Initial Idea**

Start from a very simple seed word such as 'kettle'...
by way of free association the following words might
emerge:

tea	morning
boiling water	kitchen
steam	whistle
contain	water
kettle drum	cattle or sheep in a field

2 **Choosing –
The Power
of Limits**

Choose two words to explore in movement, drawing
and words:

Water Contain

3 **Exploring –
Themes and
Variations**

(a) Move freely and experience the images of the
two words Water and Contain in the body.
(b) Limit the movement to one part of the body,
change to another part.
(c) Experience the difference between moving one part
and the whole body.
(d) Change your relationship to space:
• Move near the floor, then far away from the
floor...
• Move horizontally and vertically, in any
direction you like.
• Move in relation to:
(i) The eight basic directions of the sky – North,
South, East, West, and points in between –
NE, NW, SE, SW.
(ii) In relation to Labanotation – forward,
backward, right side, left side, right forward
diagonal, left forward diagonal, right
backward diagonal, left backward diagonal.
(iii) Eshkol-Wachman notation – (0), (1), (2), (3),
(4), (5), (6), (7), (0).
(e) Change your relationship to time and rhythm –
experiment with moving in various qualities:
slow, fast, legato, staccato, crescendo, decrescendo,
and more.
(f) Transfer the experience into two dimensions, by:
drawing, painting; or recreate it three-
dimensionally, with materials such as clay,
plasticine, paper, soft cloth.
(g) Close your eyes; let the imagination elicit images
and words. By way of free association the following
words might emerge:

(a) The Eight Directions of the Sky

(b) Labanotation

(c) Eshkol - Wachman Notation
The Horizontal Plane in Scale 1=45°

(Tali Ne'eman -Sabo)

Water	Contain
flow	keep
life	hold
ocean	receive
spring	protect
earth	strangling
drowning	boundaries

4 **Focusing – Experience on the Symbolic Level** Focus on one concept, theme or word to deepen and sharpen the process. Explore in movement the polarity inherent in your choice, like *'protect'*. Experience the positive and negative aspects-feelings of security, love, caring, trust, shelter or, framing, limiting, obligation, responsibility, prevention. Transfer the experience into any other medium: visual or verbal, music or sound.

The outcome may be a creation of a dance, a painting, a musical composition or a poem.

5 **Contextualis-ing – Meaning and Value** Share your experience in small or large groups. Relate it to your present life situation, the *Here* and *Now*. Emphasise the use of insight, rather than intellectual interpretation. Do not judge yourself or others. Pay attention to the unconscious and creative material that emerged. Look at the new perspectives that have become available, and encourage participants to continue on their own path of self-discovery.

Often members of the group present an unsolved situation, such as not being able to reach a specific place on the drawing, or find it difficult to ask for help. In that case we suggest they ask for help from the group. One woman requested a number of people to make a bridge in order to help her reach her magic island. On the way a whole story evolved, and everyone contributed their spontaneous ideas, such as bringing along a picnic basket, taking a dog along, and more. Thus she learned how to ask for help, and was able to reach a previously unattainable goal.

The Way We Work

> Following Confucius' teaching, we like to think that we give students one corner of a subject and allow them to find the other three corners for themselves.
>
> *Geddes 1991*

We address the whole person:

- in body
- in nature
- in relation to other people.

We connect to the archetypal level:

- through Taoist Elements
- through Biblical figures
- through Greek Goddesses and Gods.

INTENTIONS

The parts of the Metaphoric Body unfold in the way we live them. Our intention is to present ideas not prescriptions, and we include stories from our own experiences as background. Drawing or modelling enables participants to externalise their interior process, allowing identification and disidentification to occur.

FLEXIBILITY

As we give instructions for the session, we make clear that no one task is mandatory. Because people are so accustomed to following instructions rather than paying attention to their intuition, we make a special point that participants find their own rhythms and do the exercises that are appropriate for them. We offer drawing and writing as suggested ways to deepen, reflect on, and record the movement experiences.

PASSIVE/ACTIVE: MOTION AND STILLNESS

There will always be an interplay between the two sides. Life itself is seen as always in motion, rather than being static. There is stillness in motion and motion in stillness.

BODY MAPS
A life size map of the body is outlined on a sheet of paper, and filled in relationship to a set of questions. This process enables a person to relate feelings to a visual representation of the body. This technique can be found in the *Scapegoat*. It can, however, be used on its own, or in relation to any other process.

FEEDBACK AND REFLECTIONS
Feedback and reflections are given in some chapters; others are presented as blueprints.

SESSIONS AND WORKSHOPS
Some sections of this book consist of a single process lasting 20 minutes to an hour. Other sections provide material for a two to three hour workshop. Still other sections suggest ways to develop one theme over several consecutive sessions.

VISUALISATION
Visualisation does not have to be visual: it can be any image, a sense of smell, or a sound. Visualisations usually last from one to five minutes. Individual visualisation processes depend on the participants involved.

JOURNAL/DIARY
We also recommend that participants keep a journal and note the changes which occur in daily life.
 Suggested questions include:
 • How do you sense your relationship to your body/mind?
 • How do you relate to your environment?
 • Do you notice any changes in your interactions? Are you treated differently at work? At home? Can you stand your own ground without being destructively aggressive?
 • Have you met any new challenges?
 • Do you enjoy writing, drawing, painting, or making music?

How to Use This Book
LAYOUT
The book does not have to be used in a specific order. However, we suggest that the Taoist Elements, the Biblical stories and the Greek stories should not be attempted without some experience of the resources of the physical body. Every chapter is a unit. There are cross-references and different layers which readers can weave together to make their own patterns.

Every moment in life is a combination of movement of the physical frame, feelings, thought, soul, and spirit.

CHOOSING EXERCISES AND WORKSHOPS

We ask the readers to travel through the book, dip into its resources, enrich their experiences, and uncover their own true movements, discover new ways of relating to the community of all living things.

ENVIRONMENT

It is important to work in an environment which is clean, well aired and warm enough to be comfortable. For certain experiences it is desirable to have a soft floor, mats or foam rubber to prevent bruising, particularly for body work. When working outside, it is necessary to provide safe boundaries and enough quiet for people to concentrate. A comfortable, nurturing environment inspires the feelings of safety and trust which are conducive to creativity.

BASIC MATERIALS FOR EXPRESSION

The following is a list of basic materials that we recommend keeping on hand every time you work. Other specific materials are mentioned in the relevant chapters.

- Crayons: wax or oil
- Felt tipped pens
- Water based paints
- Plasticine and/or clay
- Paper: coloured (sugar paper), size A3/A2, if possible
- Tissue paper
- Visual aids: art books; (and any others), magazine cut-outs, or any other scraps
- Musical instruments to accompany sessions: percussion instruments, or others
- Tape recorder.

Resources of the Physical Body I
The Body From Anatomy to Metaphor

The body is not something we have, but who we are. It is our intelligence. It is how we organize our experience of both ourselves and our world.
C.M. Johnston

The body is the material manifestation of soul and spirit; it is our 'temple', and the gateway to the personality. Through moving, sensing, feeling and thinking, we express ourselves. We look and listen, outside and inside, attuning our awareness of both. We look to see, we listen to hear, and we touch to sense.

The way we travel is by experiencing the body through knowing the anatomical structure, exploring its potential mobility, the kinaesthetic awareness. This experience is enriched by the use of creative arts in shape, colour, sound, and poetry. In turn, this will facilitate an expressive body, sensitive to feeling and form.

We learn to acknowledge the parts of the body and their relationships, as well as to orchestrate their interplay. All the processes experienced in this part contribute to becoming conscious of movement habits. By bringing them to the attention of the conscious mind we have the opportunity to change our patterning, to 'tune' our bodies, to get a sense of being 'neutral' and to experience 'eutony'. This resonates in our emotional and spiritual lives as well as our physical presence, leading to the balance of body/mind/spirit.

'We act in accordance with our self-image. This self-image governs every act and is conditioned in varying degrees by three factors: heritage, education, and self-education' (Feldenkrais, 1972). Through education we can learn to 'stand up' for ourselves and experience the flow of energy (Chi).

We develop the kinaesthetic perception (the feeling of movement) by *scanning the body* and relaxing in relationship to the floor. By working on one side of the body we have a place from which to compare the improved mobility with our ordinary state of being; and by *visualising the movements* of the body internally we bring about a heightened skeletal awareness.

Neutral is a state of being without expectation, through which one is able to observe oneself – it is the place from which one can be in *Eutony:* where the extensor and flexor muscles are balanced with the right amount

of tension, ready to move; this is otherwise known as a *dynamic relaxation,* that enables us to be *deliberately spontaneous* (Feldenkrais, 1972).

> We are not only acting as personalities but we are also acting with our bodies. We live constantly with the knowledge of our bodies. The body-image is one of the basic experiences in each person's life (Schilder, 1970).

Metaphor is a descriptive term or phrase applied to an object or action to which it is not literally applicable: describing one thing in term of another. Working through metaphor creates a rich kaleidoscope of experience; it is a mirror of the body, mind and soul that reveals unseen parts of ourselves.

Balancing (Leah Bartal)

By releasing points of physical tension, we bring the body to that point of 'dynamic relaxation' in which one can be 'deliberately spontaneous', and unconditionally free to visualise one's movement through *guided imagery.* Projecting the body's image on symbols creates unlimited shapes and forms, which enables us to express them through the multiple dimensions of creative time and space. Being in the *here* and *now* we are able to participate in the metaphoric 'Play of the Spirit'. (See *Serious Play,* our introduction to Biblical stories and Greek Myth.)

From a poem written by a student:

> A dead body is the best protection
> Dead bodies have no cravings
> Dead bodies don't ask awkward questions
> A dead body is safe
> A dead body aches.
>
> I keep my body in a leather bag
> So they won't kill my soul.

Skeleton – Bone, Muscle, Skin

There is no doubt that our body is a moulded river.

Novalis Aphorism

The whole of this section contributes to a greater understanding of the self-image, and helps build confidence, from within-to-outside, and from the external to the internal.

Structure and Form

The body is a composite organism, within which bones, muscles, and skin perform different functions. By focusing the attention on each separately, we recognise their specific importance so that we are able to concentrate on the weight-carrying capacity of the bones, the muscles' ability to move bones in space, and the containing quality of the skin. All this provides a richer experience of the body as a whole.

After gaining this sense of the diversity, most people feel taller, wider and have a greater sense of the space they fill: this is the first step in 'standing up for yourself'.

Movement Experience

WALK Begin by walking around the room. Pay attention to how you walk and develop a sense of your posture. Maintain this body-image.

Walk again. This time try to differentiate between the perception of bone, muscle, and skin...What sense have you of your bones...of your muscles...and how does the skin feel? Become aware of the parts in relation to the whole...the unified movement. Is there any contradiction? Does one hold up the others, obstruct, or resist them?

SCAN AND SENSE

Lower yourself to the floor, roll around with the same attention to the interaction of bone, muscle and skin. Become aware of the spiral path of the body and the interplay of the limbs.

Lie on your back...close your eyes...scan the contact of your whole body with the floor. What parts are touching the ground and what are far away? Legs, pelvis, torso, shoulders, arms, hands, neck, and head...concentrate and identify each in turn.

Now start again from the feet up with the sense of touch and weight. Pay attention to the right foot...left foot...the contact of each of the heels with the floor. Continue with the right lower leg...left lower leg...right thigh...left thigh...the pelvis, its right side...its left side...

Now check the head and neck, does it feel different on the right and left sides? How does the right shoulder touch the ground...how does the left one? Sense your right lower arm, then left lower arm...follow with the right hand...finally left hand.

To end, sense the body as a whole: lying, sitting, and standing.

THE BREATH OF THE SKELETON

TAOIST BREATHING

The effect of the following experience is to contribute a heightened sense of the shape of the skeleton and the relationship of the various parts of the body. Very often the body will feel 'lighter', even elated.

BREATHE

Lie on your back. Inhale into the left arm. Begin with the fingers, letting the breath flow through the lower arm, continuing through the upper arm, into the shoulder joint...and exhale along the same path. Repeat a few times.

Inhale into the right arm in the same way, beginning with the fingers, through the lower arm, the upper arm into the shoulder joint, and exhale from the shoulder through the upper arm, lower arm and fingers. Repeat.

Cross Currents: Inhale in the same way through the right arm into the shoulder joint...let the the breath pass across to the left shoulder...and exhale through the left arm. Repeat. Now proceed in the same way on the other side.

Inhale into the right leg. Draw the air through the toes, the ankle, knee, into the hip joint...and exhale in the same way, from the hip, down the thigh, lower leg and foot. Repeat several times. Repeat other side, starting with the left leg.

Cross Currents: Inhale in the same way through the right leg into the right hip joint. Pass the breath across the pelvis to the left hip joint, exhaling through the left leg... Repeat several times. Now proceed in the same manner starting with the left leg.... Repeat several times.

Breathe into the spine from the coccyx, up over the head... across the skull, and over the face. Return the breath under the chin, back into the body...exhale along the front of the spine, down into the pubic bone and out of the body. Repeat several times.

Imagine the breath being wrapped around your torso. Breathe in from the spine across the ribs, closing in on the breast-bone, and breathe out in that way. Pay attention to the movement of the rib cage.

Put your hands on the outside of the ribs to sense the movement of expansion and contraction. Think of the interaction of the bones, muscles, and skin. Get the sense of your whole body breathing and being breathed.

Metaphoric Experience

WORK WITH PLASTICINE

This experience will make students aware of their body image. It is important to have the eyes shut, so as to enhance an immediate tactile sense through which the conscious communicates with the unconsious aspects of personality. Most people are surprised at what they create, and gain new insights into understanding their own body-image, thoughts, and feelings.

Sitting, close your eyes. Take a chunk of plasticine and soften it in your hands. Divide it into two parts. Begin to mould it in separate hands, changing the shape of the plasticine alternately with a fine touch, then a rough touch.

Compare both hands. Leave soft traces in the fine touch hand, then do the opposite, leaving deep traces in the other of stronger pressure.

An expansion into the metaphoric aspect is possible, through the polarities of active-passive, soft and strong, fine and rough tensions, enhancing a wide range of expression of feelings through the material.

The active-strong-rough pressures can either bring out anger, aggression, hate, and destruction...or they can be positive and emphatic, as in a moment of realisation, an 'Ah yes'! Likewise, the passive-soft-fine pressures can express loving,

caring, or sharing or, in duality, an inability to 'get in contact', or as a feeling of being distant.

Plasticine is the ideal metaphor for these tensions, since it can instantaneously mould to the person's reaction and, unlike other materials, is able to change indefinitely and repeatedly.

After this activity, notice the change in your sense of skin, muscle, and bone.

ELONGATION

STAND WITH OPEN EYES
Move around, feel your body, spread your limbs, feel your bones! Allow the elongation and expansion...feel the inner space. Become aware of the orchestration of bones, muscles, and skin.

Stand with feet apart, closing eyes. Shift the weight of the body forward, and return to centre. Repeat several times. Be aware of the length of the bones. Tune into the two forces: the gravitational and anti-gravitational pull that appears between the feet, the back, the head and the neck. Take up more volume, enhancing yourself in space...

VERBAL EXPRESSION
Often, participants reflect and express themselves in such ways:

'I feel like a king'
'I can fly'
'I have grown in size'
'I have the power to carry my responsibility.'

Focusing on skeletal awareness, imagining bone structure, and sensitising the skin, brings about changes in posture. By thinking about the skeleton and bone structure, the muscles adjust to an imagined length; and the skin becomes as the filter or screen of all the body inhales and exhales.

DRAW
Draw your body or shape it in plasticine at the end of the session. You can draw your self-image and your feelings. It can be representational or totally abstract, a reflection in colour or in a few written words.

Hands – Communication, Touch, Stories

The hands are very much the expression of the personality; as well, they perform a wide variety of tactile functions. By looking at the composite parts that create the structure, the sense of the whole hand will be brought to life, deepening the sense of touch and the whole body's sensitivity, and the realisation of their being the servants of the soul.

From Anatomical to Metaphoric Perception

Ask everyone to sit comfortably on the floor with eyes closed.

TOUCH & SENSE
Let everyone encounter their own hands by touching and exploring the infinite possibilities of expression...

Now concentrate on the texture of the skin and nails, temperature and flow of energy, sensing the difference between inside and outside the palm. Receive as much information from your hands as possible. Ask the group how many bones are in one hand. We were surprised by the widely varying replies, ranging from 14 to 30.

DRAW
Present an anatomical print of the hands' structure. Ask each person to draw a hand by careful observation, counting the bones. (Drawings should not be traced.)

It is desirable to colour the bones with different colours according to the grouping, to notice the difference between the types of bone. There are eight carpals, five metacarpals, fourteen phalanges. Having discovered the many bones, explore the mobility and versatility of movement of the hands; they are infinite.

DIALOGUE WITH THE FLOOR OR OBJECTS

MOVE
Allow all parts of the hand in turn to touch the floor or any other surface, exploring different qualities and using different rhythms. Try the many possibilities; notice the qualities of the hand and object when they come into contact. Arrive at a dialogue between the static and dynamic qualities of the hands and the floor, or other objects.

FEELING DIALOGUE

Ask the group to touch their own body in a way that allows them to express feelings, and to make contact with the ground in different ways, with varying emphasis:

> Soft-Hard
>
> Direct-Indirect
>
> Quick-Slow

Sense the different feelings. In our experiences, responses in movement include anger, power, strength, stroking, caring, loving, hesitancy, surprise, and demanding.

After the experience of the kinaesthetic perception, anatomic structure, movement and touch, we come back to look at our own hands and their qualities.

DRAW
& PAINT Ask everyone to put one hand on a piece of paper, draw the contour, and colour it in, putting in as much detail as possible. Then follow the same procedure with the other hand.

MOVE Continuing the journey of the hands we return to movement, as a conversation between two hands: we explore the possi-

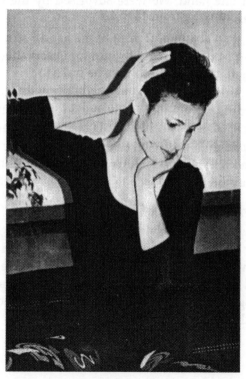

(Eliyahu Ne'eman)

bilities of symmetrical and asymmetrical movements. Real and abstract dialogues, that can lead to story telling, evolve from this.

Metaphoric Experience: Situation and Story Telling

WITH
A PARTNER
Build dialogues with hands only, using one or both at a time. Although the emphasis is on work with hands, the rest of the body and the face are always involved.

REFLECT
An example, as recounted by one student, related to the use of hands without verbal dialogue:

> **The Wedding**
> The excitement of a first meeting
> Falling in love
> The courting period of the couple
> Caring for each other
> Hesitations, conflicts and doubts
> Building a relationship
> The tying of the knot
> Becoming a family unit.

MY HANDS – THE SECRET CIRCLE

MOVE –
TALK
Expression in hand movements and words simultaneously:
Form a small circle of people to create an atmosphere of intimacy – one by one, move your hands, and say:

> My hands are stroking
> My hands are painting
> My hands are playing an instrument
> My hands are cooking.

Repeat the actions with expressions of feelings, while the group echoes the gesture with empathy:

> My hands are afraid
> My hands are loving
> My hands hate
> My hands are in conflict
> My hands are praying.

Again, go once or twice round the circle. There should be no restrictions, allowing participants to repeat their own or another's topics. Now repeat the same structure with the same variations, in relation to another, starting 'Your hands...':

> Your hands are strong
> Your hands are supportive
> Your hands are courageous
> Your hands are pushy.

MY METAPHORIC HANDS

GUIDED
IMAGERY, Closing the circle of our creative process in which we explored
CLOSE the hands, in movement, as structure, touching or as an ex-
EYES pression of feelings, everyone receives a sheet of paper and is
 asked to visualize their hands as a metaphoric image...

DRAW Allow an image to emerge for the experience you had of your
PAINT hands. Transfer the experience to paper with colours and
WRITE words.

REFLECT **My Hands**
 These hands relate the story of my day
 Different from my essential being
 They write, record, evaluate my time
 Finger the muscles of my energy
 And show, beneath the tactile sense, reality.

Back – Sensitivity, Awareness, Expressiveness

> Anything that can help sensitize the musculature and restore the natural
> mobility of our backs will do much to add to our sense of freedom and
> aliveness. .
>
> *Selver, 1982*

We contribute to the process of awakening the body/mind interaction,
increasing consciousness, enabling one to change and re-educate (in the
words of a seven-year-old child) our 'People Pattern'.

A strong and flexible back is the reflection of a well tuned person whose
body/mind/spirit is co-ordinated and flowing. It can function as a sup-
port as well as express feelings and emotions. Many people come to us
suffering from backache. They consider the body as not belonging to
them, although they spend a lot of time, money and thought on how to
cover and decorate the body with garments.

When we ask students how many vertebrae there are in the neck, the
answer is always somewhere between two and ten.

Movement Experience

This is one way to approach the process of becoming conscious of the
body/mind/spirit interaction. The first stage is an encounter of the back
with a static environment, sharpening the senses, and thus stimulating
the body to enlarge its 'movement vocabulary'. This encounter activates
'sleeping areas' of the back, allowing you to meet 'new places' in yourself.

Through contact with different surfaces you develop a subtle touch and receive tactile knowledge of materials and objects.

LIE ON
BACK

What is the quality of your contact with the floor? Listen to your breathing. What parts of the body are touching the ground?

ENCOUNTER WITH AN OBJECT

TOUCH/
SENSE

Get up. Walk around and find a place in the room where you want to stand, near an object. Close your eyes. Sense the surface of the object with your back alone. Collect as much information as possible in this way; bend your knees as much as necessary.

Open your eyes. Look around and find another place to touch with your back. Close your eyes again. Find as many possibilities as you can of exploring the object. Let the body move freely. Open your eyes. Repeat...and explore in the same close-eyed manner.

(Alicia Sclovich)

REFLECT Which was the most interesting, meaningful encounter?
- What was the reason for your choice?
- Which place was most pleasant?
- Which was the least agreeable?
- What was new in your experience?

RESPONSES 'I found the wall very supportive, strong; I felt my back as a unit...I could spread my whole back and give my whole weight to the wall...it was a smooth feeling.'

'I found the chair the least satisfying because it had no weight, it kept moving away from me, I could not rely on it.'

'In order to explore the chair I needed to spread my knees very widely, working very hard not to push the chair away giving me the chance to work very delicately... I enjoyed the experience of subtle unfamiliar movements.'

CONVERSATION WITH ANOTHER BACK

The second stage is about communication with another person – a living breathing human being – and relates to knowing another from an unseen place in oneself, discovering different qualities of touch, and receiving unexpected energies.

BACK CONVERSATIONS

PARTNERS Sit back to back with a partner: one is A, the other B. Close the eyes. Be aware to sit on the 'sitting bones'...and do not lean unduly on your partner. Begin to explore your partner's back.... Do anything you like, without hurting one another.

Partners A open their eyes, move away from B...sit a moment, then stand up. Partners B remain seated with closed eyes.

CHANGE PARTNER Partners A walk around the room and choose another back to sit against. With closed eyes develop a conversation with the new partner...(while keeping your first experience at the back of the mind).

Partners B open their eyes, stand up quietly and find a new partner. Do not speak, but keep your previous experience at the back of the mind.

Both partners open their eyes and, without speaking, all return to their original partners. Close the eyes, explore again the first partner's back.

LIE ON FLOOR Lie on your back. What is the quality of your contact with the floor? How does it compare with the sensation in the begin-

ning of the session? All who were partners recollect their experiences.

DRAW – WRITE
Taking paper and as many crayons as you need, divide the paper into four parts, in any shape or size you like. Close your eyes again, try to remember all your encounters. Then express, in colours on the paper, the different meetings you had and write a few words or sentences near each drawing.

SHARE
Form a large circle putting all the drawings in the centre. Share experiences and feelings verbally.

RESPONSES
Among some discoveries made by participants:

'I felt as if the whole weight of my partner fell on me...I had to struggle to push it away, straighten up, to be able to achieve a "balanced conversation". My boundary was invaded, and I needed to assert myself.'

'I had to make a great effort to reach my partner, I felt abandoned.'

'I felt a warm stream of energy coming my way.'

'It felt like being in a staff meeting.'

'My small of the back had a field day, it was touched with great care and support...my breathing space became softer, my backache disappeared.'

'I had a very lively contact, with subtle innuendoes.'

'I discovered to my surprise the great difference between sitting with crossed legs, straight legs, and bent legs...while the feet stood on the ground, every change in placing the legs affected the back.'

FOLLOW UP
In the wake of these experiences be aware in your daily life of your sitting habits.

- How do you relate to chairs? To the floor?
- What does a sofa offer you?
- How do you find yourself sitting at work, or outside?
- In nature, on rocks, tree trunks, or on sand?
- Do you notice your sitting bones?
- Do you put more weight on one than the other?
- How do you place your pelvis?
- Is it flexible or rigid?
- How does it influence your back when you move with it forwards or backwards?
- How does it influence the way you sit?

- How often during the day do you think of elongating your back, allowing your inner space to expand and breathe to its full capacity?
- How much space do you allow yourself to take up?
- Do you want to be noticed?
- Do you want to disappear?
- Do you want to sparkle?

A back can tell a whole life story!

EXPRESSIVENESS OF THE BACK

SIT Awaken the back:

Sit on the 'sitting bones', either on a chair or on the floor. Begin to play with the back, moving it very softly in all possible directions – let the movement flow as much as possible.

Gradually give more shape to the movement...starting with the 'sitting bones', shift the pelvis to one side, then counter-balance the movement with the torso, letting the head and neck follow passively. Shift the weight of the pelvis to the other side...letting the rest of the body follow...be aware of creating the letter S. Repeat many times.

MOVE
PELVIS Continue working with the pelvis, putting your hands on the rib-cage to sense the movement, and to stimulate the breathing.

Let the head and neck follow the movement...become conscious of the counterbalance that is necessary in the formation of the letter S, which flows continuously.

SHAPING THE BACK TO BECOME EXPRESSIVE

FEEL
EMOTION Let the back express different feelings, whether you sit on a chair, on the floor, or out of doors. Try to express the following emotions, list A representing polarities, list B, cause and effects:

A	B
tired-awake	funny, laughing
angry-peaceful	mysterious, curiosity
rejected-accepted	wounded, crying-pain
apathetic-joyful	tickle, giggle

WITH A
PARTNER The above is just a sample example of possibilities. Now choose your own emotions, and work with one partner or in a group.

REFLECT Finally, lie on your back, close your eyes, and consciously reflect on all that has happened.

Metaphoric Exercise: Chairs

FANTASY Whose back sits in what kind of chair? Let the image come into your mind for the kind of chair your back would be comfortable in...

- Is it a straight backed respectable dinner-table chair?
- Is it a comfortable arm chair? Or a throne?
- A bench?
- A bar stool?
- A baby's sling or pram?

Then imagine the shape of the backs of people you have a relationship with: what kind of chair would your mother, father, sibling, friends, lover, spouse, be?

RESPONSES From a family therapy session, some children's images were: A favourite aunt as a fragile antique; the mother as a heavy, deep and soft armchair; the father a bed of nails, and the brother, a broken rocking chair.

Pelvis – Centre of Power, Tan T'ien

The pelvis is in essence the driving force of the person – it is the strongest link, essential for a balanced postural relationship.

Bartal – Ne'eman

The Tan T'ien is the source of energy, situated about three fingers below the navel, according to Eastern Tradition. This energy point is called 'Hara' in Japanese.

Touching, Sensing, Visualisation

LIE DOWN Lie down, close your eyes and try to find the pelvic bone by sensing with your hands. Holding the pelvis, roll it from side to side, and forwards and backwards... Repeat many times.

Open your eyes, sit up, share your experience verbally in small groups.

OBSERVE DRAW Bring to the group photocopies of the pelvis from an anatomical book, clean sheets of paper and crayons. Look at the

illustration and, from observation, draw the shape of the pelvis with as many colours as you like.

Movement Experience

VISUALISE/
DRAW

At the end of any of the following suggested movement sequences, close your eyes, listen to your breathing, and visualise the pelvis; let an image or images appear in your mind, before opening your eyes again. Open your eyes and draw or write a few words about your experience.

SPIRAL MOVEMENT

MOVE
HIP JOINT
& PELVIS

Lie on your back, spread your arms to either side, the palms facing the ceiling. Bend your legs, putting your feet on the floor as far apart as comfortable. Move your pelvis and legs to one side, allowing your legs to fall to one side as near to the ground as possible without touching anything. Return to the centre. Move your pelvis and legs to the other side. Repeat the movement from side to side several times, while your shoulders, head and neck remain in the centre. *Rest*, while straightening the legs. Observe the changes in the relationship between the pelvis and the ground. Bend your legs again, repeating the same movement with the legs from side to side, adding simultaneously the movement of the head, neck and eyes in the same direction. Repeat many times. *Rest* with straightened legs.

CO-ORDINATE
PELVIS, HEAD,
NECK AND
EYES

Bend your legs again, putting your feet on the ground as far apart as comfortable. Move your legs and pelvis from side to side, whilst moving your head, neck and eyes in the opposite direction...Do not hold your breath. *Rest*. Bend your knees. Cross the right leg over the left thigh, moving the left leg and pelvis without pushing: the left leg carries the weight of the right leg... Repeat many times.

SENSE

Sense the rotatory movement of your pelvis. Slowly unfold your legs, stretching out and observing the changes in the pelvis. How do you lie on the floor? Repeat the same movement with the right leg over the left. Move your pelvis and leg to the left as before. Simultaneously roll your head, neck and eyes to the left, and return to the centre. Unfold your legs. *Rest*. Sense the changes that occur in your body in relationship to the floor. Repeat the same action, ie, bending your legs, crossing the right leg over the left, while moving the head and neck

to the opposite direction simultaneously. Unfold your legs – sense the difference between the right and left side of the body.

REFLECT Close your eyes and visualise the movements so far. How did you feel at the beginning; what changes happened?

By working on one side of the body and highlighting one improved side we sharpened our perception. Pause to compare the sensations and feelings with our 'ordinary' state.

Repeat the whole process on the other side. It is very beneficial to remember and visualise each step, so perform the movement in your mind until you have a clear perception before the action.

PREPARATION FOR GETTING UP

SPIRAL
MOVEMENT (*Extend movement from back to include arms and hands.*) Begin by lying on the back. Cross one leg over the other. Turn to the side of the standing leg until you can lean on your hands. Return to your back, change legs, rolling to the other side and putting hands on the floor. Repeat several times, until the movement flows and you can change legs, from side to side, without any jerks.

With repetition, the movement will become easier and smoother; the speed will increase until you will be able to get up on your feet in a spiral movement. Repeat this as often as

Getting up (Ziv Ne'eman)

you like, until you gradually acquire a feeling of 'lightness', ease and a sense of joy.

When the movement is free, it will make a spiral path in space. All movements, when flowing freely, create a spiral, allowing the body to fold and unfold in tune with the shape of the bones and the joints.

Metaphoric Exercise: The Clock

LIE ON BACK Bend your legs, place your feet on the ground at the width of the hips. Draw an imaginary clock dial on the back of your pelvis:

> the coccyx is marked 6 o'clock
> the top of the pelvis 12 o'clock
> the right side of the pelvis 3 o'clock
> the left side of the pelvis 9 o'clock.

MOVE Move the pelvis several times from 12 to 6 and the reverse, pressing on the floor as if leaving the impression of the numbers on the ground. Unfold your legs...rest. Then bend your legs again as before.

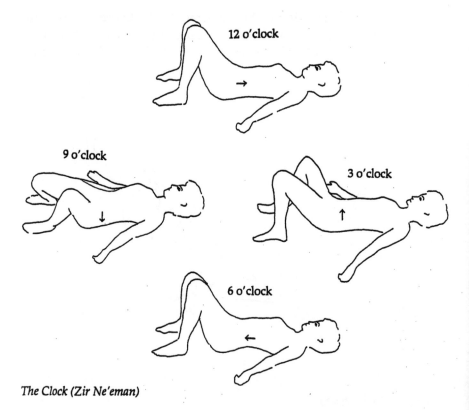

The Clock (Zir Ne'eman)

Move the pelvis from right from 3 to 9, leaving the imprint of the numbers on the ground. Unfold your legs and rest. Observe the changes in the way you perceive the contact of the pelvis with the ground.

Bend your legs again. Press the pelvis clockwise into the ground, proceeding from 12 to 3, moving in stages from 12 to 1, to 2, to 3, and then back to the centre. Repeat this quarter circle many times.

OBSERVE/
REFLECT

Unfold your legs – pay attention to the ongoing changes in the contact of your pelvis with the floor, comparing the sensation with that of the side that has not been active. Listen to your breathing; do not hold your breath, your movement should be independent of it.

Bend your legs again. Press your pelvis into the ground, anticlockwise from 12 to 11, to 10, to 9, and return to the centre. Repeat this quarter circle many times.

Unfold your legs – Rest. Observe the changes in your perception of the pelvis and its relationship with the rest of the body, as well as with the ground.

MOVE

Proceed to move the upper part of the pelvis, in a half circle from 12 through 1, 2, 3, then return from 3, through 2, 1, towards 12, 11, 10, and finally 9. Do this many times, forwards and backwards. And now, in the same way, with equal repetition, move between 3 and 9, through 12 in your upper region.

Throughout this movement the legs are bent and the feet stand on the ground at the width of the hips. Pay attention to the movement in your hip joints, allowing flexibility, without dropping the thighs too low towards the ground.

In similar fashion, draw the lower half of the clock on the floor.

Move your pelvis, as if to press the numbers into the ground: Begin with 6, proceeding clockwise, through 7 and 8 to 9, returning from 9, through 8, 7, to 6 and continuing anti-clockwise through 5 and 4 to 3. Reverse in this manner many times.

OBSERVE/
REFLECT

With repeated action, awareness will become clearer and the movement more flowing. It should be easier to breathe freely and independently of the movement. Unfold legs and rest.

HEAD CLOCK

MOVE
Bend your legs again as before. Draw a smaller imaginary clock dial on the back of your head.

Proceed similarly to the pelvis clock, beginning to move the head up and down so as to leave imaginary imprints of 12 o'clock at the upper head, and 6 o'clock at the lower back of the skull, where the chin is closest to the chest. The head should not exert pressure on the ground, and the breath should be free.

Roll your head to the right, clockwise, to touch the ground with number 3, and to the left to touch 9 o'clock. Repeat many times. Unfold legs and rest.

Bend legs again... Move the head around in circular motion clockwise, from 12 to 3 to 6 to 9 and finally to 12. Repeat the same circular motion anticlockwise, from 12 to 9 to 6 to 3, and finally 12. Repeat many times.

With practice, you will become more subtle in your movements, and be able to differentiate the times in between, ie: 1 and 2 on your way to 3; 4 and 5 on the way to 6, and so on.

OBSERVE/
REFLECT
Observe the sensation of mobility of the head and neck, listening to your breathing. How does your whole body feel in relation to the floor? Rest, bending and stretching your legs whenever you feel the need to do this.

CO-ORDINATE
Bend your legs once more... Try to co-ordinate the movements of the pelvis and the head and neck, parallel to each other. Allow for freedom of movement, not forcing anything, breathing freely. You will gradually find a flowing rhythm of movement. Increase the speed only if it flows naturally without any effort, alternating between clockwise and anticlockwise.

VARIATION
Play with the possibilities of moving your head and neck – in the same direction, in opposite directions, up and down and so forth. Allow your feet to participate – stretching, bending the ankles, rolling the feet clockwise, anticlockwise. Let your hands play as well.

These movements are equally possible sitting on the floor, or a chair, in an office, or in the kitchen.

CENTRING, SERENITY AND GROUNDING

STAND
OR SIT
The following movements can be done standing, or as easily sitting on a chair. Stand with the legs in a comfortable position

and bend the knees. Move the pelvis forward and backward without moving the torso and shoulders. Rest.

Move your pelvis from side to side without moving the torso and shoulders. Rest.

FLOW AND COORDINATE Imagine you are a belly dancer, allowing the pelvis to move in any direction, playing with it until it moves smoothly. Now let it curve, make circles and figures of eight. Allow your torso and shoulders to accompany the pelvis freely, so that the whole body can flow in coordination. Do not hold your breath.

PARTNERS TOUCH HANDS Walk around the room. Look for a partner. Stand opposite your partner at a comfortable distance, with your knees bent. Bend your elbows. Touch each other's palms with a delicate feel, be aware, and explore the flow of energy between you with sensitivity. Let go.

CHALLENGE Face your partner again, putting your right foot forward. Centre yourself, touch with your palms. Without moving your feet 'stand your ground'. Now begin to challenge each other. Gradually put more strength into the encounter, and focus on centring the pelvis, keeping the weight on the back leg.

INDIVIDUAL WORK: FULL LEG – EMPTY LEG

STAND Close your eyes. Stand with legs apart at the width of the hips. Let your arms hang freely at the side, with knees bent. Shift the weight of the body from side to side – from 'full leg', with weight, to 'empty leg', without weight. This motion, in the Eastern Tradition, is identified as 'Yin-Yang'. Centre yourself.

Taoist Breathing

STAND Put your left hand inside the right, palms facing up, about three fingers below the navel, in front of the 'Tan T'ien'. On the inbreath lift the hands up to the front of the forehead, to the 'third eye' position at the middle of the brow, while on the outbreath lower them back to the Tantien, with the palms facing down. Repeat, making it into a slow, flowing, continuous movement. Move very slowly while continuing the exercise. Repeat several times.

Feet – Grounding, Animals

The Root of the Body is in the Feet.

Going on means going far, Going far means returning.
Ancient Chinese Texts

(Alicia Sclovich)

The 'Root' of the quote evokes the image of the earth. We focus on the feet and contact with the ground as a way of grounding the whole personality.

Feet carry the body throughout a lifetime. They contain the nerve endings of the whole organism. We expand the range of movement possibilities to deepen our experience and reconnect to an instinctive, animal-like sense of perception.

Physical Experience

SIT/
TOUCH

Loving Your Feet – especially in the winter.
(The following movement experience needs to be done with bare feet.)
Awareness of the Feet: Sit with crossed legs, or one leg bent. Begin to warm your feet and start the circulation of the energy:

touch, rub, and massage gently one foot... To heighten awareness, work all the sections on the same foot.

Hold the foot with one hand; with the other hand gently bend the toes: from the ball, forward and backwards. Use one hand like a glove for the foot, and stroke along the whole length of the foot, lengthening the toes. Take each toe separately between the thumb and index-finger, circulate clockwise all the toes. Repeat anticlockwise. Circulate the left foot with the right hand several times clockwise. Repeat anticlockwise. Hold one leg above the ankle with two hands, and shake the foot loose. Massage the sole of the foot with your knuckle in straight and small circular motions.

REFLECT Close by gently massaging your foot and compare the sensation of this one which has been worked upon with the other still waiting to be touched. After working with both legs, get up slowly and start walking with a new awareness.

LIE/ Lie on the floor and awaken all parts of your body. Accent the
BREATHE movement of the spine, the torso and pelvis, noticing the relationship of the head and neck. Listen to your breathing.

Fill your abdomen (belly) with air – allow the ribcage to widen, move your torso and arms with the breathing. Get up on the inbreath, and return to the floor on the outbreath. Now do the opposite: rising on the outbreath, and returning on the inbreath.

Open all your inner space, including the top of the lungs, the base of the spine, and your genitals. Exhale with the natural wave of air, allowing the abdomen to go in on the outbreath...alternatively, try the opposite – what we call the 'paradoxical' way...pushing the abdomen out on the outbreath.

STAND/ End up standing, adding voice to your movements like vowel
VOCALISE sounds: UUUH, AAAHH, OOOW, OOOH, EEEEH, I I I I HH. Then alternate these sounds... And now try consonants like: SSS, SSSH, PE, KRRR...as near to animal sounds as possible. Alternate vowel and consonant sounds.

CREATIVE PROCESS

EXPLORE Focus on the feet – touch the ground with different parts of the
TOUCH the foot: ball, heel outside, inside, the toes. Find the parts that don't normally touch the ground. Touch them with differing

intensities: soft, hard, strong, aggressive, caressing, hesitating, beat them suddenly, then move slowly and carefully.

IMAGINE Imagine that you walk, run, and jump, on differing surfaces of your choice.

WRITE Write down three important words associated with this activity to reflect your experience.

Metaphoric Experience: Animals

GUIDED IMAGERY I

VISUALISE Close your eyes and listen to your breathing. Choose an animal you like, with which you identify. Now accent its contact with the ground through your feet. Stay with it as long as you need to, to become really familiar with it.

Movement Experience

The following session may be accompanied by suitable music. Often we use African drums.

MOVE WITH MUSIC With the feet only, try to move as the animal of your choice. Find different situations to express and sense the animal's 'quality' through the feet. Move in a way that is characteristic of that animal in the manner that you wish to express it.

You may now add other parts of the body to complement, enrich and extend the movement. Start to move with one or two parts of the body. Get in touch with the sensual quality of the animal. Gradually include more and more parts until the whole body becomes as much as possible the animal you chose.

WRITE/ PAINT Write down your reflections, reactions, feelings and sensations; or paint them; or do both.

RESPONSES Some personal reflections:

Giraffe – 'I like the peacefulness, the grace, the way it walks, exudes a quality of warmth, its softness, beauty...and it likes me being a vegetarian'.

Fish – 'It is my animal, I am like a fish – I live in warm water, am protected...I flow, I have plenty of space and freedom. I am in the water, invisible...don't speak, have the company of the other fish and plants...I am part of a group, like everyone else; I belong to the herd, the

family, the community...I feel safe, there are no attackers around me'.

Head of a Rabbit/Body of a Lion – 'It didn't work, everything was jumbled up. I was confident like a lion, could roar, and had a strong bite...but on the other hand, I was inquisitive and afraid, running away and hiding like a rabbit.'

GUIDED IMAGERY II

VISUALISE To deepen the experience, repeat part, or all of process, this time visualising an animal that you dislike, are afraid of, or cannot identify with.

MOVE/
DRAW/
WRITE Repeat the whole creative process, ie: moving, drawing, writing, and reflecting. To balance the exploration, move between the two choices of animals, and find a relationship with your present life experience, or choose one specific issue.

Breathing – An Expression of Wholeness

Then the Lord God formed man of dust from the ground, and breathed into his nostrils the breath of life; and man became a living being.
Genesis 2:7

Breathing together (Alicia Sclovich)

According to the Bible man without breath would be only a lifeless lump of earth. Through this breath Adam became a living soul. Life means rhythm. With its first breath the new born baby enters into the rhythm of life: exhaling giving, inhaling taking...the *perpetuum mobile* of life.

Breathing reveals the state of the body, a physical function as well as an expression of soul, and a spiritual process: it always includes the whole person and the personality.

Ilse Middendorf (1990) likens the breathing to Jung's concept of the four basic functions: Thinking, Feeling, Sensation, and Intuition. Sensing and feeling are repressed from childhood. One of the great gifts of feeling the breath is the sensation of wholeness that enables us to deepen our consciousness.

Eastern traditions consider the breath to carry *Chi*, the vital life force, a yin-yang relationship that brings emotional stability. Unhealthy ways of living produce a distortion in the sense of wholeness. Our work is a contribution to the redress of the balance.

Chuang Tzu has said: 'When man *breathes* in and out or inhales and exhales in order to release the old air and take in the new, man hibernates like a bear and stretches his neck like a bird. He is really trying for longevity' (Chung-Yua, 1963).

Movement Experience

Lie on your back, bend your knees, putting the feet on the floor a pelvis width apart; the heels beneath the knees. Feel the five places where breathing is most prominent:

- At the top of the lungs, beneath the clavicles; sense the delicate movement.
- Embrace the sides of the ribcage; sense the expansion and contraction.
- Sense the rising and sinking movement of the diaphragm (solar plexus).
- Put your hands on the abdomen, the 'Tan T'ien' (three fingers width below the navel); sense the ball-like expansion and contraction.
- Sense the lower abdomen – its rising and sinking movement. Pause.

SIT Put your hands where you are most aware of your breathing. Sit with crossed legs. Put your hands in front and behind at the level of your diaphragm and the level of your 'Tan T'ien'. Be aware of the simultaneous expansion forward and backward.

Breathing from the 'Tan T'ien' (Ziv Ne'eman)

PARTNERS Sit with a partner, one behind the other. The one behind places the palms on different parts of the partner's back, to focus the breathing creating a mutual flow of energy.

EASTERN FORMS

TAOIST BREATHING From the 'Chi Kung', the ancient Chinese Art of healthy movement and breathing, we have adopted two basic forms:

Breathing connects the individual body to the air around it; it is a constant interaction, a relationship. The clearer we become in this relationship, the easier it becomes to be breath, which is being inside and outside, part of everything, that which is described as *Tao, the Way*.

SIT Sit with crossed legs.

The Buddhist way: draw your breath into the lower abdomen and exhale with a soft abdomen, drawing it in and gently pushing it against the spine. Repeat several times. Pause.

'Breath for Immortality' – the paradoxical way: draw your breath into the upper body and exhale by filling and pushing the abdomen out, which brings 'Chi' into the lower body and the feet. Repeat several times. Pause.

BREATH, MOVEMENT, AND SOUND

STAND Stand with rooted feet between earth and heaven (do not lock your knees). Feel the air around your body – fill as much space as you need. Look horizontally into the far distance, following an imaginary river. Exhale a few times as a preparation.

VOCALISE Inhale and exhale; voice the outbreath with the vowels: A, E,
 EE, I, O, U, one at a time, and end the sequence with the syllable
 SU... Notice that with repetition the exhalations will become
 longer and stronger.

MOVE/ Move and voice your breath; let the movement guide the
VOCALISE sound, or the sound guide the movement in simultaneous
 harmony. In time, the sound quality will expand and become
 fuller, and the movement will soften and flow. Accompany the
 movement with whistling, and give free range to your imagin-
 ation.

Metaphoric Experience

BREATHE **Fish** – let the breathing become like a fish, involving your
AS ANIMAL whole body: allow the flowing, the undulating wavelike
 motion become you, or you become it. Move in space, on
 the floor or on a chair.
 Cat – let your breathing become like a cat in the way it
 stretches, expands, retreats, rolls over on its back
 completely relaxed, and allows itself to be stroked.
 Allow cat-like sounds to come out of your breathing.
 Birds – experience breathing like a bird; focus on the back,
 allow wings to grow from the flow of your breath.
 Experience small birds, fluttering excitedly, twittering,
 singing. Experience the growth of large expanding
 wings, of soaring to great heights, being suspended
 weightlessly in the air.
 Identify with birds of prey, hovering, focusing on
 their victim until they suddenly dive to their target. If
 you can, imitate their sound.

Rigid and Soft

This section consists of two parts. The first one can be used on its own;
the second – Visualisation – should be preceded by the first. Together, they
can be experienced in a session of one and a half to two hours' duration.

Movement Experience

MOVE To experience a neutral state of the body begin as follows:
ON BACK Lie on your back; make yourself comfortable.

Bend your legs, separating them so that they are a pelvis width apart. Put your feet on the floor. Push the feet into the ground, straight underneath you.

Allow any movement to happen that will result from this pressure. Most probably the pelvis will lift off the floor. If the spine rises to the point where the back creates a 'bridge' and most of the weight rests on the shoulders, make sure not to press unnecessarily on the neck. This can be done by rolling the head from side to side while in this extended position. Return, vertebra by vertebra, to the starting position.

After this first trial, repeat the procedure, but instead of pressing into the ground straight beneath you, imagine that you are lying with your feet downwards on a slope of 45 degrees. This will necessitate pressing on the ground in a diagonal direction.

You could not bend therefore you broke (Leah Bartal)

OBSERVE Be aware of the difference in the quality of the movement.
- Is the pelvis more ready to move?
- Do the vertebrae connect differently?
- Does the whole movement become smoother?
- Do you notice any other differences?

Repeat the whole procedure at least six to eight times, making it easier every time.

- Do you hold your breath?
- Can you roll your head freely from side to side while the weight is on the shoulders?
- Is any unnecessary pressure occurring anywhere?
- Does the abdomen allow free breathing?

Rest in any position you like.

MOVE IN DIAGONAL Lie on your back. Bend the left leg. Place the left foot on the ground. Straighten the right arm above the head, touching the ground. Push into the ground with the left foot. The result of this pressure will be a rotation in the pelvis to the right, without lifting it off the ground. Return to the starting position. Repeat six to eight times. Rest.

The sensation should be as if the passive side is being ironed on the floor. Pay attention not to hold your breath.

Repeat the whole movement sequence on the other side. Rest.

ESHKOL-WACHMANN NOTATION Lie on your back. Extend both arms and legs diagonally on the ground: Planes (1) and (5), (7) and (3) (see p.15).

Bend the left leg; touch the floor with the left foot. Imagine lying inside a sphere. Lift the right leg and the left arm off the ground, move them towards each other. Draw an imaginary line inside the sphere; right leg and left arm may meet halfway (Planes (1) and (5) meeting approximately at (4).) Return arm and leg to the floor. Repeat six to eight times.

Pay attention not to hold your breath. Push the small of the back towards the floor. Rest.

Lie on the back. Bend the left leg. Put the left leg on the floor beyond the right knee. The right arm is stretched on the floor above the head. Roll the pelvis to the right, the left arm remaining on the floor as far as possible. Return to the starting position. By leaving the left arm on the floor, the chest will stretch horizontally and the shoulderblades are made to move. Repeat six to eight times.

VARIATION The head can roll with the movement, or against it.

Metaphoric Experience

VISUALISE This section is the first step in using abstract visualisation derived from a body sense on a psychological level. It provides unexpected deep insights into very basic character traits and a reliable reflection on a person's awareness of themselves in the here and now. (In our experience, anyone who has difficulties in letting the objects blend, usually has more than average resistances). It is able to release many habitual tensions, as the story at the end attests.

IMAGINE Begin by lying on the floor. Close your eyes. Scan your body from inside. Focus on the most rigid part, a part that is hard, unyielding, and resistant – it may be the pelvis, the neck, the eyes, or any other part of the body. Remain focused until the rigidity takes on the shape of an object – it may become a metal pole, a coathanger, a rock, or anything else. Fade the image to the back of your mind.

Re-scan your body. Now focus on the softest part, a part that is pliable, tender, smooth – it may be the buttocks, the stomach, the mouth, or any other part. Remain focused until the softness takes on the shape of an object – it may be a pudding, a sponge, cotton wool, or anything else. Fade the image to the back of your mind. Rest.

Bring both images simultaneously into focus: Keep them there until the two become one, blending into each other, shaping a new form. What is it? What form has it taken? What are its functions? Is it practical? Is it useful? Does it give pleasure or pain? Explore its texture, its colour, its smell...can you hear it? Would you like to touch and hold it? Or does it disturb you and make you want to get rid of it?

DRAW/ Draw or paint on paper the three objects: the rigid, soft, and
WRITE blended one, adding any words that come to mind.

PARTNERS Find a partner to work with. Turn your painting into a move-
TRANSFORM ment to express the found objects, to communicate the
DRAWING qualities of your images: rigid, soft, and blended. Work one at
INTO
MOVEMENT a time to enable the partners to observe each other. It is possible
 for the observer to write down his/her reactions.

SHARE Follow this by a conversation about the whole process – the choices, the painting, the movement.

Now the partners make a nonverbal conversation using their own movement phrase. One may change partner for this

second stage. At the end of the session the group may share the paintings and the movement.

This procedure has been used by us with actors and dancers, to explore psychophysical dimensions of characters. For example, where would your character feel rigidity in his/her body? Where would they feel the softest spot? How will the two qualities be blended? What new insights does it bring? And do they feel resistance to this process, or does it make it easier?

Our experience in the therapeutic field encouraged us to get participants to look at their interpersonal relationships under a 'hard', 'soft', and 'blended' light.

Personal Stories

Following a session on 'Rigid and Soft' parts of the body:

An Account of a Journey I Made...

'I was told to think which part of my body was tense, and which was soft, and to blend the two. And so my story unfolded.

The tense part proved to be the back of the legs and my thighs. I visualised a corn on the cob made of rubber inside and gradually it affected the base of my back which was a square sheet of glass. They were joined together by suction rather like a table with two legs. It then began to float around in space and around the earth, which became a hamburger. I could see the moon, which was a plate, and the sun, which was itself. The hamburger opened its 'mouth' and I was pulled into the darkness where I could smell the warm meat. I floated along its dark corridors and suddenly came into the London Planetarium where I became a table with two chairs. People put things on me, ash trays, which slid off. Suddenly the legs grew longer and longer, and I smashed through the roof, up into space, passed the hamburger and against the wall of the movement studio. I felt very firm against the wall, as I was lying horizontal to it. Then I began to see myself vertically and I saw the whole shape of the leg. The London Planetarium was the hip joint, the hamburger was the knee joint, and the sheet of glass was my foot. Joining the glass and the hamburger was the corn on the cob which now went right through the hamburger and on to the London Planetarium (the hip joint). When I got up I found my hip to be looser than it had ever been before.'

Following a series of workshops, students were asked to write a conversation with their body.

Left and Right Shoulders

'The left and right shoulders were in a warm bath. They took this occasion to start one of their endless wrangles. As always it was the right shoulder, spoiled and petulant, who began:

R.S. 'I suppose you are pleased with yourself!'

L.S. 'No, not really. Though today was rather good.'

The right shoulder could stand it no longer.

R.S. 'Go on then. Boast. Tell me about it!'

L.S. 'But you were there. You saw what I did.'

R.S. 'But I don't know how you feel, do I?'

L.S. 'But you've done it before! You always do all Leah's exercises.'

R.S. (*Spitefully*) 'No, today I didn't. Didn't do anything today.'

L.S. 'You did a bit!'

R.S. (*Eagerly*) 'How do you feel?'

L.S. 'Just wonderful! I could do anything.'

R.S. 'Go on.'

L.S. 'I feel relaxed, I feel I could float away in this warm water. I feel supple, loose but controlled, and well, great really!'

R.S. 'I feel so low...' A pause. 'I think it's time to go.'

L.S. 'Say when'.

R.S. 'We don't stay long in the bath these days, do we?'

L.S. (Regretfully) 'No, we don't.'

R.S. 'Still, she is the boss.'

L.S. 'Always has been.'

R.S. 'Always will be.'

L.S. 'Maybe she'll do exercises with you tomorrow.'

R.S. (Very eager) 'Do you think she will? Really? Ooh...I quiver with anticipation.'

L.S. 'Yes probably. I think it's some kind of a test. To see how we feel or something.'

R.S. 'Ooh, you are clever! You're probably right.'

L.S. 'You'll see tomorrow.'

R.S. 'Definite message...no more warm bath. Got to get her out.'

L.S. 'You lead. I'll follow'

R.S. 'You always do.'

L.S. 'Now we are going to try another way.'

R.S. 'Let's get out....'

And I got out of the bath, lifting both shoulders at once, undecided, and for the first time the Left Shoulder took the initiative.'

'Another Cup of Coffee...'

The author of the following piece had an almost unbelievable history of illness. 'To be able to produce a script like this and laugh about it – it shows how thoughtless I have been to survive' she says. 'I have been the emotional lavatory of my family.' She had/has cancer, was burnt by radiation in a hospital, was helped mainly by a homeopath/hypnotherapist, a spiritual healer and is a member of my ongoing

group. Occasionally we have some private sessions. She is exceptionally creative, has worked as a teacher, paints, writes, and has danced.

'Another cup of coffee' groaned the liver. 'Here we go again'.

'Oh, things aren't that bad, anyway not as bad as they used to be,' the pancreas reflected: 'we haven't been on red alert for ages. Things have quietened down a lot. She only drinks the occasional cup. I quite like that China Tea she drinks though'.

'It makes us squint' said the eyes, trying to be funny.

'Mmmm...I suppose you're right...' replied the liver. 'I haven't used my pain under the right ribs technique for quite some time. It's getting quite boring. At least I don't have to work quite so hard filtering that red and white wine, vodkas with tonics...eek, quinine, coffee, Indian tea...and as for that dreadful adrenalin...'.

The legs uncurled themselves and yawned: 'We don't know what you are all complaining about, we've had to carry you all around whilst you were on malfunction'.

'So would you malfunction if you'd been treated the way we were', retorted the liver and pancreas. 'At least you were exercised each day whilst she walked home from work...and what's more, you were fully extended and flexed at her Jazz Ballet classes. She was so busy thinking about you two, she forgot all about us. She split body from body, as well as body from mind. She made a real mess of things'.

The brain trying to referee, interrupted: 'Poor girl, the winds of fate have blown and battered her for many years. She tried, but she didn't exactly have the right start – an accident they said, a party screw they said, shot gun marriage they said. She tried to keep herself on course but metaphorically speaking, her rudder was already broken'.

The lymphs wriggled impatiently: 'We gave up when we were nineteen years old. We made a wonderful lump the size of a golf ball which proved to be of great fascination for those people in white coats'.

'Oh no', groaned the neck: 'don't remind me, they cut me open and then used invisible beams'.

I almost died due to the radiation, and my lymphatic system was burned for good. My salvation came in the form of human hands not machines; a kind healer has now substituted his own invisible beams through his hands.'

Following a session on animals, this piece was created by two people, derived from one of the women's nightmare about an alley-cat that ate her fingers.

T'ai Chi into psychocats

The slow sinuous movements of the T'ai Chi – lifting both arms in front with the inbreath, rotating with the Yin/Yang circle of the hands, pushing

hands sideways, circling with our belly energy, brushing knee with right hand, pushing with left hand, 'Embracing the Tiger'* ...crossing the arms in front of the chest, 'Returning to Mountain'* ... The opening from the 'Alleycat' – graceful but strong and confident; retreating to safety – cuddle, stroke, fight, pat, paws pursed...approach the street with pride, walk along it, the territory is ours...our home, the alleys are narrow slits – the sky shines through the huts...

A shadow approaches, does it mean danger? Better be prepared. Curl the spine, ready to attack...a false alarm, just another cat. We play, we stride along together, opposite arms and legs, extending-retracting... What now, a dangerous one approaches...

Tense up, baring the teeth: 'Meow'...What does the other cat want? Is it really friendly? Better be cautious, it might scratch or attack, 'meow'...

We circle around each other: hissing, spitting, moaning, growling and humming grotesquely...shoulders hunched, on tiptoes, walking stealthily – head in isolation...we move on, paws curled...run around a corner, side by side...

Legs lift high up to the chest, feet and toes pointed, back arched head thrust forward...slide sideways, our bodies meet, our backs touch, comfort and support each other – listening, coping, adjusting to the footsteps following...turning slowly into something else...a domestic cat perhaps?

This domestic cat shows its thrusting underbelly.
Backs together – longing
Sides together – leaning
Head together – nuzzling

MIDNIGHT – TIME TO GO HUNTING

Here she comes down the narrow lane, she won't escape us!
Let's jump, scratch, hiss, bite 'quite tasty fingers.'

* Names of movement phrases from the T'ai Chi Ch'uan form.

Resources of the Physical Body II
The Body in Relationship to Objects

The object expands beyond the bounds of its experience by our knowledge that the thing is more than its exterior presents to our eyes.

Paul Klee

Through objects we can bond and commune with the world at large; we can become an integral part of the Universe. Jean Bazaine wrote: 'An object awakens our love just because it seems to be the bearer of powers that are greater than itself' (Jung, 1964).

As a builder needs to know the functions of stones and mortar before he can plan and design a house, we lay the foundations from which to understand oneself and explore the wider world of archetype and myth. In the previous part of the book we began with an individual's physical body as a resource; here the path continues with the link between people and the environment. Everybody relates in space and time to other individuals and to objects: natural and human-made ones. The 'Other' can be a person or an inanimate object. Objects can be bridges to deeper personal insights and memories.

As Winnicott (1971) says, a baby's recognition of 'a "not me" possession' can be an 'attachment to a teddy bear, or any other toy' following 'the first fist-in-mouth activity'. Between the object and me there 'is an intermediate area of experiencing…the object-relationship'. This primary relationship is experienced through movement, an ongoing developing concept of self and relationship with others and the immediate environment.

One day, as we walked in an open field on the Carmel Mountain, a sudden thunderstorm forced us into a cave; in front of us was a small area between the rocks. In there were snails carrying their homes on their backs. We observed their paths: they moved behind mounds of earth, over leaves, around small stones of different shapes, textures, and colours. Gradually, they overcame the obstacles on their way – here was a metaphor for our lives, rough, rocky, soft and yielding ground, over which we are continuously struggling and overcoming, between free flow and boundaries, security and insecurity, both interdependent and indispensable. Security can be your home on your back, or a thumb and a blanket.

We move from the body to the natural environment, relating to our surroundings in the present, the *here* and *now*. The environment provides images and metaphors to reflect ourselves. Objects from daily life are vehicles for self-exploration: they enable each of us to project our own emotional experiences. This leads to the discovery of the synchronicity of inner and outer events.

Rosemary – Developing Free Association

BUILDING TRUST

We arrive with a branch of rosemary or lavender to pass around the circle. We use this very simple stimulus to start a group process, to develop free association, spontaneity, and imagination in a non-threatening way.

The rosemary makes the rounds several times. Everyone says a word while holding the stem. Saying our words helps us to discover the collective and individual consciousness of thought and feeling in a social context.

The word can be descriptive or emotional; a noun or a verb. There is permission to repeat a word, not to strive for originality, and there is permission to let the imagination go off and be spontaneous. This atmosphere allows the student to be free and escape mental blocks and fear. Everyone is acknowledged without judgement.

Mr and Mrs. Critic are the most powerful voices in our society. In spite of our emphatic permission to repeat simple words, people still become bored or blocked by fear. Repetition can enforce a pattern, be it cultural, social, emotional, or archetypal. Our intention is to inspire confidence without expectations. Some people are able to take off from this simple beginning, and go on to create spontaneous poetry. We write all the words down either on the blackboard or a large sheet of paper. Then we sort them into categories:

descriptive	emotional
factual	imaginative
simple	colourful

Sociological, ecological or cultural statements are also welcome.

We form small groups to create an improvisation with the words from one or more category, and we can perform these scenes for the rest of the participants.

Plants and Trees as Metaphor

Plants placed in a room are a reflection of nature and come in many
shapes. We relate to them as *metaphoric images*. The images reverberate in
the individual to evoke emotional responses.

The earth is made of many layers; the tree is made of many rings; the
plant has one stem but many petals or flowers: thus we address the many
layers of personality.

Movement Experience: Scanning the Body

SELF-
OBSERVE

Begin by lying on the floor. Imagine that you are lying on the
earth. What kind of imprint do you leave? Make yourself a
general image of your whole body... Become more specific:
how does the head touch the earth? How do the shoulders
touch the ground? Can you sense your shoulder-blades? Do
you feel your ribcage? Through breathing, can you sense the
movement of the ribs? Do they contract and expand? Can you
feel your pelvis touching the earth: does it feel heavier than
the rest of the body? Can you feel the small of the back
touching the earth? How do the thighs touch the ground? Do
they feel similar or different? Do the lower legs touch the
ground? Is there a difference between the two? Can you feel
the back of your knees? Can you feel your ankles? How do the
heels imprint themselves on the earth? Does one arm feel
different from the other? How do the elbows touch the
ground? Is the right different from the left? Do the wrists touch
the ground? Do the palms of the hands touch the ground? Can
you feel every finger? Do the arms feel different from the legs?
Can you sense them as branches of yourself?

IMAGINING
MOVEMENT

Imagine the movement of a tree or plant. Move the limbs
freely: the arms, hands, legs, feet, the head and neck. Sense the
air embracing your body as it moves around a tree.

Imagine your body to be like the trunk of a tree. Start
moving with the air, gradually rising from the floor. Focus on
the movement in the big joints: the hips and shoulders. Im-
agine them to be like the branches and stems of the tree. Allow
for free movement improvisation: emphasise the importance
of gesture; move fast and slow, slow and fast; vary the

rhythms. Work separately to move the shoulders alone, or the hip joints. It is possible to work on one side at a time. Imagine that things cover you, such as leaves, thorns, fruits, or berries. How do they relate to your movement: do they swing, or blow with the wind? Are they ripe or colourful, drab or dormant?

Relating to the Plant

Look at a group of plants. Which one do you like? With which can you identify? Choose three plants:

IDENTIFY — Express their character in movement. Do this with one part of the body to begin with. It is important to work with minimal and maximal movement. After one part alone work with two, three, and more parts, until the whole body is involved. Return to minimal symbolical movement and to a static shape. Repeat this process with every one of the chosen plants.

WRITE — On a piece of paper write down associations you had with each of the plants during the whole process: looking – moving – choosing.

The following work can be used to illustrate the 'Law of Heavy and Light Limbs'. This law states that when a heavy limb moves, it carries with it its appropriate light limb: the terms 'light' and 'heavy' may therefore be used of any limb (indicating whether the limb moves actively or passively). This law is not to be confused with the general feeling of heaviness or lightness in the body (Eshkol-Wachmann, 1958).

CHOOSE
REFLECT — Choose one specific plant and stay with it. Reflect on it. What does it mean to you; what can it tell you about yourself? With what part can you identify? What part feels comfortable? What part feels uncomfortable?

MOVE — Express its specific character in movement. Does it open? Does it grow horizontally or vertically? Is it solid, strong, full, or light, or soft. Does it branch out? Is it long, narrow or sharp? If the plant was a person, what character would it have?

PAINT — Draw or paint your impression and emotion as expressed through shape, feeling and sensation. Add one sentence to each drawing.

SHARE — Share your experience: in small groups or in a big circle.

Personal Story

It was an interesting process to have to choose from the various, wonderful trees that I saw. One was so big I thought it could be overwhelming...but I decided that I'm in such a wonderful space internally right now, that I could go for it! And it worked! I chose the big one, as well as one just like it (also covered, laden with lavender-coloured flowers) to be a little peaceful, and therefore balance the two.

When we danced outside I had no major insights, but enjoyed feeling the weight of the flowers dripping from the tree, and the sudden way that the leaves would be flipped over by the wind.

When we went inside, I became very tired. I thought I wouldn't be able to move any more...But slowly I reawoke, and almost before I knew it I was rolling outside onto the pavement. Then to my great surprise I was climbing up the doorway and hanging from the door: like the flowers hang from the tree! It felt very good: stretching and looking out over the neighbourhood...what will the neighbours say??!

The two words which propelled my movement – *expansive and cascading* really brought me to life. My associations were:

lush	peaceable
purple	extravagant
restful	turning
glorying in 'me-ness'	holiness
abundant	overflowing

And from this, a poem bloomed:

> In spite of
> tiredness
> pain
> muscle hurting-ness
> cramping
> lack of energy
>
> my body
> danced me!
>
> Able to
> cascade and expand.

My energy I couldn't have imagined: *good God imagine it!*

> Dance me, God!
> With all your Goodness!
> Dance in me.
> Dance me.

God-ability / dance-ability

> Am I danceable?
> I am ready and available
> I am!
> Sof Sof Ein-Sof! (So on and forever)

Group Soul Tree

At this point it is possible to introduce reproductions of works of art, postcards, magazines. We use 'The Tree of Life: Image for the Cosmos', by Roger Cook (1974). The image can be from descriptive, metaphoric or symbolic art: the 'dream tree' or the 'magic tree'.

PAINT Every one is asked to paint their own imaginative tree – or part of a tree. The drawing can be put wherever the person likes in the room: on the floor, or wall...

GROUP IMPROVISATION

MOVE It is possible to build as a group an imaginary forest, or create a magical group tree, like a totem, with sounds, voices and music. The group's expression can also be likened to a carving: the will of the group creates a group image, or a spiritual identity of integrated souls. Have you experienced this kind of integration in any real life situation? Perhaps in a team, a family, or any other group?

Masks – Masked Images of the Soul

Another facet of body awareness leads us into qualities and images of people, reflecting the many parts of the soul. The images can be the face of a familiar family figure, teacher or boss, emerging from the sense of the body.

The body stores memories, feelings, sensations in the muscles, bones and skin. Unlocking and releasing knots that have been created by traumatic events in our lives, we become conscious of processes by which we function. We combine the tensions and rigidities perceived as body sensations with more defined perceptions of people that affect our lives. These images come very much to life when acted out. Translating the sense of the remembered person into body movement and interaction with people makes it very real.

Beyond this point, we want to widen the experience by introducing masks: in this way we can sense and more readily identify with the archetypal figures. We can move freely and, without inhibition, play out any drama in our life, past, present, and projected into the future. Also, participants can more readily experience the 'peculiar sensations' by which 'ancient' or 'primitive' cultures – our ancestors – communicated with Nature's spirit and spirit forces, which had a deep physical, psychic, and spiritual effect on human nature: in short, the forces which have led

to our own present existence and still govern our lives, whether we are conscious of them or not.

Masks are a link, a bridgeway between the conscious and unconscious personality, the individual and the group soul.

Preparation: Tension and Release

LIE

Lie on the back: close your eyes and listen to your breathing. Scan your body in the following way:

Pay attention to any tension you can detect in your right hand, starting with the fingers; increase it, hold it until you are clear about the sensation, release. Repeat this with the right lower arm, right upper arm, right shoulder. Release and rest.

Repeat this with your left side in the same order.

Then continue the process with your right foot, from the toes to the ankle: any tension you discover, increase its strength until you have a clear picture of it. Rest. Continue with the right lower leg, right upper leg, right hip joint. Release and rest.

Repeat the process of detection of tension and release in your chest, head and neck, and shoulder; add the pelvic region, then release and rest. Combine the sense of all the tensions and their increases into one action, and let go of it.

RISE

Roll on your side, get up slowly to your feet and recreate the tension of your body in the vertical position. Look at the shape you have created – this is the expression of the tense part of your body.

WALK AND SCAN

Move around the place, get a sense of yourself, meet some people; reflect on the atmosphere in the group, and return to the floor. Get a sense of the soft parts of your body. Where is the least tension? Where is no resistance? How are you at your most relaxed? Scan the whole body: choose your own way.

Roll around...stand up and get a sense of your body without any tension: what is your shape? Move around the room: how do you relate to the group now? Let go and walk around as 'neutral' as you can be, without too much or too little tension.

Imagery and Masks

IMAGING A PERSON

Lie on your back, close your eyes. Sense your whole body; listen to it breathing. Gradually become aware of the tensions in your body, become aware of the most rigid part. Remain

focused. Get the sense of the tension: become one with it, trust what will emerge. Allow it to become the image of a person associated with this quality: stay with the feeling until you have fully absorbed it. Gradually release the image and return to a neutral state. Listen to your breathing.

Gradually become aware of the softest part in your body, where you feel no restrictions, most at ease, and without tension: focus on that part, get the sense of freedom. Remain focused. Become one with it, trust what will emerge: allow it to become the image of a person associated with this quality. Stay with the feeling until you have fully absorbed it. Gradually release the image and return to a neutral state. Retain the sense of both images. Open your eyes, roll to one side, and get up slowly.

EXPRESS
CHARACTER
Standing, try to recreate the found qualities in the vertical line of your body, meeting other people.

MASK MAKING

We prepare masks of various expressions: if possible, allow the group to make their own masks. If available, bring pieces of material or gauze to enhance the experience.

Choose a mask and suitable material to build the image you have seen in your mind, relating to what emerged from the rigid part of your body.

EXPRESS
IN VOICE/
MOVEMENT
Combine the sensation in the body with the feeling of the mask. Take on more and more the character that emerges, and the expression of the mask you have chosen.

Interact with your surroundings and the other characters in the room: add verbal expressions and allow improvisation to develop. Reflect on the reaction of the group and your own feelings... Rest for a moment.

Repeat the process, remembering the qualities associated with the soft image. Rest for a moment.

Find a third mask that has the qualities of both. Allow for the blending of both images into a more integrated character.

DRAW/
WRITE
Open up the experience by drawing and writing the three images. Share the process in the group as a whole. Ground, by referring to real life issues.

REFLECTIONS Dialogues With Masks

'That's why you smile, because you know I don't want to know you...understand: be you, I want to be me. But you're so clever because you are the part of me that I deny; and I'm the part of you that gives you life'.

'Oh you make me smile, because we're not individuals, but part of the same mind. Yet, we are from different ends of the pole. It is because we have this unspoken understanding that makes us so unique'.

'Isn't it strange how you and I can talk like this...can be so positive and negative, and yet be at peace?'

'I want to frighten you, but I seem timid.I think it's because I'm really frightened. I'm anxious and if I do seem frightening, I wouldn't really hurt you. I feel masculine – it's part of me wanting to be dominant, or anyway confident. I'm very interested in other people; and now even more so, concerning what lies under their mask!'

'I'm hurt – you don't care...so I have nothing more to say to you'.

> **'Golden Nose'**
> Bold majestic, golden nose
> Cautious distance
> Curiously, dangerously near
> Wrinkled forehead infested with crawling
> creeping curling asps.
> Attention seeking emerald eyes
> Dumb, unspoken words
> Talking eyes, motionless mouth
> Sunlight highlights pain and sorrow
> Softens into kindness, naivity
> Gullibility golden, golden grief.

Giving birth to a new self (Naomi Adler)

The Body in Relationship to Works of Art – Individuals in a Museum Environment

One way of expanding the bridge between people and a human-made environment is to sense works of art through the experience of the body – it creates empathy, an immediacy of relating, to a creative and a transpersonal dimension. It can help people to understand classical or abstract art in a new way and connect to paintings and sculptures in a nonverbal manner, so creating a new language of communication.

Movement Experience Before Visiting the Actual Exhibits

MOVE Begin by moving one arm in straight lines on various planes, broken, interrupted lines. Change directions at different angles. Repeat the movement with both arms at the same time: creating a conversation between them, using straight and broken lines. Add other parts of the body: the torso, head and neck, and legs. Walk in space, leave traces of straight lines on the floor, move at different angles: right angles, obtuse, and acute ones. Walk freely, in any way you like. Move in curved, flowing lines, make circles and spirals on the floor.

GROUP Divide into two groups: one moves in straight lines, creating both body movements and lines in space; the other moves in curved lines, with similar movements. Change speeds: move fast and slow alternately. Let one group move, while the other observes.

IMAGING IN MOVEMENT Imagine your body to be a paint brush – become a small thin one, then a large fat one, a round brush, a flat one, or a palette knife. Imagine that you are being dipped into water-colours, oils or acrylic.

PARTNERS Work with one partner: one being the painter, the other the brush or the canvas.
Clarifying and Understanding the Intention of the Artist:
Find one picture you like, and another you dislike. Say what you like or what you dislike about the picture. Gather the group to talk about concepts and intentions of the artist and the components of the picture: what is the theme, shape, and medium of expression? What type of brushstrokes are being

applied? Or, in the case of a sculpture, what mode of carving or construction is employed?

Look for structure, balance, symmetry, asymmetry. Is it powerful or delicate? Is the paint thick or thin, or mixed? If it is a sculpture, what materials were used? Is it framed?

PARTNERS

Work with Partner

Everyone goes to the pictures of their original choice, the ones they liked and disliked. Share your impressions with a partner. Repeat this several times with different partners. Return to the group.

Between the group members, agree on the choice of two pictures as an example. Talk about them: ask 'what do you see?' Then look at one picture: close your eyes... What feelings or sensations does the picture communicate? Share the experience.

'MOVING' THE
PICTURE

Transfer the sensation and the feelings from the surfaces of the picture into the body; use the whole body or parts of it alternately. What happens when you do this? Does the picture take on new meaning? Does it feel more familiar? Is it more interesting? Has it more than one meaning for you? Has your understanding of it changed? Repeat the same process with the second picture. Give it a name, or rename the picture.

This process is particularly enriching in relation to abstract art, heightening the sense of involvement, becoming more personal and significant. No longer is one an observer, but a live participant in another person's creation.

(Ziv Ne'eman)

The Body as Social Communicator

Many of our most painful and joyful experiences emerge from our interactions with other humans. Through our work, we have developed experiential ways to deal with human relationships in the family, at work, and at leisure. In our workshops participants have the opportunity to practice communication skills in a playful nonthreatening way. We give psychodynamic processes, nonverbal expression through the body and in art.

The following issues arise in most social situations:

How do we meet people?
Do we touch each other?
How do we respond to each other?
Do we want to see and be seen?
Do we want to hear and be heard?
What does the body express consciously?
What happens unconsciously?
What are our personal boundaries?
How do we express strength?
How do we express weakness?
When are we 'victims' or 'rebels'?
How do love and power manifest themselves in our relationships?

We explore these considerations, through exercises based on:

Spatial Interactions – Individual and Collective Space.

Physical and Emotional Boundaries.

Group Dynamics – Leadership and character studies.

The exercises can be focused, adapted, and expanded to work with many different groups: in the classroom, in therapeutic groups, at conferences; as a way to bring a new group together, or to wake up a group when they have been sitting too long.

The combination of giving people the freedom to express themselves, and a form in which to do this, creates safety and trust for the individuals within a group, and brings the group into harmony. In our conflicting world it is essential that people learn to be more truly themselves and also to respect each other.

Circles

We explore stillness in relation to movement, and movement in relation
to stillness: it can be a beginning or an end, a cyclic occurrence, and relates
to what went on before, in our past. There is a point where we decide and
do, and a point at which we come to a *standstill*. There is a continuous
interaction between coming and going: always one point, and an infinity
of points in our existence. Sometimes we initiate the action, and at other
times we react. There is a beautiful painting by Van Gogh, 'Starry Night',
which depicts a decisive moment of union between inner self and outside
world as a Yin-Yang formation, the opposing sun and moon unified in the
swirling of the clouds. As Van Gogh himself wrote of the picture: 'First of
all the twinkling stars vibrated, but remained motionless in space, then
all the celestial globes were united into one series of movements...Firma-
ment and planets both disappeared, but the mighty breath which gives
life to all things and in which all is bound up, remained'.

Turning can become a way of getting 'high', releasing a different level
of consciousness. Mary Wigman used to let her dancers turn for hours; if
they became sick, they went out and returned to continue. 'By dancing,
by spinning around his own axis in figures of eight or around the sun,
man incorporates the movements of the universe, of planets and atoms,
of galaxies and electrons. As he winds, he creates the still point in his heart
and turns the Universe into being; as he unwinds, he turns his spirit back
to his divine source' (Dore Hoyer, quoted in Purce, 1974). To this day the
Dervish men in Iran and Turkey, in their sacred ritual ceremony, whirl on
their own axis, the right hand opening to heaven and the left to earth,
connecting the two to centre in themselves.

Movement Experience: Meeting for the First Time

LOOSEN
UP
As an introductory experience to loosen up a group, allow
people to get a sense of space and location. Moving in a circle
is a basic way of being together.

Start walking in a circle; gradually increase the speed until
you begin to run. Slow down, relax while moving. Return to
walking speed. Lead the group into a snake path, first making
the circle smaller and denser, and then lead it out again. Repeat
several times. Start the group moving again in two linking
circles, in a figure of eight, 'Dragon Walk'. Allow different
members of the group to lead and change the placing of the

figure of eight in smaller units; larger ones; opening up until the circles fill the whole space available.

The leader is to move and cut through the lines. This requires a good sense of timing and of space to allow the movement to be continuous and dynamic, every person being responsible for moving between other people without interrupting the flow of the group. Return to the opening sense of moving in one circle. Alternate between one circle and curved lines, changing speeds.

MOVE IN
CIRCLES

Make three circles, one inside the other. One person stays in the centre, while everyone else moves constantly, as the group leader changes instructions:

>All circles move clockwise
>The centre circle changes to move counter-clockwise
>Everyone faces the person in the centre
>Everyone faces away from the centre
>The outer circle changes to move counter-clockwise, while facing the middle circle
>The middle circle faces the inner circle
>Each person faces anywhere they like

SHARING

Share the experience verbally, exploring the question of where you felt most at ease, and least at ease? How did you feel when the others focused their eyes on you, while you were in the centre? How did you feel when you were being ignored, and were not the centre of attention?

Boundaries – Individual Space and Limits

Many experiences in our daily lives test our boundaries. Our interactions with our families, at work, and in social situations all require us to deal with our individual and social identities. The following exercises are designed to explore the limits of individual space, and examine issues of stress, aggression, and cooperation, in a playful safe environment. The session may be accompanied by music.

Movement Experience through an Elastic Loop

GROUP

At the beginning, we provide a large loop to contain the whole group. Everyone holds on to the ribbon and the members of the group interact with each other. Who is co-operative? Who

is disruptive? Who takes risks? Who is a passive follower? Who is sensitive to their neighbours?

INDIVIDUAL Everyone receives a three yard long loop of elastic ribbon, half-an-inch wide. Begin by looking at what the material offers you: how does it change shape and tension? Move: standing, sitting, or lying down. What changes: the material or you?

Opposites and Opposition

MOVE IN SHAPES Work with opposite concepts and shapes. Find possibilities in relationships, such as narrow and wide, knotted and loose. How do you entangle yourself? Find many ways.

PARTNERS Now disentangle. Is it easy or complex? The loop can also be used with partners:

RELATE TO SPACE Together, two people use one loop, covering as much space as is needed. The group leader stops the action without warning from time to time. At these moments, observe where you are in space, in relation to the ribbon. Look around. How much space has been covered? Where are you in relation to the other person? How do you feel about it?

DRAW/ FEELINGS SHARE Everyone makes as many drawings as they wish to express their feelings and the shapes of their experience in relation to their partner. Look at each other's pictures and talk about them.

VARIATION An interesting variation is for two people to work with one loop with one on the inside, and the other outside, as two opposing forces. Explore different natures, such as, giving and taking, unselfishness and manipulation. Or, three people work with one loop, two being active, the other an observer.

SHARE To end, bring the group together in one loop again. Share your experiences.

Limits and Open Space – Using Chalk, Rope, Thread

GROUP MOVEMENT Walk around the room, explore the environment. Use different directions. Walk in various rhythms. Limit the space with a line drawn on the floor with chalk, a rope or thread. This boundary creates a definite space in which to move from wall to wall without touching anyone.

Walk as fast as possible...as slow as possible...at any desired speed. Narrow the space gradually by adding more

lines on the ground, inducing the feeling of tightness and constriction.

How do people behave? How do they behave in a 'tight corner'? Who waits? Who is pushy? Who hesitates? Who dares?

PARTNERS Each couple receives a piece of chalk.

Define your own space on the floor in any shape you like. Move on different levels, at varying heights, as you like, cover more or less space.

Use all parts of the body. Change rhythms: fast and slow. Concentrate on extremes of transitions. Reduce the personal space, draw more and more restricted limits. Repeat the process several times. Choose to move alone, or touch the other person physically. Everyone should experience moving alone or in touch with another.

SHARE At the end, share your feeling experience verbally with each other in a circle.

Density and Open Space

Personal Story

One day I was walking near my home and came to an unfamiliar place. In front of my eyes spread a vast yellow carpet, whose beauty struck me. I was fascinated by so many flowers, each within its own space, and its own internal organization. The petals formed an orderly circle; the stamens were bunched in the centre at random, close to each other. I was attracted by the coexistence of organised and random structure in one place. Density and dissemination were at different ends of the same pole. I normally hate yellow, but this was an inspiration...a real in-spiration: This was the stimulus to explore 'density'.

Crowded Environment

Go outside into the natural world, and collect three or four objects or materials which remind you of density. Nature offers both organised density and chaotic density.

People brought earth, stone, dry leaves, a piece of turf, grass, pine kernels, flowers. Other objects such as cigarette boxes were also found.

Poles apart, opposites, contrasts, together or separate: our bodies contain all these things. Many layers unfold as we allow ourselves to explore and witness our process. From an apparently trivial word 'density' we uncover an abundance of memories, both recent and from the

Flowers in autumn (Tali Ne'eman-Sabo)

distant past. In the process of working, our intellectual concepts and judgements are challenged by the density of our bodies, the truth of physical experience.

EVOKING DENSITY

LIE ON FLOOR	To evoke the sensation of density, and the associative sentiments of closeness and pressure, which can manifest themselves physically, emotionally, or socially, we begin by lying on the floor. Explore ways of moving the body that bring the limbs together and apart.
MOVE	Bend the torso, pelvis, head and neck and stretch out. Move one limb at a time...then two at a time. Use your arms and legs together or separately. Find variations. How much space can you cover? How small can you become? Make four or five definite shapes. Repeat them. Change the order in which you move in these shapes. Pause.
ASSOCIATE	Allow feelings to emerge...What do they mean?
PAINT/ WRITE	Do you have memories connected with them? Paint them. Write down these associations on a piece of paper. Choose one

or two words that connect as a theme. Still lying on the floor, return to movement and develop this particular theme.

Frequently, our first spontaneous reactions to the concept 'density' is negative, unpleasant. We fear being pushed around or boxed in but with movement experiences feelings may change. Some comments which have been voiced or written or described in drawings, include:

RESPONSES

'I want to jump from a box'	'I am being held back'
'Pushing against something powerful'	'Being rebuffed'
'Edges being bent inward'	'Folded up'
'Forests, jungles'	'Marshes, undergrowth'
'To be in a womb or a shell'	'A warm place'
'Reminds of my childhood'	'I feel secure'
'My brain'	'Loving hug'

Movement Improvisation: Urban Stories, Daily Dramas

The participants are asked to move in space until groups form spontaneously. You can choose to do the following process either as a movement exercise or as a talking one, or both. Students may be themselves or assume characters.

GROUP MOVEMENT
Ask the group to move about in an unorganised manner, with random movements. Gradually, they begin to relate to each other, forming partnerships and groups. At that point ask a series of questions:

MOVE AND REFLECT
Who are you? Where are you? Where do you come from and where do you go? How old are you? What is your purpose in being here? Are you at ease? Do you feel joy? Do you want to be here? How do you connect to your environment? How do you behave? Are you aggressive or assertive? Does the crowd interest you? If so, for what reasons? And if not, why not? Do you feel secure? Does the scene evoke any early memories? Can you recall similar feelings?

PAINT/ WRITE
All these questions can be explored in writing or painting as well as in movement and dialogue. This process creates a tapestry of group experience. How do we move through space with others?

SHARE
What is our social identity?

RESPONSES
An exchange between several members of a group:

L. I have now disciplined myself to walk by the sea every morning at half past six. I feel very privileged, I can just stand by the open sea – the time I can have for myself made me think about many things...but most of all about freedom and peace. I can walk with my dog at any time of day or night.

V. When people go out for midnight walks on Richmond Common, they are likely to get either assaulted or arrested by the police.

L. In the Orkneys you can stay out all night. Here in London I have to watch my children, they are so trusting. At home in the Orkneys, they can stay out at any time of day or night.

B. In Tel-Aviv I had once a two hour nightmare – I lived by the beach near a main road and my six-year-old son had disappeared. When he came back with a friend I hit him, and he said: 'You didn't have to hit me for this': he was totally oblivious to any danger. On the other hand I could leave him for several days in a kibbutz with friends, and he didn't mind, he also trusted and felt secure.

Polarities and Opposites: Movement and Stillness

Yield and overcome;
Bend and be straight;
Empty and be full;
Wear out and be new;
Have little and gain;
Have much and be confused

Lao Tzu, Tao Te Ching

Movement Experience: With Gong

MOVE TO SOUND

We use sound as a focus to begin to find the movement in stillness, stillness in movement. We sound a gong and ask participants to react as an echo in movement, reacting freely to the sound vibrations.

With eyes open or closed, allow one arm, a leg, the head and neck and other parts of the body to move and be moved.

We emphasize paying attention to the space covered by the movement, and the space between movements. Repeat this

practice with a partner, move alternately, exploring stillness and movement, as if in a conversation, with or without sound.

VARIATIONS

DIFFERENT
SOURCES
- One partner moves, the other enters without listening.
- Mirror each other.
- Mime a story.
- Make patterns and symbols, ie: flowers, practical objects, or a heart.
- Explore questions and answers in abstract movement.
- Accompany with a gong, drum, or wooden block, experiment with changing rhythms, like staccato, legato, etc.

The root level of opposites begins with the body's sense of in breath and out breath, and the relationship between breath and feeling. Polarities extend into our nonverbal interactions with people: a continual movement between cooperation and conflict.

SCANNING

LIE/
SCAN
Begin by lying on the floor. Scan the body: What parts touch and what parts do not? What parts feel definite contact with the floor?

Where is the sensation confused or unclear? How do you sense large areas of contact? Where is the contact limited? Listen to the rhythm of your breath; put your hands where you feel the movement of the breathing. Imagine a rhythmic pulse graph in the air, charting the in-and-out breath, like a heart beat machine.

FOLLOW UP
To extend this work beyond the session, check the rhythm of your breath in varying situations: when angry, sad, or tense; when calm, happy, and content. Where are the distinctions and variations? Observe the breath of sleeping babies.

WORK IN COUPLES

MOVEMENT
AND
PERCUSSION
Work spontaneously in couples to the accompaniment of percussion instruments; or use the walls, chairs, tables, to produce the sounds. Progress to longer conversations where each partner has time to improvise, and to make his point. When you change from one partner to another, make an organic

transition and not a sudden mechanical change. Some of the
opposing qualities partners choose to explore, include:

up	down
near	far
forward	backward
closed	open
curved	sharp edged

STRONG AND SOFT

EXPRESS
FEELING
Exploration of 'strong' and 'soft' accompanied by percussion.
Develop the movement towards violence as an expression
of the aggressor's strength. Now towards the expression of the
victim as soft and weak. Focus on one theme like a quarrel
between two people: provide a safe space between the two that
may not be trespassed upon, to prevent accidents. Explore the
feeling responses.

Power – Over-Confidence – Anger

How can these negative impulses be transformed into positive self-con-
fidence and assertion in a safe environment?

CONTROL

GROUP
ISSUES
Begin to visualise a situation in which you are in charge of a
family, a group, a class, an army. React in movement to the
image. How do you move when you hear the word *control*?
Alternate between movement and stillness. Does it feel more
powerful to move or be still? Do you prefer to stand in your
own power? Do you like to be controlled or contained? Do you
feel you are naturally self-assertive? Can you retain a quiet
confidence?

RESPONSES
'Self-control comes from within, from gentleness, from inner
peace of mind.'

'The need to dominate covers up an essential weakness, an
antithesis to freedom.'

'I love the word "influence": domination releases violence in
me.'

'My biggest conflict is with being servile, needing to defend
myself. I need to prove myself.'

'One can find power in both softness and strength.'

'I need to collect strength to lead and direct, to listen and feel
empathy with those I lead.'

'I am unclear in my perception. Where am I in control of myself and where do I control others?.'

'It is easier for me to control myself without hitting anyone and be kind to myself.'

'My power is from inside'.

Personal Story

A poem: 'Neither in my hand nor in my voice...'

> I will never try to hang on to anything by force,
> or by shouting,
> because I haven't got the power to control another in this manner,
> but the inner power of the soul is strong indeed.
> The power of love, understanding and wisdom.
> The power of honour and will are the strong bonds between people,
> that ties them together and brings them closer:
> to listen and look at each other
> without the need for domination.

Hands – Relating, Feeling, Sensing

> Palm of the hand. Sole, that walks now
> only on feeling...
> It steps forward into another's hand,
> changes its doubles into a countryside,
> travels into them and arrives,
> fills them with having arrived.
>
> *Rainer Maria Rilke*

The hands know many things and express qualities on many levels. In the following section we consider the kinaesthetic qualities of the hands: the feeling level, and the hands as they communicate messages to ourselves and each other.

KINAESTHETIC LEVEL

Sit down, moving your arms and hands. Alternately open and close your hands into a fist. Begin this movement in the hands and lower arms and progressively include the upper arm. Expand the arms and hands into very large movements as if to wake up. Connect these movements with your breath. Move the arms and hands close to yourself and far away. Exhale with the larger movement. Let the whole torso participate. Allow it to rotate and move in any way you want. Change the accent of the movement. As you alternately close and open the hands, accent the opening, then accept the closing. Keep the hands close to your body, move

the fingers, flexing all the joints. Feel the flow, let the fingers unfold one after the other like a fan, towards yourself and away.

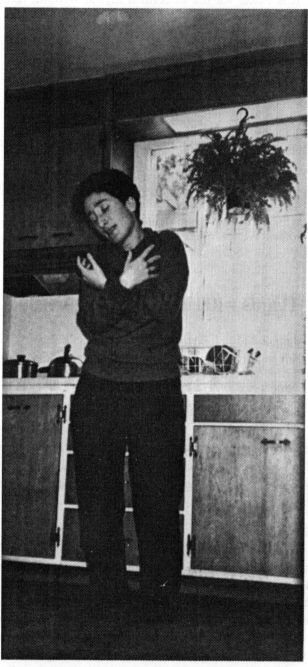

Caring hands (Nira Ne'eman)

FEELING LEVEL

MOVE/ FEEL Work with closed eyes. Open and close the arms and hands expressing different qualities. Move in different directions, change speed and rhythm. Be aware of the opposing sensations. What are the emerging feelings? Allow free word associations to surface. Focus on one pair of opposites. Open your eyes; say the words that come to you. Students found that their hands contained the following polarities:

fear	security
stinginess	generosity
restraint	explosion
introversion	extroversion
secrets	openness
collect	spread
mine	yours

We experiment with different themes that emerge from the group. We choose one theme of opposites to work with. Everyone in the group works on the theme, expressing their feelings in movement: giving their own interpretation using the act of opening and closing the palms.

COMMUNICATION LEVEL: COMMON SPACE

ALONE &
TOGETHER Extend the movement into space using different heights. Move around using the whole body. Change rhythms and dynamics. Meet other members of the group.

DRAW/PAINT After experiencing the movement, draw your reflections on a piece of paper. Try to draw from the pervading feeling, rather than through conscious perspective. Or try both ways in turn.

FEAR AND SECURITY

WRITE Write some notes exploring this subject. What kind of fear do you feel? What feelings of security? Where did you experience these feelings? When in your life, at what time, in what context? With whom were you in relationship?

SHARE Share the experience of the session verbally, with a partner or the group.

DRAMATIC INTERPRETATION

One variation we worked on was called *mine* and *yours*.

This exploration led us to R.D. Laing's *Knots*, from which we wove:

> if it's mine
> it's me
> if it's me
> its mine
> if it's not mine
> it's not me
> if it's not me
> it's mine
> if it's not mine
> it's not mine,
> not mine,
> it's not me
>
> then who am I?
> if me is not mine
> and mine is not me
> then who is me, and what is mine?

The Mother*

The Mother is a basic experience in everyone's life, and here we focus on this primal relationship. We explore the emotional web between mothers and offspring, identifying the breathing, physical gestures and inherited movement patterns in reality and through inner visualisation.

We like to introduce reproductions of paintings, sculptures, or postcards, from magazines and books, readings from literature and poetry. Sometimes we ask participants to bring objects given them by their mother, or reminding them of home.

Variations on the Mother Theme

Explore the theme creatively. Touch on 'mother' in a tactile, sensual, experiential way.

MOVE SENSE/ A Day in the life of a Mother
MEMORY Begin by moving as if you were performing ordinary chores in the home. Repeat several times: hold one gesture, become

* A collection of photographs can be found in *The Great Mother*, by Erich Neumann, p.5, 37–47 specifically

aware of the body sense. Where do you hold tensions? Exaggerate the shape, pause, and check again for discomfort and tension. Experiment with different activities. Repeat the process. Choose two or three activities and make a movement phrase that you can repeat. Play around with the theme, change directions and rhythms. Interact with each other.

TRANSFORM Create choreographic patterns using your own phrases.

VERBAL EXPLORATION The group shares and discusses ideas and qualities expressed, ie:

Domineering
　　　　Loving
　　　　　　　Caring
　　　　　　　　　　Nurturing
　　Available
　　　　　Possessive
　　　　　　　　Giving
　　　　　　　　　　Worrying
　　An institution
　　　　　Manipulating
　　　　　　　　Overbearing
　　　　　　　　　　Rewarding.

DRAMATISE Work in small groups, exploring the *mother's role*, using sounds, intonations, and words.

RESPONSES The following topics were verbalised, and then explored...

'You're getting on my nerves.'

'You're always pushing me to become a genius.'

'You're worrying and overprotective.'

'The table overflows, the house is always open: no one starves in this house.'

'She sits there on my back forever, I'm tired, I never have time for myself.'

'Ask my mother, she knows everything.'

Kinaesthetic Perception

INTROVERT/ EXTROVERT FEELINGS Begin to move with one part of your body with which you identify most... How much freedom do you have? Where do you feel restricted? The movement may take you to any level in space, and you may move in any speed you want. Find different ways of feeling close to yourself: intimate, secure, loving. Stay with yourself for some time – what do you sense?

Change to the opposite: find different ways of being outgoing, available, giving. Alternate between the two qualities. Bring the movement to its extremes of total withdrawal and over-extension. Allow feelings and images to emerge.

LIE/BREATHE REFLECT Lie down on the floor, close your eyes, and listen to your breathing. Pause. Can you identify your mother's breathing? Pause. Can you hear your child's breath? (Your physical, or your inner child?) Pause.

What do you sense? What qualities of your mother or child are you most aware of? What do you love most? What do you hate most? What behaviour of your mother drove you mad? What of these are you doing to your own children?

Transfer the feeling onto paper: drawing, and writing word associations.

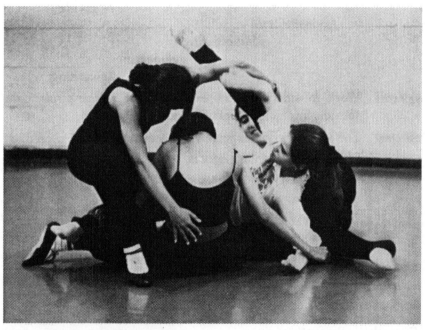

Birth as metaphor (Alicia Sclovich)

INTERNALISING MATERNAL QUALITIES – ANIMA/ANIMUS – YIN/YANG

FOCUS To deepen the process choose two opposing qualities to focus on:

fullness	emptiness (womb/house)
vulnerability	strength
caring love	manic love
calm comfort	agitated frustration

Move freely and experience the qualities you chose in your body. Change your relationship to space. Change your relationship to rhythm.

EXPRESSIVE ARTS Transfer the experience into any other media: visual, verbal, music, or sound. Share your experiences in small or large groups: notice the unexpected facets of your relationships. And finally, share with the whole group:

- What traditions do you carry on?
- Which of your mother's traits or attitudes have you consciously or unconsciously adopted?

ARCHETYPAL MOTHER Consider:

My Mother, I as Mother to my
children.
What do I expect from
myself as Mother?
What do my children expect of me?

RESPONSES MEANING AND VALUE

One group's exchange...

I. 'I was taught not to ask questions. When I had my second child I was asked at the antenatal clinic, whether I want to say any thing to those about to be become mothers for the first time. I said, yes: why didn't anyone tell us the reality of the situation, that you don't get a minute to yourself from the moment the child is born. And if you don't have maternal feelings, you don't need to feel guilty about it. The woman in charge just looked at me in disbelief. It was a turning point for me between feelings and reality.'

N. 'I want to find out whether I could come to terms with not having a child. Maybe I can find a balance between internalising and giving out, the need to have a child, and the reality of not having a stable relationship with a man.'

L. 'I chose to have my two children, I am happy with them without a man. I also empathise with women who didn't want to have kids.'

W. 'I have a problem with tape recording, I feel inhibited, it feels as though someone is putting their hand over my mouth.'

L. 'Did anyone ever stop you from talking?'

W. 'Many times. When I used to tell my mother things, she used to tell everybody else and she tore my poetry up – I was in total

shock about this. I felt invaded then, and the taperecorder rea-
woke those feelings.'

V. 'I had the experience of my mother repeating stupid things I had
said, everybody listening and I was cringing with embarrass-
ment, I hated it and never understood why she did it.'

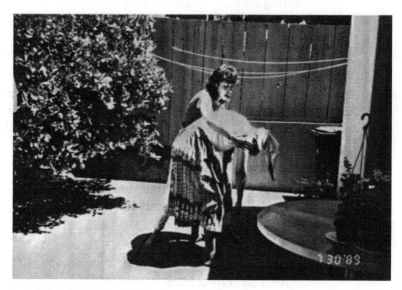

Mother holding (Nira Ne'eman)

Personal Stories

PERSONAL STORY (1)

Now I try to become her. I find myself lying curled up on the floor, and I feel how
helpless and inadequate she feels, what a failure – what an awful way to feel, I begin
to cry and then to cry harder at her pain and my shoulders shake – and Ruti who
knows how to be a mother as my mother never did and never will, comes to me
and I tell her it is OK, because it is. Then I try to feel what the panic is like for my
mother, and I feel a sense of optimism, that things will be better... I drive faster,
hurry...because I'm late... I'm rushing rushing rushing hurry hurry...and then the
despair comes back and I slowly sink to the floor again and this time as I curl up, I
pull the shawl over my head because I don't want anyone to see my face, and now
I know not to sob so that people will leave me alone. This is what my mother lives
with, this terrible sense of inadequacy. I will not be my mother. I know how to
nurture, and I know my strength. I know that whatever comes, I can deal with it
and continue to grow. I am able, I have the power.

PERSONAL STORY (2)

My words were 'MaMa' and 'open and closed womb'. I have a child, I was very ready to be a mother and lover. The labour was hard, and the baby was an *unbelievable miracle*. Motherhood is for me very deep, although I was passionately involved with my career as a dancer/choreographer. I have to cope with social pressures from professional friends who are chemists, psychologists, lawyers who ask: 'What do you do?' My mother gave up her career lovingly and was a wonderful mother. I want to find a balance between motherhood and work.

PERSONAL STORY (3)

Soft Love – Choking Love

At first I could not connect to her, soft love – choking love, I started to ask questions – why is it so, this need to give and to receive? This intense passion to love – why do I have always to stay with the tribe? She is always tuned to what the tribe needs, never to my needs. When I am around her she wants me to be her baby, to return to her womb.

Now I am healing myself – I am healing my mum.

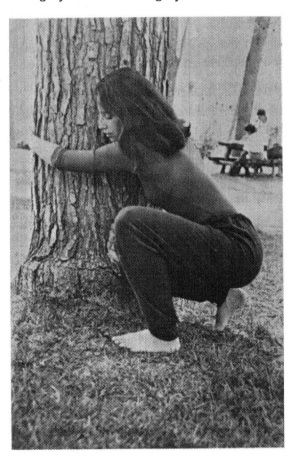

Childhood landscape (Avinoam Alon)

Childhood Landscape

The following allows one to project emotional material on found objects; it elicits spontaneity and increases sensitivity. Most people have a real or imagined link with the 'Garden of Eden' feeling, and with the sense of primal innocence: a refreshing contact with nature. We are looking for the connection to the inner child as a creative source evoked by the senses.

Working with a partner gives resonance and magnifies the experience.

OBJECTS FROM THE ENVIRONMENT AS METAPHOR
It is preferable to work in the open air, in a natural environment. Go out and look around at the surroundings.

CHOOSE PERSONAL SYMBOLS
What attracts you? What are you drawn to? What can you identify with?

Collect three or four objects that remind you of your childhood. Put them on a sheet of paper, or in any other frame.

SELF-IDENTIFICATION THROUGH DESCRIPTION OF OBJECTS
FOCUS
Sit with a partner – one closes the eyes, the other witnesses and takes notes. The person with the eyes closed is given one item at a time, to describe objectively its shape, size, and quality, ie: whether it is long, thin, round, hard, heavy, soft; contains many or few components, or is one unit; and whether it is prickly, dry, wet, brittle, etc.

IDENTIFI-CATION
The working person begins to identify subjectively with each object, and allows many words to emerge by free association. The witness keeps on taking notes. The partners reverse roles.

CONCLUSION Partners share their experiences verbally.

Movement Experience: Shape and Quality

EXPLORE IN MOVEMENT
Identify with one of your objects. Take up its shape and quality in your breath. Begin to move with your hands and arms alone; transfer the movement to other parts of the body: allowing yourself to take up as much space as you need and move with your whole body.

EXPRESSIVE ARTS
Work on the creative process. Choose two objects, close your eyes and move the shape and quality: let them become an

image of your childhood. Focus on one image: move it, draw it and write about it.

SHARE Share your experience in a group.

RESPONSES Some people lived their whole life in the same landscape. Others always saw the same tree, eg: one man talked of an oak, where the family used to sit around, to share a meal and tell stories. A cactus reminded one woman of her youthful adventures and her romantic experiences in the scout movement, and later in the kibbutz. All these memories reflect the family environment and early relationships. It opens a whole childhood panorama. Relate it to your own life story in the present: what elements have remained, what has changed? Be aware of your own development.

Coda – the Inner Child as Metaphoric Experience

We have all experienced intimate feelings towards something we love, or have loved in the past. It can be a plant that we nurtured; or, as in childhood, the dolls and teddy bears, or other animals we felt close to, who were our best companions.

As we get older we become more detached from these kinds of sentiment, which can even seem 'childish' or 'sentimental'. Often we transfer this deep intimate love to a hobby, or a creative work of art, which we seek to nurture in the womb of our imagination. This we call the 'Inner Child'. Locate this feeling within you. Find something for which you feel this deep attachment. Are you already in touch with it? Or is it something you recognise deep within your soul, but have neglected, for one reason or another?

If you are unfamiliar with this feeling, imagine it as a seed, a potential, something you need to sow, and nurture with your own spirit: it will never grow without your love and care. Keep this image within you. Take it home, or wherever you go, and even when it seems to disappear from you for some time, always continue to pay attention to it: and then it will have the chance to appear in the most unusual places in your life.

Personal Story: Letter From Childhood

This personal story came out of an involvement lasting several years. I met Patricia as a student in a Community Theatre Course. She later joined my private groups and personal sessions. She became the co-founder of Theatre of Black Women, the first company of its kind in England. Patricia writes and directs children's operas, and publishes her own poems. She recently gave birth to a daughter.

An Open Letter

Dear man,

I am writing to let you know
that I'm a woman, now
to remind you of the scars you gave me
left me
to remind you of the nights I cried
to remind you that I was not your bride
to remind you that I was a total stranger
to remind you that my mother was your wife
to tell you that I am taking you to court
to tell you that the charge will be...
RAPE...

I hated myself for what you did to me
I hate those parts of you in me
and the promises you made me keep
'blackmail', Child-mail...
male
male
male... fear
on me a little little girl
was I...
did mummy never wonder where I was?
what lies did you tell her?
what lies must I tell her this time?
how will you stop her?
from lashing me, beating me, shouting up at me?
how will you stop her this time?
and the next
and the next
and the
...the...

Dear man,

I'm writing to let you know
that I'm alive and well
that my body is well
but my mind...is...mind...is...

Dear man,

I'm not out of my mind
No! I'm in my mind
Yes! in...my...mind...
and not going mad
I'm not insane so don't laugh in my face
or smile your gold teeth at me!

Dear man,

> I'm telling everyone, everything
> all the times
> all the nights
> all the pain
> the hurt, the smell, the sweat, all the...all the...

Dear man,

> She's always known
> I know she's known
> the belt told me so
> her eyes told me so
> her voice, her face, her hands, her knees
> they told me over and over and over again
> and I felt it so
> The day she kept me from school
> in your bedroom
> she tried to kill me
> she lash me
> she beat me
> she scorn me
> she speak up on me
> because of you man
> because of you!

Dear man,

> I'm writing to let you know
> that I'm a woman now
> to remind you that I was a child
> and my mother was your bride
> to remind you
> to remind you
> to remind you
> to remind you
> to remind you
> to remind you
> to remind you...
> ...the charge is RAPE
> and
> I
> am
> NOT
> guilty!

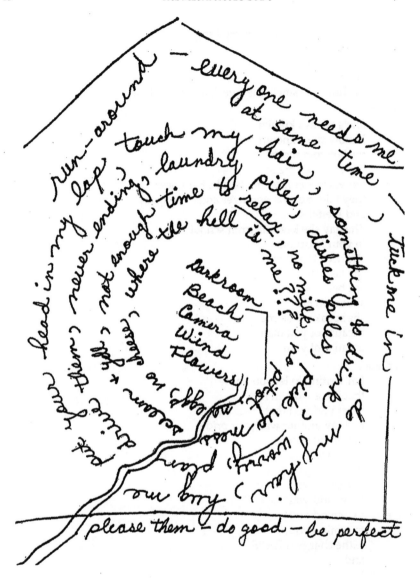

A day in a mother's life

Resources of Taoist Elements
Wood Fire Earth Metal Water

Symbolic thought opens the door on the immediate reality for us.

Mircea Eliade

According to the Taoist belief, one can only become a sage by losing and losing, by letting go instead of holding on, by emptying oneself of emotions and preconceived ideas, and by having the courage to "go down into the water".

Gerda Geddes

The Chinese concept of the Five Elements dates back more than 4000 years, and contains all phenomena of nature. The symbols of the elements are used to describe an allegorical journey through life – past, present and future, reflecting one's very essence and reaching deeply into human consciousness. These elements are both symbols and objects that bring about closeness to nature and existence. They symbolise the connection between humanity and its environment, and the relationships between human beings. In the same way, the elements interrelate with each other.

The concept of the Five Elements grew out of careful observation of natural events. They provide guiding principles for physiology, pathology, diagnosis and therapy in traditional Chinese medicine and acupuncture to this day. In Western tradition there are only four elements: *earth, air, fire,* and *water*. According to Felix Mann (1973) the Chinese *metal* is the equivalent of the Western *air* element, as it conducts the lung meridian. The Chinese also incorporate a fifth element, *wood*.

The elements imply an archetypal idea and are not restricted by a physical sense. This is underlined by Jung's in-depth study of Chinese philosophy in the formation of his own conceptualisations, related to human action, thought, feeling, sensing and intuition. Jung also considered balance as a virtue sought by the inner psyche of the individual, as well as by entire cultures.

The process of life itself is always thought of as being in motion, rather than as a static condition. The process occurs more like a rhythm or creative dynamic of tension-release, ever on-going and repeating the cycle.

That which shrinks
Must first expand.
That which fails
Must first be strong.
That which is cast down
Must first be raised.
Before receiving
There must be giving.
Soft and weak overcome hard and strong.
This is called perception of the nature
of things.

Man, when he enters life
is soft and weak.
When he dies
he is hard and strong.
Plants when they enter life
are soft and tender.
When they die
they are dry and stiff.
Therefore: the hard and the strong
are companions of death:
the soft and the weak
are companions of life.

(Lao Tzu, Tao Te Ching)

Inter-Relationship between the Creative and Destructive Cycles

In the ancient text of the Nei Ching, Yellow Emperor (Veith, 1949) the interrelationship between the Five Elements is explained simply and beautifully.

Wood gives birth to fire,
Fire gives birth to earth,
Earth gives birth to metal,
Metal gives birth to water,
Water gives birth to wood.

The 'Cheng' or 'Creation' cycle leads to what is known in Oriental medicine as the 'Mother-Son' relationship:

Wood burns to make
Fire whose ashes decompose into the
Earth where are born and mined
Metals which when smelted become
Water (liquids) which nourish trees and plants.

'Cheng Cycle' – The 'Creative Cycle' or 'Mother–Son Relationship'*

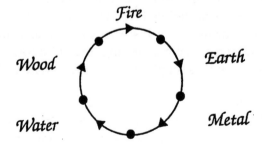

Fire

Wood

Earth

Water

Metal

Also explained in the Nei Ching is the 'Ko' cycle, often referred to as the 'destruction' or 'control' cycle; based on this principle, certain elements overcome the power of others:

Wood is cut down by metal,
Fire is extinguished by water,
Earth is penetrated by wood,
Metal is melted by fire,
Water is interrupted and cut off by earth.

'Ko Cycle' – The 'Destruction Cycle' or 'Control Cycle' [*]

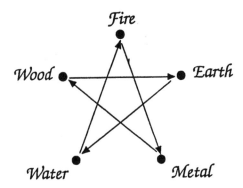

If the energy of the mind-body is relatively clean and healthy, this relationship is not destructive. It is the natural channel or avenue to allow energy to pass along. However, this energy can become blocked and harmful. Inspired by the Chinese understanding we work towards finding balance in movement and visualisation. The images of the Five Elements serve as a transformative focus that enables changes in understanding particular blockages that have prevented the unfolding of a person's potential.

We developed a cycle of life related to the Five Elements through kinesthetic awareness, in a reach towards wholeness. The outer lines represent the creative forces and the inner ones represent the controlling forces. Man in the centre is in tune with nature and equal to eutony.

Each Element represents in itself a world of dark and light, of positive and negative; in combination known as *Yin–Yang*, the archetypal pair form the poles of Nature, at the foundations of Chinese thought. Yin–Yang are complementary opposites which together form a whole. This symbol reflects the duality and polarity of consciousness. The opposites are interdependent, their conflict can never result in the total victory of one

[*] D. & J. Lawson Wood, 1973

In Tune with Nature and in Eutony*

Organisation and proper use of the body
derived from the ancient Chinese
philosophy of the Five Elements

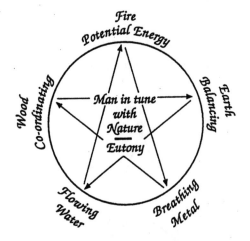

Flowing meets potential energy, controlling it;
potential energy meets breathing;
breathing meets coordination;
coordination meets balancing;
balancing meets flowing.

side; there will always be an interplay between the two sides. In other words, they are the life process – *a creative dynamic motion of tension and release* – a forever repeating cycle.

> That which lets now the dark, now the light appear is Tao.
> (Wilhelm, 1967)

> This continuous interaction gives rise, in turn, to the Five Elements from which all events and objects are derived. This doctrine of the Five Elements applies to the internal microcosm of the individual self, as well as to the external macrocosm of the universe. (Legeza, 1975)

According to the 'Nei Ching' (Veith, 1949 and Capra, 1975), in the beginning the world was a void, a formless indivisible whole, the ultimate 'no-thingness'. There was neither heaven nor hell, night nor day, birth nor death: 'thing of none', or 'nothingness'. From this nothingness evolved what Lao Tzu called *Tao* or *The Way*. All manifestations of the Tao are generated by the dynamic interplay of the polar forces Yin–Yang, as two banks of a river: Yin the bank that is shaded by a mountain, Yang the bank

* Balancing muscular activity through the right amount of tension, see Bartal and
 Ne'eman 1975

that is lit by the sun. Yang refers to the *masculine creative energy* of sun, fire, heaven. Yin represents the *feminine, dark and receptive energy* of moon, water, and earth. Within this context all polarities such as good and bad, pleasure and pain, and ultimately life and death, are not absolute experiences belonging to different categories, but are merely two sides of reality: extreme parts of a single whole (Capra, 1985).

Thus each of the Five Elements is both finite and infinite, relating to the micro- and macrocosm. The literal name for what has been translated as 'Elements', in Chinese *'wu-hsing'*, means 'passage', which underlines our understanding of the Elements as qualities of energy changing in the course of time.

We introduce the Elements as a metaphoric tool to carry life experience, reflect personal essence, and reach deep into the psyche, while at the same time underlining the individual's relationship with the natural surroundings. By using these images we help the transformative process of the individual, bringing to light unconscious and forgotten attitudes. The Five Elements evoke memories within us of past experiences – touching any one of them calls forth the mind and body's sensor faculties, enabling participants to relate to themselves physically, emotionally, intuitively and creatively.

To each person these metaphors speak of different images, connecting the human psyche to the eternal message and wisdom of polarity embodied in the ancient Chinese science. This experience offers a strong stimulus for the imagination, enabling participants to work on their own development and identity. Many of the images and feelings experienced through the Elements enlarge the creative and cognitive aspects of self awareness and personal growth.

In summary, these ancient archetypal elements are like an old watercourse along which the water of life has flowed for centuries and represent a blueprint for change. The chapter ends with participants' reflections uncovering the transformative process in different forms.

The Allegorical Journey

We introduce the allegorical journey of the Five Elements in two phases. First, through physical awareness of the body, and second, by way of imaging in symbols and archetypes, touching the emotional and spiritual levels. In our experiential work we consider the element air as the equivalent of metal (as mentioned on page 90). Being aware of breathing and air is vital to the awareness of the body.

Phase One: Preparing the Ground

Begin by lying, sitting, or standing.

Open every session with breathing from the 'Tan T'ien'* and bring awareness into the body: breathing in the lower belly rather than the chest.

Calm and focus your mind. Feel the ground you are standing on: let the energy rise through the soles of your feet. Give life to the body by breathing into all its parts: move all the limbs, feel the energy-'Chi'-circulating.

CHI: 'THE INTENTION DIRECTS THE CHI AND THIS IN TURN GUIDES THE BODY'

Think of the body lengthening and widening continuously, as a channel or any connecting link between *cosmos, human and earth*. When moving in space, feel the fullness and emptiness of the legs alternating like Yin–Yang. Change levels, move with awareness, alternate between stillness and motion. We will experience each of the elements separately – opening with a brief introduction to its metaphoric meaning.

THE ELEMENT WOOD

> Root of all things
> Connecting heaven and earth
> Changing with the seasons
> Yielding to the winds
> Giving birth to new Seeds.

Movement Experience

SMALL BASE Begin by standing with closed straight legs – a small base.
LARGE BASE Move whatever is possible in this position.

Change: to a small base with bent knees; move as much as possible.

Change: to a large base, with legs straight – apart.

Change: to a large base with bent knees…

Explore the varying possibilities and qualities of the different bases, in relation to: being rooted to the ground…yielding to the changing seasons…moving with the wind, rain and snow…

TREE Imagine tree trunks such as those of oak, beech, birch, or
TRUNKS bamboo… Where did you feel rooted, with straight or bent knees? How were you most grounded, on a small or a large base? How far could you expand and reach out?

* The 'Tan T'ien' centre is situated three fingers below the navel

The Element Wood
(Photograph: Eliyahu Ne'eman; Etching: Leah Bartal)

THE ELEMENT FIRE

> Alive and sparkling energy
> The glowing flame expands
> In anger it burns and destroys
> In love it warms the heart
> Forever spreading light.

Movement Experience

Begin by sitting, standing, or finding a 'natural' position. Start with a small movement in one part of the body. Gradually accelerate and let the movement spread throughout the body until it burns and destroys.

The Element Fire
(Photograph: Evie Rote; Etching: Leah Bartal)

CRESCENDO/ Accompany the movement with different sounds. Let the
DE- movement rise and fall, one becoming the other, as in Yin–
CRESCENDO Yang: a living flame.

Allow flame-like impulses of movement to explode and dim-
inish: vertically, horizontally and diagonally. Allow breath
and sound to guide the movement, penetrate space without
control, invade other people's boundaries.

REFLECT How did you feel with the different qualities of movement:
using one part only, or involving the whole body? Working
with strong and dynamic movement? How did you react to
your boundaries being invaded? How did you experience total
destruction?

The Element Earth
(Photograph: Eliyahu Ne'eman; Etching: Leah Bartal)

THE ELEMENT EARTH

 Mother Earth supports and holds
 Contains and balances the elements
 Appears as sand, as rock or mud
 Her womb provides abundance and shelter
 To all creatures alive or dead.

Movement Experience

Begin by lying on the floor: imagine the ground beneath you as different surfaces, such as sand, rock or mud. Roll over these soft, hard, or sticky, imaginary grounds. Walk over similar imaginary ground: sense the difference, feel the resistance, stability and instability.

GROUNDING Balance your body between containing and spreading, giving and receiving: be aware in your body of emptiness and overflow; experience holding and letting go.

REFLECT On what surface do you feel safest? What foundations are most familiar or strangest? What environment is most dangerous?

THE ELEMENT METAL

> Spreads everywhere in space
> As life providing breath
> Moving wandering fragrancy
> Sharp blades or cutting edges
> Inspiring purifying Spirituality.

The Element Metal
(Photograph: Aharon Amit; Etching: Leah Bartal)

Movement Experience

FLOWING/
CUTTING

Begin by spreading around the room... Feel the air around you around different parts of the body. Reach near and reach far: close to the body and away from it. Shape your body in a curve and let it go, like a steel blade being bent and springing into a cutting edge. Move with lightness, quickly and slowly.

REFLECT

How do you feel with different qualities? Do you prefer being light or being heavy? Are you more comfortable being close to yourself, or expanded? Do qualities of flexibility and sharpness agree with you? Where are you at home?

THE ELEMENT WATER

Formless itself moulded by a river valley
Wild waters, gentle waters
Forever flow down to the Sea
Low ebb, or high tide
Rising or sinking in the rhythm of life.

The Element Water

(Photograph: Eliyahu Ne'eman; Etching: Leah Bartal)

Movement Experience

MOTION/
STILLNESS

Experience stillness in motion, and motion in stillness... Let the body rise and sink in different ways... Flow with the movement, and meet other flowing bodies.

Tell in movement the story of a small brook, a large river, a waterfall, an ocean, as calm or violent waters.

REFLECT

How do you feel 'being' a small brook or large river? How did you communicate with others? What kind of obstacle did you meet? How did you experience violent and calm waters?

Phase Two: Imaging in Symbols and Archetypes – Touching the Emotional and Spiritual Levels

> Mo Tzu: 'The body (Yin) is like the leaves and roots of plants, while the soul (Yang) is like the seed; the seed will continue to live forever'.
>
> *Geddes, 1991*

Experiential Model: In Relation to the Five Taoist Elements[*]

SEED THOUGHT Start from one of the five elements, for example *wood*.
By way of free associations the following words might emerge:

growth and death	carve
roots – trunk – crown – leaves	between heaven and earth
balance	yielding to the wind
co-ordination	change with the seasons

CHOOSING Make a choice of two words from the free associations:

> *roots* *carve*

EXPLORING – THEMES AND VARIATIONS

1. Move freely and experience the images of the two words...*roots* and *carve* in the body –

2. Limit the movement to one part of the body, then change to another. Experience the difference between moving one part or the whole body.

3. Change your relationship to space: move near the floor and far away from the floor. Move horizontally and vertically, in any direction you like. Move in relation to:

 (i) The eight basic directions – the cardinal directions of the sky: North, South, East, West and points in between.

 (ii) Experiment with moving in various qualities – slow, fast, legato, staccato, crescendo, decrescendo, and more.

4. Transfer the experience into two dimensions by drawing, painting.
 Or recreate it three-dimensionally with materials such as
 – clay, plasticine, paper, soft cloth, and others.

[*] See 'Creative Process' Experiential Model p.??

5. Close your eyes, let the imagination elicit images and word associations:

roots	*carve*
expanding	furniture
hidden	door
twisted	bold
belonging	creating
uprooted	hurting

FOCUSING – EXPERIENCE ON THE SYMBOLIC LEVEL
Focus on one particular theme or word to deepen and sharpen the process. Explore in movement the polarity of your choices. If the word *door* was chosen, experience the positive and negative aspects, feelings of being open or closed. What does it mean to you: security, shelter, passage, boundary; or secret, rejection, isolation?

Transfer the experience into any other medium: visual arts, musical composition, or poetry. This may result in remembering an important life event, a long forgotten trauma or a new insight into a family situation.

CONTEXT-UALISING – MEANING AND VALUE
One member of a group was able to connect to traumatic experiences during the Nazi Holocaust that she had repressed for 40 years. The words *root* and *door* connected to her family and childhood memories of unbearable despair. The roots of the tree were hidden to begin with and the door enabled her to open up and eventually share her awful experiences with her children.

SHARE
Share your experience in small or large groups. Relate it to your present life situation, the *here* and *now*. Emphasise the use of insight, rather than intellectual interpretation. Do not try to judge yourself or others. Pay attention to the unconscious and creative material that emerged. Look at the new perspectives that have become available and encourage participants to continue on their own path of self-discovery
The Symbolic Journey

The Symbolic Journey

Wood

Barbara was a Community Theatre Arts student of mixed race (an English mother, Nigerian father) and one of eight children. When she started in the workshops and sessions, she was very inhibited and, although

talented, it did not show at the time. She participated in a session preceding work with masks. Without hesitation she chose *wood* as her element, and produced a very powerful, confused drawing, full of images: of roots, chigwood, chunks, undergrowth, jungle vegetation, creeping trees. And words came pouring out:

caged

trapped
gnarled

anguish
strong

screech
weak
aaah!

sinking
danger

fight
sad

secret

great
fiery
hidden

fright

screaming
sold
bold

lost
still
twisted
lonely
pressure
bursting

'I was angry when I started to draw my perception of WOOD, and was still angry, perhaps slightly less when I had finished. I feel as though I took my anger into the drawing, and also into words. (The crayons that I used had a hard time!) I drew spontaneously and wrote down words that jumped into my head.

For a change, there was very little, if any, premeditation. On the whole, one way or another, these words apply to me, especially the me that was in an angry mood. But then I ask 'So What' – it is no wonderous revelation, I may not have articulated so many adjectives if asked to describe myself, but they are not such a surprise.

However, perhaps I should consider the mostly negative choice of words here. If I try to look at them objectively then I would say that they are tantamount to an impending nervous breakdown, about which if I viewed them subjectively I would say was rather extreme – extemely bound up: I settle for suppression. It was difficult for me to translate the exercise in to a mask performance. This is not really surprising, if I am emotionally, physically, and mentally shut up. No wonder it would be difficult for me to release myself in performance, wouldn't it? I haven't said much about *wood*, have I?

p.s. Psychoanalysis at will!!!

I am actually taking this seriously – even if it doesn't come over too strongly'.

Shortly after this experience her singing improved beyond recognition. Two more sessions followed. One, going into an imaginary mountain (*earth*), the other drawing her present self as an 'Ideal Model' – 'Psychosynthesis', she found a previously undiscovered funny, playful, zany side to herself. She went on to become a founder member, writer and performer of a Black Theatre and other Companies. The contact has been ongoing over four years.

Wood

Rita is a woman in her early fifties, a mother of four children, divorced, and a university professor. Rita said this was her first experience in dance/movement and the creative process. 'I have a greater orientation toward my mind than my body', she said in the group's verbal processing. This is her account of the workshop experience:

'Nira's workshop gave me a new and unexpected insight into myself. Before it began, I was fully prepared to work with the element of fire, towards which I always felt a curious and inexplicable attraction.

When you then told us about the fifth element in the Chinese system, I realised immediately how much more congenial it seemed to me right then, and recognised in that old and very personal associations that I have always had with wood, its warmth and its beauty especially; the shelter it offers to the creatures of nature, and the shelter it gives to the human environment as well.

In my fantasy, however, the wood that I imagined remained outside me rather than becoming an intimate part of myself. I saw wood as beautifully carved and polished works of art. I tried to touch it, but I felt hesitant to do so because it inspired too much awe in me; I was thus mainly a passive observer.

When we were asked to draw what we had experienced or seen, I tried to reproduce it, but failed to do so. Then I decided to let myself be guided by my hand and my feeling about wood. I felt more and more like giving it the appearance of a door. I remember feeling calm and comfortable and had a sense of relief when it started to look more like a door.

During the next exercise I imagined seeing a tree, or rather being a tree. I tried to experience the different parts of a tree – the strength and stability of the trunk, the mobility and flexibility of the branches. Drawing the tree I started with the roots and proceeded with the trunk. When I came to drawing the branches I tried to make them look like flames, in order to satisfy my original intention to identify with fire.

The wooden door – the fact that it was closed – seemed to me significant. It evoked contrary feelings in me: one of excitement because a closed door presents a passage to something else that is concealed behind it, that awaits discovery. It also presents a challenge for me to go from the known to the unknown. I would like to think of all our encounters with the world as explorations where we open doors behind which are things that wait for our understanding and our affection. The other feeling was quite the opposite, because a closed door also signifies *exclusion, isolation, withdrawal,* and *rejection.*

It reminded me that the feeling of being an outsider has been with me most of my life, whether it was willed by me or whether it was imposed upon me. I am becoming more conscious of the power I have to close the door on my experience, memory or situation that threatens my psychological balance, my emotional or intellectual efficiency.

I can become the door and it is due to my volition how open I should be to experiences that come to me from the outside world, and how much of my inner life I allow to gain admittance into my consciousness. My covering the roots of the tree I drew was an acting out of my will to 'close the door' to a source of pain and grief in my life, that is nevertheless *root* and *branch*.

I was a victim of the Nazi persecution. All my father's family were lost in the terror. Perhaps my family was represented by my roots of the tree; my utter despair was something I did not want to think about. The bare roots made me aware of how I had covered over the memory of my family. Through the workshop experience I could once again connect to the grief and pain. I have moved through the closed door: I see so many things again.

The metaphor of the element *wood* has become a catalyst to a new level of perception. After I wrote these reflections, I made photocopies of the material, and gave them to each of my children. I want them to know more about me, since I am beginning to understand myself in a new *light*, shining from the underground – the roots – of my past. So I have found the fire element after all, down the *wood* path or *way* of my re-awakend consciousness.'

Earth

Bob is in his early fifties, divorced with one son. He is a former professor of English, is now a Clinical Psychologist, and is currently undergoing therapy. Bob said this was the first time he experienced movement and drawing in therapy. Bob gives the following account of his workshop experience, including random associations through the *earth* element.

dead – alive	spring and vegetation
mold – seed	love and death
wet – dry	Tammuz, Osiris, Adonis
dormant – blooming	Persephone, Demeter, Pluto
formless – form	red earth of New Mexico
hot – moist	the feel of black earth
hard – pliable	the Grand Canyon

DEATH – REBIRTH

'At first movement I feel a great imprisonment – earth, sluggish, cold, wintry, dormant, slowly coming to life with rich spring smells and feeling of moist soil – then the rising of a new season *through earth*... Relapse back to that basic grounding, which leads to rest, death, decay and around again. So earth, which seems inert, is motion, mover, and air, which always moves – motivating nothing in itself – a lot of male bluster and commotion as opposed to abiding unassertive female earth (except California, earthquake land). The Great Mother archetype, cosmic, fruitful, nourishing, devouring, sending us forth into form and light, calling us back into dissolution and darkness.

To choose earth is to choose human love, which is likewise intense, fruitful, transient, ultimately dying. The temptations for me are toward air and fire – the impermeable and transcendent, but right now that's not the way I'm going. Earth is what you get your hands in – the nitty gritty – direct feeling, where our feet are, where we're grounded, and where we, as Mephisto says 'zu Grunde gehen': and so we will.

In contacting the element *earth* I became still more aware that it is time in my life to turn away from abstraction, to allow myself to feel directly, pursue and explore relationships rather than avoid them, take risks, expose myself...immerse myself in the uncertainty of love.

I have the possiblity of resuming a relationship that broke off two years ago with a fascinating, romantic, passionate, delightful, difficult and extremely independent woman, someone very different from me...it would be a dynamic and destabilising time, something that would draw me from...the ivory tower, which I guess I am ready for, since now I feel I have enough power...to be a true complement to her...like Anteus, I'll find this kind of power in the earth. My choice of this element is a real turning toward and recognition of my own power and aggression, which I've all my life been very reluctant to do. These issues have also come up in therapy, but not so clearly.

I liked the mixed media, the choice of various directions to reach the same element, the emphasis on polarities, the awareness of convergences, and the integration of the senses. It becomes a powerful vibratory way of exploring and interacting with the hidden depth, in more than just an analytical approach.

After moving for half-an-hour, I drew a large vertical plant, suspended in the air: *unplanted* and *rootless*. On the far left of the page, I coloured light grey stems, followed by a green stripe across the page made with strong and direct strokes. Next came the bright yellow marks on the small grey stems, *strong* and *direct*, *light* and *indirect*...the conflict residing within me

of masculine and feminine aspects of myself. *Earth, wood,* and *water*: symbols of the *mother*...I need to experiment with the polarities, as Jung said: 'We encounter the inner form of animus or anima in our dreams, fantasies, visions, and other expressions of the unconscious when they disclose contrasexual traits of our own psyche', so to experience a more balanced sense of self.

My experience with *earth* was an authentic expression of the unconscious. I was so deeply involved I did not remember any of my actual physical movements – only the feeling of being on the one hand strong and vertical, as contrasted to a hesitant quality...since all of the elements are polarised, if you stay with one of them, sooner or later you *break through to the other side.'*

Metal

> My breath is soaring into the sky
> My grief is pulling me into the pits
> My joy soars like soap bubbles
> My fear contracts my intestines
> Am I guilty or innocent?
>
> My steps are straight, decisive and strong
> Their metallic quality is elastic and soft
> I am coming and going
> In lines, circles, triangles, squares
> My pathways connect and separate.
>
> I can let go to roll and stroll
> And dream of cars and trains
> And wires and planes,
> Magnetic keys
> Electronic wheels; pots and pans
> Chopsticks and woks;
>
> Perspectives – Decisions – Determination – Resolve
>
> I am cruising – hovering – waiting – planning – flying...

Metal/Air

Yael is a 39-year-old artist, married, mother of one child, who chose *air*, which Mann (1973) sees as the western equivalent of *metal* and stands for the lungs and breathing (see p. 89).

'I knew that the element I most associate with was *air*. The feeling I had that morning was a very negative one. The air went through me and pushed me around, my life was not stable. I moved like air, and the air could move me at its will, I would react to anything. I lacked direction,

and was floating. The good part of the floating feeling was that anything could happen; the negative side that I could not initiate anything.

When I started to move, I felt how strong the air was around my body. The force pulled my elbows and arms down the sides of my body and made them quiver. The force of gravity and air went through me. I began to breathe the air inside me, the air became part of my life force. I let it in and out of my chest and down into my stomach. I felt very thin. The air inside me connected with the air outside. I could also feel it going in the joints of my body, where there are no holes, but it felt to me as if they were so flexible that the air inside was being pulled by the air outside. Finally I lost the distinction of what was inside and what was outside...it was done...it was wonderful...my body in contact with the air outside. I felt very light and good. I drew the three stages of the person. I experienced it was inside and outside, at first a very big difference and a coming together with a lot of movement. After the first painting air was heavy and visible. It was part of my body. Then it became delicate, imaginary, not space. It is my body! In my second drawing all these very heavy vibrant colours became very lyrical and light. It was the essence of my experience, like a clean sheet of shiny metal.'

> Quivering arms –
> The air above and below is heavy they weigh a ton, like heavy metal
>
> Air outside, fast – empty
> Air inside not
>
> Holes in my body – at the wrists
> in every joint
> the air goes through,
> is drawn out
> draws me out
>
> Delicate balance –
> air inside and air outside
>
> Shaped air, sharpe as metal
> it moves me
> I move it.
>
> Air slides off the thickest,
> yuckiest mud
> and makes holes in between
>
> There is no suffocation –
> and no stability
>
> Air is heavy
> Metal is heavy
>
> Air is visible
> Metal is visible

It is my body –
Air is delicate
Air is imaginary
It is not space
It is my body…fast, slow, violent, passionate,
destructive-creative.

Earth/Air/Water

Ester had been with Leah in therapy over a year and had not been able to
write until that moment. Then suddenly, on the day we worked on the
elements, she wrote two stories, covering four sides of a large sheet of
paper: creating a circular motion. The picture she had first drawn was of
a tree trunk, sunshine, waves, clouds, and large blue spiral surrounded
by a red circle. At the moment she started to write, she said: 'Look Leah,
a miracle, I am writing!'

First there was nothing
Then Atum created himself out of his own will.
Then he created water, the primaeval water
there was nowhere to stand, so he created mountain
the primaeval mound.

He stood on the mound and spat out air
there was water, there was land, there was air.

He then created the sky goddess and the vegetational god Geb.
They fell in love and Geb lay on *earth*
and the Sky Goddess on top of him.

This made Atum angry, and he told Air to separate them,
by going in between them.

Air pushed Sky Goddess up and held her there separated forever from
Geb the vegetation.

But at night, when it was dark, she always came down to Geb and lay on
top of his body.
At day break she went up into the sky.

Life Giving

When the God with a million eyes killed the baby Hanuman,
his father, the God of Air, took him in his arms and went to the
Underworld to a cave and there he cried with Hanuman in his arms.
On earth all living things died,
all the plants, all the animals, all the people were dying.
Indra, the God with a million eyes, looked in the heavens,
looked on the earth, looked in the Underworld for the God of Air.
Finally he found him, crying in the cave with Hanuman, the baby
Monkey in his arms.
He realised that he had killed the son of the God of Air

and that is why there is no Air in the world and all living things are dying.
So he brought Hanuman back to life and promised that when he grows up,
he will be strong and graceful and jump like the wind
and fly through the air
and use his powers well and wisely.
So the God of Air took Hanuman back to the earth
and all the dying things came back to life.

Fire

Ruth, a very successful solicitor, had had an extremely deprived child-
hood, and has done many years of growth work, including transpersonal
workshops and psychosynthesis, and has participated in an ongoing
Qabala Group. She has had acupuncture and shiatsu treatments, and
worked with Leah on some Feldenkrais-based movement.

We present the sequence of four individual sessions describing both
our work, and the client's reactions.

REACHING FOR FIRE

1st session: started by scanning the body contact with the floor, focusing
on pressure points, until she could feel the whole spine touching the
ground. It continued with my touching her with my hands, especially
releasing the head and neck.

The five elements were suggested. She chose *fire*: 'it seems attractive'.
She moved around the studio as fire – came to a halt and felt that she was
being pulled down, becoming very depressed:

'No good!'

'The fire needs air'.

She tried imagining ways to let air get through to the fire, but to no avail.
Then she imagined the air itself, I started working physically with my
hands, gently pressing on the ribcage, increasing the exhalation. We used
'paradoxical breathing', ie: exhaling while extending the abdominal mus-
cles, thus releasing the diaphragm. We worked on the back, kneeling 'cat
position': on hands and knees.

Ruth discoverd a painful spot between the shoulders:

'Christ on the Cross!'

We opened up the physical channels. Following this she was asked to
make a drawing of her experience. She drew red, yellow, and blue as a
ground; in it was enclosed a black body.

2nd session: about a week later, started by scanning the body again, whilst
lying on the back. This time the image was to be of 'displacing air' by

various parts of the body, ie: where there was air on the floor, 'is now your pelvis, your torso, legs and arms'. We decided to explore further the element *air*.

Ruth imagined air to be outside and inside her body. They fused together – a bubble emerged – the bubble became a balloon, the balloon became membrane...the body was like skin between the outside and inside, becoming thinner and thinner – a Zen type – 'Total Experience', she moved in space like air. Inside and outside being one.

3rd session: was a repeat of the element air. Leah asked her to scan the body while lying on the back, imagining lying on sound, i.e., what sound does the contact with the floor produce in her imagination, is there a different sound for the pelvis, the torso, the head, the arms? Let air go through the body. Arms were cold to begin with; gradually energy started moving about. There was a noticeable imbalance between the left and the right side of the whole body.

An imaginary axe hit Ruth on the chest – energy started moving around – a great energy block was in the left armpit.

An image of a crippled man with longish hair, very thin limbs and a bony face became visible. The left leg was either withered or a part missing, the right leg was very strong. He walked on crutches in a large square with a cathedral in its centre. It was in the Middle Ages in France or Germany. Ruth felt it to be like a reincarnation experience, which may account for her extreme one sidedness in this life.

4th session: delving into the water element. This time the scanning was to be on an imaginary waterbed – parts of the body displacing water, making indentations: how much water would the pelvis displace? The same for all other parts, like torso, head, arms, and legs.

Allow water to enter the body. Ruth became afraid to sink from the weight of the water in the body. I suggested she let the water out through the mouth and the top of the head. An image of a Chinese wooden bridge came into view, it broke and fell into the water. A straight pipe with water became visible; it opened in a series of blocks to reveal another, smaller, pipe running along the inside. This ended with a foundation of water splashing out. Ruth felt floating: 'I am making it happen... Stop... I am afraid that if I do not make it happen, nothing will happen...'

I took Ruth's right hand, it was cold. And she said: 'I picture being in the fluid of a womb; what should come through the umbilical cord is blocked'. Ruth stopped breathing. Suddenly great heat passed from the right hand through the upper part of the body; this continued for a while, it became a pulsating energy, ever increasing. Then, instead of taking it all in, she gave it out – it developed into an outward flow – and with this

came the realisation, that the holding in and taking in, without the feeling of giving out, was a childish leftover which was blocking communication on many levels. It felt like a realisation and a real shift of willingness to give and take as an adult, instead of feeling the need to take first, like a deprived child...

> I had almost broken through, there was however still constriction in my chest and the feeling again, as if someone was trying to cut through my breastbone with a chopper. I think, once that happens, a lot will be released.

Water

Alice, aged 50, is an artist, married with two children. She said the Five Elements Workshop was her first experience with any kind of therapy. In the group's sharing process Alice showed her drawings and gave the following account of her workshop experience. (The following describes the client's reflections and our description of the process itself.)

'It's interesting – when we started, I thought that *earth* was my element. I hate water – at least I did. But the element that came to me was *water*. I often could say we have in us all the parts (elements). I found also a lot of memory involved with my mother and swimming and protecting or depending. I don't feel the need for therapy. I don't want to change some things anyway. I don't have time to concentrate on the self. Its no good. Water had to do with breathing. There was an instability, a coming and going, as if there were different aspects. Trying to be flexible was very desirable. The tide was coming and going, breathing in and out, like the impermanent quality of life.

Always I do circles, coming and going, repetition. I never do arrows. I like stripes. I like one centre, and everything coming from the centre. The elements touched me because they are archetypal. They are essential to life...they stand for so much fear and joy. They trigger many internal cycles. When you are in a bad period in your life, a big disappointment or obstacle, experience tells me that this won't last forever...like the tide...a phase of your life, and it will disappear.

There are phases, like three cycles...as a child, middle age, old age.

As a child I was afraid of water, and I think my mother was over-protective, very afraid – like I will drown by only touching the water. When I was 12 or 13 years old, I learned to swim at school. My mother was present too. Afterwards, my mother did not let me go swimming with the others, so I went secretly, with friends. I was angry. I don't want to be protected, although it is also very nice to be protected.

The water is insecurity for me – unstable. I am settled now, in a stage where I can fulfil many things. I get very involved in my things. My work is not dealing with people – you have to go to yourself. I work in phases. When I am in this wave, I don't want to break. When I can't pursue my creative idea I have a lot of drive.

I become angry and very irritable. Movement is very good for mental health. It has to do with my energy. I have to do it (movement) now... I have many commitments. Last year I began a new phase in my life, swimming every day, encountering the water. I have to structure myself as an artist. I don't work from 9–5 in the office. For me the centre is very important. In my drawing I came back and strengthened the centre. I have always to go recuperating from living. I am very involved, doing more than I can do. This is my weakness. I need to go back to structure, looking for stability. I can go back.

You need in your unconsciousness a kind of dependency. It came from my father. He was the king of my life. He was always the man in my childhood. The Knight. The King, giving security, open to everything, giving security... I want to be dependent, and also independent.'

In her first movement experience, Alice moved with strength and direct-ness, using a good deal of weight while in a sitting position. She began by standing on her knees, moving her arms using the vertical plane, drawing her arms toward herself, then forward again, resembling the 'coming and going' motions she later described in her first drawing.

When she moved to a standing position, Alice used the same repetitive movement she had used in sitting. She reached forward on the vertical plane using both arms and bending her upper body, while her right foot remained forward in a stable position. She began with the same move-ment, then began to reach to the side and forward in a 'swimming' motion, including more use of the horizontal plane, using the near and far space of her kinesphere. When she described her experience in the processing period she verbalized the feeling 'coming and going'. Her movements were sustained and rhythmic, with the quality of weight. The predomi-nant movement continued to be a postural and gestural motion, gathering into the centre then going out again almost as if searching, and constantly moving back into the vertical and horizontal planes, mainly using hands and upper body. She allowed her back to follow her movement, along with her arms, hands and head.

In the process of drawing, Alice moved with a great deal of energy and enthusiasm, repeating the movement, almost like a ritual she could not stop. After the experience with moving, she drew the spiral drawing, 'dancing' her colour on the page with strong, quick and direct little jabs,

very repetitive, impulsive and rhythmic. She appeared to be able to go on for a very long time. After making some little sharp dots on the page, however, she returned again and again to the centre to emphasise it again. She used bright colour. In the first picture she used strong, heavy pastel colour, giving the overall impression of almost 'drowning' in the colour and design. In her second drawing, Alice designed a form with more space around it and lighter quality both in form and shape. The many dots surrounding each 'spoke' of the wheel were made with different colours and pencils.

In both her drawings and movements, Alice moved with control, organising herself within structure and symmetry, expressing again and again her need for a centre. A recurring theme of Alice's experience was acknowledging polarities – her fear *versus* her love of the water; dependence *versus* independence; instability *versus* stability; 'drowning' and overwhelmed *versus* centred and structured; protected and overprotected *versus* unprotected and left 'at sea'. In choosing the element *water*, Alice was able to identify important polarities that spoke to the issues of her life. She appeared to experience the phenomenon of eidetic imagery. As Arieti (1976) explains, the depth of power of the eidetic image enables one to maintain an emotional feeling and aid in the process of creativity.

Alice's imagery grew out of a strongly felt body sense described by Gendlin (1969) as being important to acknowledge in a conscious way. Through use of modalities, movement and drawing, Alice was able to bring feelings to the surface to be processed later in words, and was able to relate in a concrete way to her life's issues. Alice's association with the on-going flow of stages of life recalls Erikson's theory of the stages and themes of each important cycle (Erikson, 1963). In 'Dreams and Fantasies' Jung stated his belief that 'the image of the sea, or a large expanse of water, coincided with the nature of the unconscious, because the latter can be regarded as the mother or matrix of consciousness. Therefore, the unconscious, when interpreted on the subjective level, has the same maternal significance as water' (Jung, 1961).

Alice's Reflections

> After Moving and Drawing Waves, water, tide, coming, going,
> Back and forth,
> breathing in, breathing out,
> everything is floating, flowing,
> nothing stays.
>
> Everything is flexible,
> it comes, it goes, it comes, it goes...
> Nothing stays forever, nothing disappears...
>
> Life is an eternal circle,

Life is polarity, yin and yang, high and low,
black and white, day and night,
happiness and sadness, winter and summer.

Everything that disappears will eventually come back.

No reason for despair,
nothing lasts forever,
despair never lasts forever.

Enjoy your happy moments...
they don't last either.

Everything is fleeting, floating

Face it:
Experience every phase in life to the fullest;

Joy and Despair alike.

A Reflection on all Five Elements

Judith worked with all five elements during a period of five months. Here is an account of her experiences:

'The following is a description of my experiences in the workshops combining the *Five Elements* with dance, art, and group processing.
As I meditated on the Five Elements, one would seem just right. It was that element that I would stay with for the workshop. My first workshop centred around the element *water*. In the second workshop, when the family idea was presented, *water* came to me for my father, *wood* for my mother, and fire for them as a couple.

In the third workshop I worked with *fire* and the smouldering in my heart. The need for fuel encouraged me to reach out and try different types of fuel to help the fires burn. In these three workshops I was free and receptive, flowing with the image of the element, and the synthesis between its energy and the workings in my emotional and psychological being that day.

In the fourth workshop it was suggested that we choose, if we wanted, an element we didn't like. I liked the challenge of this and settled on *metal*. It was not a comfortable element for me to choose, but I wanted to stay with it, to see what information would be revealed to me.

Likewise, the last workshop, which I did individually, it had been decided ahead of time that *earth* would be used. The choosing process was quite noticeably absent at the last workshop. This preliminary stage did serve as a meditative preparation for my internal state in approaching the element. I missed it this last time.

With the last two elements, *earth* and *metal,* I found a need to make physical contact with both *metal* that was in the environment, and the *earth* outside. Because I felt a distance and an unnatural disharmony with these two elements, I could not entertain them successfully internally, but needed to make sensate contact with them.

The elements were a symbol that penetrated to personal unconscious levels as well as collective unconscious levels. I felt that my emotions gravitated to the element like iron shavings are drawn to a magnet. Each element contains a certain configuration with which specific emotions blend in a unique way.

The issue I have been working on – forever, it seems – is a one-to-one, intimate relationship with a man. The Five Elements with which I worked over a five months period, paralleled, enhanced, and furthered my understanding and growth in this area. As I look back on all the pictures I drew, I see the first one as a gathering of the parts necessary to come together to form a meaningful result. The *water* workshop called forth the parts of myself that I need to look at consciously in order to progress. It was very abstract and elusive. The last picture, done in the earth workshop, is uncannily similar to the first picture; however, it is more concrete and formulated. It is a picture of me giving birth to myself. As I look back on these five months, that would be the theme I would choose.

My mother and father are significant in my growth process, both in the first twenty years of my life, and as an adult. Observing myself and wanting to choose consciously my path in life, I have gained a certain sensitivity to my body and my emotions through the workshop in which my parents came up. The element of *wood* symbolised my mother and the upper part of my body. Turbulent waters symbolised my father and the lower part of my body. Fire was the symbol for them as a couple, also representing my own energetic field.

In dance energetics I tried to allow the turbulent waters from below to flow and soften the rigid wood that was above. My awareness of how I use *water* to contain *fire* gives me insight into my confrontive, direct, and oftentimes angry approaches to resolve issues. This awareness not only helps me see patterns, but opens me to the presences of other ways of choosing solutions and situations. I found in the workshop that by being the turbulent waters, the rigid wood, there was the polar opposite contained within the element and in my body. By experiencing it, and consciously formulating it, I saw new and deeper aspects of it.

The third workshop, the *fire* workshop, got me in touch with my smouldering embers in my heart area which needed new and different types of fuel. I was encouraged to reach out and try different fuels to feed my *fire*.

A metaphor in my life; through warmth I must extend myself in the world to people to get what I want, need, and desire. By doing this metaphorically through dance and art, I am more easily able to act in real life.

The *metal* element, as I mentioned earlier, was a difficult one. Yet, by accepting that obstacles and difficulties come up in life, the opposite occurs, that it furthers my growth, rather than limits it. The *metal cage* metaphor occured with this element; I felt out of my element; locked into a box; unable to express. As I did the drawing my picture reminded me of ET. Just as ET scared a lot of people, and was attacked, he had special powers and sensitivity that charmed others. Yet he chose to return home to his people. He knew who he was and where he belonged. I feel I am learning who I am and looking for where I belong.

The last element, which I did not choose but Nira and I decided I would work on, was earth. *Earth* evoked many negative feelings about my mother, which I have just begun working on in therapy. I have been in denial of my difficulties with my mother, just as I wanted to deny earth a chance in these workshops. I was able to touch earth, stomp on it, dance on it, lie on it, surrender to it, play with it; through making that sensate contact bring to consciousness the blocks concerning my mother that prevent me from giving birth to myself.

Of the four Jungian qualities, I scored 0 on the sensate. Thus, it is through the sensate that my growth will occur. The dance and art workshops are a beginning step towards revealing the awareness that is hidden in my body and psyche. Working on myself in this way, gives me understanding of the content of my difficulties in relationship with men, and allows me to be more sensitive and caring when relating to people.

The directness, control, weightiness, and strength that I exemplify can get in the way of a relationship when used inappropriately. Feelings need support, love, sensitivity and gentleness, and firmness. Thus, on another level, the process of the workshops have given me the experience of the above, as well as the knowledge.'

Resources of the Mythological Body I

Serious Play

For all created things must have a period of recreation.

Z'ev ben Shimon Halevi

We consider our work to be 'serious play', which encourages the child within us all to break through the layers of adulthood, to respond again as children do, with a lack of inhibition. This attitude is at the root of the transformative nature of our work, and best summarises the spirit in which Biblical and mythological influences can be integrated to enrich the experience.

'Serious play' is at the heart of all primitive cultures' quest to communicate with the spiritual and creative force which, even if we do not recognise it, today still affects us, whether it be through religion, theatre, or sport. 'Serious play' is behind all of humanity's inherited rituals: sacrifice or carnival; rites of passage; baptism or barmitzvah; and the Mysteries, such as the Greek Eleusian Mysteries and Mesopotamian prototypes. It also lies at the heart of the ancient Greek concept of *catharsis*, the healing power of theatre.

'Serious play' is the thread that links our conscious acts with our unconscious promptings: 'inasmuch as an idea is, it must have become...' (Frobenius 1928). The 'becoming' is the *internal process* of transformation, and its 'being' is the *external expression* or result of the transformative process – manifest in body movement, the voice, drawing and writing. Many scientists and artists recount how they happened upon their most profound and creative insights, by simply 'playing' with words, ideas, or images.

Campbell's introduction to *Primitive Mythologies*, concerns 'the play element in culture': 'In all the wild imaginings of mythology a fanciful spirit is playing, on the borderline between jest and earnest' (Huizinga, 1949). 'In the playing of the game of the gods we take a step toward that reality – which is ultimately the reality of our selves. Hence the rapture, the feeling of delight, and the sense of refreshment, harmony, and re-creation' (Campbell, 1987).

Bible stories were always part of our lives in teaching and choreography. In ancient Greece the gods and goddesses were part of people's

lives. In the age of mass communication and high technology, direct communication with the sacred has been lost. Through our work in theatre, education and therapy, we rediscovered the symbolic values and real 'physical', 'mental', 'emotional' and 'spiritual' healing qualities contained within these stories and myths.

Introduction to the Bible (Nira Ne'eman)

Biblical Stories

Rebekah – The Decisive Woman

Rebekah represents a woman able to self-determine her life and express her emotions freely. When she is faced with making crucial choices her deeply intuitive and decisive nature offers her a clear vision and identification of the path her family has to follow.[1]

As Leibovitz (1975) points out, she is very concerned for the welfare of other people; she is hospitable and generous. When she first encounters Abraham's servant with his ten camels, she offers him water and, without

hesitation, waters all the camels until they are completely satisfied – this fact is mentioned in the Bible three times – and to do so she needed to descend to the well and ascend, carrying the heavy water without anybody's assistance.

According to Steinsaltz (1984) *Rebekah* has the sense of being at the right time in the right place and knows instinctively her duties and mission in life; she is adventurous, curious, determined, and willing to take risks. She had to be worthy of the house of *Abraham* to become mother of Jacob, the begetter of the twelve tribes of *Israel*.

The Story of Rebekah

In the story, Abraham's servant has a fantasy of how the destined wife for Isaac should behave and, lo and behold, the first person to appear by the well outside the city walls appears to fit the image.

The story contains many doubts: Will he find her? Will she agree to come? Will her family let her go? Abraham's servant and Rebekah's family are both uncertain, but she is intuitively determined to go; she does not hesitate. She was asked to decide herself whether she wants to go with Abraham's servant and allowed to make up her own mind, a sign that she was respected and her family trusted her. She was willing to explore the unknown and must have had a vision of her destiny. She displayed a willingness to care for and serve a complete stranger.

Rebekah is a model of a woman – maiden, wife and mother (Steinsaltz, 1984). She is the archetypal mother who has to fight for her own and her children's survival in a harsh and cruel world. She is thoroughly feminine and has a deep understanding of her husband Isaac, who is trusting and does not suspect any evil in others.

According to the Bible, Abraham was old, advanced in years, and the Lord had blessed Abraham in all things. And Abraham said to the senior servant of his household: 'Go to the land of my birth and get a wife for my son Isaac' (*Gen* 24:4).

The servant took ten of his master's camels and set out, taking with him all the bounty of his master; and he made his way to Aram-naharaim, to the city of Nahor. He made the camels kneel down by the well outside the city at evening time, the time when women come out to draw water. And he said: 'Oh Lord, God of my master Abraham, grant me good fortune this day and let the maiden to whom I say 'please lower the jar that I may drink', reply 'drink, and I will also water your camels'. Let her be the one whom You have decreed for your servant Isaac' (*Gen* 24:12–14).

Rebekah, who was the daughter of Abraham's brother Nahor, came out with a jar on her shoulder. The maiden was very beautiful, a virgin whom no man had known. The servant ran toward her and said: 'Please

let me sip a little water from your jar' (*Gen* 24:17). 'Drink my Lord... I will also draw for your camels, until they finish drinking' (*Gen* 24:18).

She drew for all his camels, which was very hard work indeed (*Gen* 24:19). The man meanwhile stood gazing at her in silence, to learn whether the Lord had made his errand successful or not. From the beginning Rebekah trusted the stranger, and took care of him.

We relate to the story of Rebekah on two levels: first, to understand the original archetypal story and that of the Biblical heroine, our ancestor; and second, through identification with the archetype, a model for our own lives in the turbulent 1990s, where this story has great topicality, and many thousands of people make the big decision and say again 'I will go!'.

Movement Experience

TO ESTABLISH TRUST

Walk around the room, begin to establish trust, lead with your eyes...acknowledge the other participants with your eyes...express different feelings such as openness, shyness, hesitation, confrontation. Standing in one spot, reach out to others with various parts of the body, and express the different feelings... Vary the movement levels in relation to the floor.

TO GIVE ACTION AND MOTIVATION

Move in a way of giving, as a simple undifferentiated action. Move and give something heavy, something precious, and something trivial or light.

DRAMATIC Imagine you are watering a camel...imagine doing what Rebekah did, watering ten camels, lifting and carrying the water jars from the well.

MOVE Find different motivations for giving and caring:
 • Giving as pleasing...
 • Giving with all your heart...
 • Giving and withholding a part of yourself...
 • Giving unconditionally...

The story continues: The servant asked: 'Is there room in your father's house for us to spend the night?' (*Gen*. 24:23). She replied: 'There is plenty of straw and feed at home and also room to spend the night' (*Gen*. 24:25). When Rebekah's brother, Laban, heard the story, he came out and invited the servant, his men and his camels to the house... Before the servant agreed to eat, he relayed Abraham's wish to find a wife for Isaac from his own people, and not from the Caananites among whom he dwelt. To which Laban replied: 'Here is

Rebekah before you; take her and go, and let her be a wife to your master's son, Isaac, as the Lord had spoken' (*Gen.* 24:51).

The servant wanted to depart immediately, but her brother and mother wanted to delay her for ten days. So Laban said: 'Let us call the girl and ask for her reply', which was 'I will go' (*Gen.* 24:58).

Seed Thought: 'I Will Go'

MOVEMENT EXPLORATION

In a group, walk around, say to each other 'I will go', in as many ways as possible: loud, quiet, determined, hesitating, questioning, and joyful. Cross a limited space from one end to the other: move in different ways:

- Go with joy, knowing what is at the other end...
- Hesitate, go reluctantly...
- Go to the other end with blind or foolish confidence...
- Go in order to achieve the crossing...
- Combine the words and movements in any way you like.

FOCUSING – EXPERIENCING ON THE SYMBOLIC LEVEL

EXPRESSIVE ARTS Transfer your experience onto paper, drawing and/or writing.

What did you feel?
What do you want to remember?
What was meaningful for you?
Can you relate it to real life issues?

REFLECT Participants expressed the following feelings and associations with 'I will go'

separation	unconditional surrender
giving up	fear, anxiety, anger
change	taking risks, new opportunities
curiosity	belief, vision
confidence	daring and strength

CONTEXTUALISING – MEANING AND VALUE OF '*I WILL GO*'

Share your experiences in a small or large group.

In the 1990s the whole world appears to be on the move and this list seems to be more relevant than ever. We could relate 'without fear or anxiety' to our personal stories. In Russia, Nira's mother wanted to leave her medical studies in the middle, to emigrate to Israel, and said 'I will go'. Her grandfather said: 'First finish your studies, you need a profession to survive in a new country; otherwise you will have to go over my dead body.' She became a dentist in Russia, and eventually became the main

breadwinner of the family in Israel for many years. By coincidence her name was Rebekah.

Leah, who emigrated from Germany to Israel left school at the age of fifteen; she wanted to learn a profession in an insecure immigrant society. She said 'I will go', and became the youngest student at Bezalel Art School: 'out of curiosity and taking risks'.

I will go (Alicia Sclovich)

IMPROVISATION

CHARACTER STUDY Explore Rebekah's character as a progression from maiden to wife and mother. Choose three or four personal qualities to dramatise in movement, sound or words. Be aware of the psychological motives of 'becoming' and 'being' of 'self' and 'others'; your relationship to your roots and your choices in leaving 'home' to establish your own family or profession.

LIFE-STORY Transfer the experience into visual art and/or writing. Develop your own story. What character qualities do you associate with Rebekah that relate to your own life story? What decisions did you have to make in your own life that were irreversible? When did you make the right decision? When did you make the wrong one?

How hospitable, caring and nurturing are you?
What holds you back, what reservations?
How supportive are you to other members of your family?
How much do you rely on their decisions?
Do you always follow what you know to be the truth?
Do you hesitate?
Do you manipulate?
Do you guide your family?
Are you aware of dangers early enough to avoid disasters?
How much do you need to be in control?
How much are you actually in control of your life?

SHARE Share in small or large groups.

'Rebekah'

Work with one individual client (taken from 15–20 hours of material) exploring:

Fear – Anxiety – Anger

FEEL AND MOVE

Nira: Express in movement your feelings of fear, anxiety,
 and anger, following your experiences of 'I will go'. You
 may use the ground and stamp with your feet as much as
 you like.

Tamar: I need space!
 You never listen to me!
 He is always occupied with himself!
 You are totally unaware!
 You don't respond to me!
 'Poor Me'.
 I need to get rid of yuckie feelings!
 I want a new relationship!

Tamar picked up a pile of cushions, and threw them across the floor, once
more bursting out...

 I need a new relationship!
 I am afraid of rejection!
 I am good enough for anyone!

She gathered back one cushion, hugging it:

 I can trust myself!
 I can get rid of the fear, the fear of being abandoned!
 I am good enough, I have strength! I will not be defeated.
 I can handle my life, I can hope, I am not a victim...
 Don't put yourself as a victim!

Nira: Don't push the river, move with the stream...
Tamar: I need a man who acknowledges me as a person, with whom
 I can have a physical as well as a spiritual affinity.

FOCUSING – *GIVING UP AND LETTING GO*

1st Stage: Loss of identity.
 Being manipulated by the mother
 Burn out
 Anger – Frustration
 Leaving me alone
 Where is my space, my time?
 Feeling I have to give up.

2nd Stage: Keeping my identity
 Being alive!
 Excited by new possibilities!

3rd Stage: Keeping identity and relating
 Giving and taking
 Giving up something willingly, allowing the other person to
 be fulfilled too, to relate to another person, and to build up a
 relationship one needs to commit oneself, to be willing to
 compromise, to give up something valuable, and... to let go.

CREATING SPACE FOR LOVE

Tamar brought a tape of lyrical music for this session. She wanted to
explore the themes of:

Self Worth – Love – Nurturing

She danced hugging a big teddybear, and said:

 I can be strong and loving;
 to love and be loved;
 be loveable;

Tamar remembers:

 I love you,
 trust yourself.
 Dance out *loveable*
 Dance out *strong feeling quality*
 Dance out *loving freely*
 Dance out *caring*
 Dance out *responsibility*
 Dance out *trust*

She hugged herself – nurturing herself

> I love as a girl
> as a mature woman
> as my mother loved me.

Conclusion

Sample how a person can draw inspiration from a Biblical story to affect their own life issues.

Leah and Rachel – Two Faces of Woman

Leah and *Rachel* personify two different aspects of one feminine principle. According to Brenner (1988) they are two opposing but complementary faces of one woman. They are doomed to a continuous struggle for dominance from beginning to end. Their duality finds expression in archetypal emotions such as love, rejection, deception, rivalry, and compromise. According to Steinsaltz (1984), Biblical personae continue to live and also to evolve throughout Jewish history, in its psychic experience and as part of the collective personality.

As written in the Bible:

> Now Laban had two daughters: the name of the elder was Leah, and the name of the younger was Rachel. And Leah's eyes were weak, but Rachel was of beautiful form and fair to look upon. And Jacob loved Rachel; and he said to Laban: 'I will serve thee seven years for Rachel,' and these years seemed unto him but a few days, for the love he had for her. And when done, Jacob said unto Laban: 'Give me my wife, for my days are fulfilled, that I may go unto her.' And it came to pass in the morning that, behold, it was Leah, and he said to Laban: 'What is this thou hast done unto me? Did I not serve with thee for Rachel? Wherefore then hast thou beguiled me?' (*Genesis* 29: 16–25)

Laban justifies the deception by saying that it is not the custom to give the younger before the elder. They make another agreement, and Jacob takes Rachel as his wife as well. 'And he went also unto Rachel, and he loved Rachel more than Leah, and served with him yet seven other years.' (*Gen* 29:30).

The story is of Jacob being deceived by Laban; Leah participates in the deception and gains her husband through her father's deviousness. Rachel is deprived of her husband at the beginning. Although she is loved, she has to share her man.

Our aim is to provide a framework within which to understand the Biblical figures as archetypal models, showing the inner mirror images of two women struggling for dominance, yet creating a whole family. Issues to be explored, are:

love	rivalry
denial	compromise
deception	persistence

After we have read the story of Leah and Rachel together, we form a circle and begin our experiential work. We generally work with this material in three or four sessions, lasting about two hours each. You may choose to experience one or two of these activities in depth.

Movement Experience: Trusting/Mistrusting-Deceiving

The group leader takes a ball or cushion and instructs participants to throw the ball from one person to the next. As people toss the ball to one another around the circle, trust is established.The group leader enters the circle and starts to play, looking at one person but throwing in another direction. This simple game brings to the surface two distinct perceptions:

- Feelings of deception and mistrust. How do you respond when you are in a situation in which a person says one thing and does another?

- The spontaneous part of our being, and the element of the unpredictable which often catches us 'unaware'. Learning to recognise that things may not occur as we have planned them makes us aware of the need to value the powers of the intuition: we become alert to catching things at 'strange angles'; to receive – or catch – things of seemingly disconnected patterns.

GIVING – TAKING – WITHHOLDING

We work in couples to explore in movement the meaning of give and take. We begin to experiment with what it feels like alternatively to give and to withhold. What movements do we use to express giving, taking and withholding? We change partners and share the experience verbally in small groups.

PUSHING–PULLING

The next step is to experience the quality of push and pull in movement only.

Change partners.

Form triads and experience the triangular relationship in movement. Be aware of the difference between relating to one person and relating to two. The potential competition is reminiscent of the family.

Try the same activity in silence with a group of four or five. Whom do you relate to most? Share the experience verbally, in small groups, relating the situation to your own family life situation.

Find a new partner. With movement and abstract sound, express being loved or being rejected, being reserved or being alienated, being open and receptive.

Change partners, but continue to work with these feelings of love and rejection, receptivity and reserve. To elaborate, transfer your feelings from movement onto paper: drawing, and using words.

We review the story of Leah and Rachel as a way to study our own kinaesthetic perceptions. Leah experienced rejection as the wife who was forced on Jacob. She fought a long struggle to achieve recognition. She was very fertile and she gave birth to one son after another; her husband's love and devotion, however, went to her sister, Rachel. Leah was not content with motherhood: she longed to have a truly loving relationship with her husband Jacob, whom she loved deeply; she tried to strengthen her ties with him.

Rachel was desirable, beautiful, playful, and confident of Jacob's love for her. She remained barren for a long time, which caused her great pain. She shed many tears and became jealous of her sister. Rachel was not Jacob's first wife. Her great fear was that she would not be able to give Jacob an heir, although she took his love for granted. 'Rachel personified a dream that did not come true' (Steinsaltz 1984).

EXPRESS FEELINGS In the next series of exercises we sense the qualities in our bodies, and take time to discover our attitude to our bodies. Do we feel beautiful, desirable, content, patient?

Begin by sitting or lying down on the floor, eyes closed.

TACTILE EXPLORATION Touch your body in any way that feels comfortable. Explore parts of your body that you do not normally touch. Vary your touch; be delicate and sensitive, strong and confident. Touch familiar and unfamiliar places. Sense the quality of the encounter. What makes you touch a specific place? What do you feel when you touch yourself? Do you enjoy your body?

RESPONSES 'I hate my legs. I like my neck.'

'I can't stand my upper arms. My feet please me.'

MOVE IN SHAPES Move with your whole body to express your relationship with it. Are you moving in soft, curved shapes, or angular, jerky lines?

Choose a quality that expresses how you feel. Emphasise and exaggerate it. Where in your body does the quality originate?

OPPOSITES Express the opposite quality in movement, noticing your feeling and reactions. Find a partner who expresses the opposite quality to you. Relate to each other. Share your experiences verbally. Be yourself, express your most pleasant accepting experience of your body. After you have expressed this fully, try the opposite.

EXPRESSIVE Record these feeling in words and pictures. Share verbally.
ARTS

Origin of the Name
This work can be used in many different contexts.

OPENING CIRCLE
The group stands in a circle then, one after the other, everyone says their name, echoed by the whole group. Repeat this process several times. At each round, say your name in a different manner: softer-stronger, louder-quieter, faster-slower.

Sing your name: all the time the group repeats the name after each person. Say your name with sound and movement...

Say your name, adding one word, describing what you like, or what you dislike, or what you are afraid of.

WORK WITH A PARTNER
 • Talk to each other, using your name only – 'Leah' 'Nira'
 • Stand close to each other, speak quietly
 • Stand far apart, speak up, very loud or shouting
 • Make an imaginary conversation using the two names only
 • Change – use your partner's names and speak for each other...

CHILDHOOD NAMES
Sitting down with closed eyes...

MEMORY Remember your childhood:

How did I hear my name called out?
How did my mother call me?
How did my father call me?

Often pet names have a cultural background. Nira's father wanted to retain the Russian connection and called her 'Nirotchka'; while her mother wanted it to be nearer the Hebrew, which was 'Nirinka'. Leah's father called her the German equivalent to little mouse 'Mäuschen'; while her mother called her 'Pummelchen' in reference to her plumpness.

Do you like your name? Would you like to change it? If so, to what name...?

Continue with closed eyes: imagine any names you were called, 'nicknames'.

Did you perceive your being called by a pet name as a cuddle or hug?

Do you remember any angry intonation when you were called? How did different members of your family call you?: Father, mother, grandfather, grandmother, brother, sister, aunts and uncles. Can you recall the sound of the voices; who was loving, caring, demanding, or punishing?

EXPRESSIVE ARTS — Open your eyes, transfer into a graphic description: draw and/or write your name in different colours, with varying strokes, thin, thick, angular, round, black and white or colourful.

GROUP SHARING — The root of your name: do you know who gave you the name and why? Were you named after a member of the family?

Does your name have a meaning, such as a flower, tree, animal, bird or some other significance, perhaps from the Bible, or some other favourite story or myth? For example, some favourite Bible names in Hebrew include Zipporah meaning 'Bird'; Zafrirah, 'the call of morning'; Moshe, 'drawn out of water'; Eliezer, 'God is my help'; Shlomi and Solomon come from the word for peace, 'Shalom'. Leah's stepmother was called Beate from Beatrix meaning 'radiant'. Leah was named after one of the mothers of the tribes. Her son, Alon (the Hebrew word for 'oak tree'), was given his name by his father, who, on seeing him without hair at birth, wished him to grow strong and centred like a tree. One of Nira's children is called Tali, which is the morning dew. Do you know many people who carry your name? Do you like it, or not?

All this experience reflects childhood memories, the relationships in the family: it arouses conflicts or highlights important issues. Quite often people want to change their names following this experience. Tensions between the parents surface from the unconscious. Some parents never call their children by their name.

SYMBOL FOR YOUR NAME — Reflect on paper: paint your name, find a *symbol* for it, for your self. Also contemplate how you named your children; if you do not yet have any, do you have any ideas of what you might like to call them?

Names of the Tribes in Israel

The stories in the Bible are written with many small hints. Each word carries several meanings, and as we read between the lines our understanding grows.

The names of Jacob's sons reveal the dynamics of the family. Everyone carries in their name the feeling of their mothers, Leah or Rachel, who also named the children of their maids, Bilhah and Zilpa.

We read the story of Jacob's children aloud in the group to set the story in our minds anew.

> And the Lord saw that Leah was hated, and he opened her womb; but Rachel was barren.
>
> And Leah conceived, and bore a son, and she called his name Reuben; for she said: 'Because the Lord hath looked upon my affliction; for now my husband will love me.'
>
> And she conceived again, and bore a son; and said: 'Because the Lord has heard that I am hated, he has given me this son also.' And she called his name Simeon. (*Gen.* 29:32–33)

The Bible describes the birth of Leah's sons Levi and Judah, and then goes on to describe Rachel's anguish that she is not bearing children:

> Rachel envied her sister; and she said unto Jacob: 'Give me sons, or else I die.'
>
> And Jacob's anger was kindled against Rachel; and he said: 'Am I in God's stead who hath withheld from thee the fruit of the womb?' And she said: 'Behold my maid Bilhah, go in unto her; and she shall bear upon my knees, that I may also be built up through her.' (*Gen.* 30:1–3)

Through her maid, Bilhah, there were two sons: Dan and Naphtali. Leah now sent her maid, Zilpah, to Jacob and two more sons are born, Gad and Asher. The story continues, as the sisters devise competing strategies to enhance their line. Leah gives birth to Issachar and Zebulun. Finally Rachel is herself able to conceive, and gives birth to two sons:

> And God remembered Rachel, and God harkened to her, and opened her womb. And she conceived, and bore a son; and she said: 'God hath taken away my reproach.' And she called his name Joseph, saying: 'The Lord shall add to me another son.'
>
> And she conceived again.
>
> And they journeyed from Bethel; and there was yet some distance to come to Ephrat, when Rachel travailed, and she had hard labour. And it came to pass, as her soul was departing, for she died, that she called his name Ben-oni, but his father called him Benjamin.
>
> And Rachel died, and was buried on the way to Ephrat, which is Bethlehem. And Jacob set a pillar upon her grave.

In order to elucidate the story further we give you the literal Hebrew translation of each of the sons' names (*Gen.* 29: 31–35; *Gen.* 30: 1–24; Gen. 35:18). In total twelve, the descendants of this family, created the whole Jewish nation.

Reuben	see, a son
Simeon	God hear me, hearing
Levi	join me, union
Judah	praise
Dan	he has judged me, he has given judgement
Naphtali	trickery
Gad	good fortune
Asher	happy
Issachar	successful
Zebulun	present
Joseph	may he add (another son)
Ben-Oni	son of my ill luck (lamentation): as named by Rachel
Ben-Yamin	son of the right hand (good luck): as renamed by Jacob.

The names 'Leah' and 'Rachel' are symbolic of a pair of domestic animals: sheep and cow. And their 'husband' is the shepherd. 'Leah' comes from 'latat' – the wild cow. In Akkadian (Northern Babylonian) 'liat' means 'the assertive one'. And 'rachel' means 'sheep' (Mazar 1962, 1977).

Creative Process

We bring our attention from considering the family interrelationships among Jacob, his wives and their children back to our contemporary situations. Our aim is to express feelings based on the archetypal family relationships in a safe and trusting environment.

Find several different positions to experience your body as 'open' and breathe into these shapes. Try the opposite. Find physical positions you associated with being closed. As a person do you usually feel more open and expanded, or more contracted and closed?

Leah

After listening to the story and experiencing your body, close your eyes. Let images and qualities emerge that describe the archetypal figure of Leah in relation to her family. Put these feelings into words. Write them down for yourself and share them with the group.

The following qualities may be associated with Leah:

stability	compromise
hope	perseverance
determination	patience
availability	fidelity
consistency	flexibility
demanding	

Movement Identification

Divide into couples: each partner chooses three or four qualities to work with. Through movement, begin to identify with one quality at a time. After each partner has a turn, expressing several qualities in sequence, the partners share their experiences. They join another couple to discuss Leah's qualities.

Rachel

We repeat the same process with Rachel:

beauty	jealousy
playfulness	impatience
confidence	pleasure
sadness	expectation
longing	cynicism
demanding	anxiety
courage	

Movement Identification

In the next exercise, we change partners, and one identifies as Rachel, the other as Leah, building the character first in movement.

EXPRESSIVE ARTS After this exchange is complete, record your feelings and experiences with words or pictures.

Integrating aspects of Leah and Rachel

OPPOSING QUALITIES IN MOVEMENT Projecting these qualities onto Biblical figures gives us the opportunity to look at these qualities more objectively. A woman needs the qualities of both Rachel and Leah to be whole. The next step is to integrate the archetypal qualities of Leah and Rachel into our own lives.

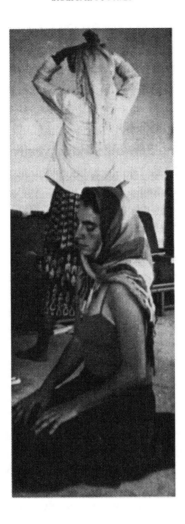

(Nira Ne'eman)

Working individually choose different feelings, light and dark, that seem to be the essence of a 'balanced person'. What do you believe, what do you value, how do you evaluate yourself?

EXPRESSIVE ARTS

Experience these qualities in your body and record your impressions. Working in a pain or a triad, present your individual experience to your partner or partners. Receive their feedback.

REFLECT

Reflect on the way you experience yourself in a relationship. What are the most important components? What is your concept of wholeness? How do you allow the threads of acceptance, rivalry, jealousy, and compromise to interrelate?

EXPRESSIVE
ART IN
GROUPS
As a group or in several groups, find a collective expression of a balanced, integrated family. How are the boundaries of individual and collective space woven together? To close the process, focus, and discuss the experience in movement, words, poetry, drawing, painting, and sculpture.

Feedback from Leah and Rachel

RESPONSES Talking about drawings and movement

Ruth: 'free, stable, waterfall black, pool contains both,
 reflects and contains, warm and expansive, outgoing...'

Lynn: 'Stable, contained is beautiful, the mother, most
 content, breastfeeding three years ago my image in relationship
 to my sister changed, I was mother to my sister, not to myself –
 choice inflexible, bad, my mother, strands are not black, life and
 death came from each other, that's the root of it – I want to come
 to terms inside me, that's why the eyes are closed – Bob needs
 me to be his mother, ironically I am the child, both at the same
 time – I must not be the abused child again, my compromise is,
 just being there, just being allowed to be – rainbow. I am trying
 to see whether I ever harmed anyone – balance the child that is
 not hurt, if I am the mother I lose myself, it's so simple, the impli-
 cation of it...'

Bob: 'Strong stable equals 'anvil', impossible to damage.
 This anvil got its heart on its head – the hammer is out of propor-
 tion and extremely large – it is suspended in a glass vacuum
 case...like in an Austrian pastryshop, a constant nothing – if you
 take the protective fragile glass away it is a potential disaster of
 self destruction. It is both immensely strong and vulnerable, on a
 trigger. It can exist in perpetuity, suspension... The second pic-
 ture is an opened empty box, something was inside and it is re-
 leased, an open window leading into the distance, a line of black
 crows – extending into the far distance, harbingers of doom,
 maybe the crows escaped – I know I had to have an open win-
 dow – the creatures can get off and get you... Third picture, a
 very stable castle, secure, someone is there, the drawbridge is
 down, front door is open, it's safe, a large flag is flapping.'

The Scapegoat – Aspects of the Human Shadow

The long bag that we drag behind us,
exposing the repressed world that is
meowing, snarling, rattling, clanging,
wheezing and rotting within us.

Robert Bly

Aaron…'shall take from the congregation of the people of Israel two male goats for a sin offering, and one ram for a burnt offering.' And then 'Aaron shall cast lots upon the two goats, one lot for the Lord and the other for Aza'zel.[1] And Aaron shall present the goat on which the lot fell for the LORD, and offer it as a sin offering: but the goat on which the lot fell for Aza'zel shall be presented alive before the the LORD to make atonement over it, that it may be sent away into the wilderness to Aza'zel' (Leviticus 16:5, 8–10).

The Scapegoat rules the realm of the shadow[2], its borderline always a cutoff from personal or universal love; its governor is projection, and its subjects identified as blame, rejection, repression, guilt and helplessness. Jung calls the Scapegoat 'a collective shadow figure, an epitome of all the inferior traits of character in individuals.' Throughout history there have been many scapegoats: the biblical ones, the witches, the healers; millions have been killed.[3] The feminine principle has been repressed and needs to be redeemed. The scapegoat grazes and gnaws at the root of our consciousness; it relates to the individual, the social, and the universal condition.

This human tendency to pervert the shadow principle is borne out by the horrors of the twentieth century. A prime example can be found in the graphic symbol of the swastika[4] – the oldest symbol known to humanity, first found in paleolithic caves – which had always represented the creative whirling energy of the Godhead. The Nazis, through abuse and manipulation, managed to transform this most ancient symbol into its antithesis, its destructive opposite.

Robert Bly (1988) suggests that we all carry an invisible bag, into which we put the parts of ourselves that our parents don't like, so as to retain their love. What then do we need to do to atone for our (our parent's) sins and guilt? To begin with we need to recognise our 'guilt', in other words to separate and to discriminate between what is ours and what has been or is projected onto us: 'Emotional abuse is so insidious, one cannot see it,' said one client. And we learn from childhood to protect ourselves by forgetting, or building barriers. This same client found a direct and ironic

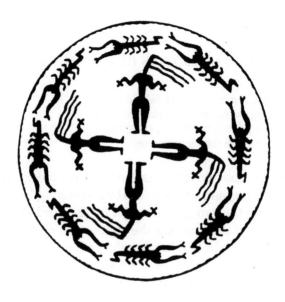

The swastika (An Illustrated Encyclopaedia of Traditional Symbols)

meaning in Bly's symbol: 'My family dumped their rubbish onto me: I was their emotional lavatory – they also kept giving me bags as presents, probably to make sure I would carry their garbage away.'

The powers of the Scapegoat need to be confronted more urgently in this contemporary age than at any other time past; until the majority of individuals learn to integrate the shadow, all human existence is threatened.

As inheritors of many generations of individual and social histories, we still carry scapegoats in our bodies. In our work we seek to confront the energies of the shadow, and so expose innate tendencies. By so doing, we bring the dark into the light to encourage and foster the inner healing potential, which is our cornerstone.

The basis of working on the Scapegoat is the will not to remain a scapegoat and not to make a scapegoat out of another person. In other words, we seek to discover the underlying patterns of behaviour that we identified with this complex, which are contained in the body's posture.

Movement Experience

LOCATE
FEELING

Feel your own *gut reaction* to the scapegoat emotions, with tensions as they are, *unreleased*: anger, frustration, dejection, guilt, helplessness, denial; and the willingness to blame others,

to hurt, or even to murder them... All these carry a burden of *pain*. Explore the qualities of pain:

How big is the pain? What kind of pain is it? How much pain do you receive? How does it feel? How much pain do you inflict?

Above all, where are the *sources* of that pain? Does it come from the family, or your sex, or from your race, or culture?

KNOWING THE SHADOW
This concentration on self, will help identify the location of the shadow within the body. By understanding how it feels, one can 'know it', 'know about it', and this consciousness is the start of losing the feelings of guilt for things: that you might have done, or were done to you, or were done to someone close to you, a member of family, or a close friend...or done to someone you identify with, of your race, colour, creed or profession.

LIE/SENSE
On your own, lie down on the floor. Work with the awareness of your back, the part you cannot see, which carries the *shadow*, in the 'bag' that Robert Bly talks about.

Listen to your breathing... Pause. Become aware of places of tension in your body... Pause. Increase the tension to maximum – what happens to the breathing?

Explore your emotions, and express what it is like to lie down. Is it comfortable, or do you have apprehensions? Explore the meaning of 'lying down' as a defensive pose, or of submission. What are the most significant memories which arise? When you have discovered the tensions in the body which create this rigidity, allow them to distort your body, to form your own 'ghost', the thing that haunts or taunts you...

CREATE THE DEMON
Let the ghost rise. Stand up, transfer the shape and feeling of tension into the vertical. By so doing, let the ghost inhabit you, so creating your own 'demon'. Move around and communicate with all the other 'demons' in the room. Do they repulse, or attract you? Do you want to join, or destroy them? Work with a partner: mirror each other's 'Demon' to understand the other person better.

RESPONSES
'I have to feel guilty... I have to bear all the drama of the mental hospital...'

'The fire in my belly, this is the demon...the child I could not keep, for fear of losing my security with a man I thought I loved, and who soon after dumped me...'

'The ghost – the burden, the scapegoat burden – I realised I carried my mother's shadow, and my ex-husband's all my life...this time I went into a cave, a series of caves, there I found the monster...'

THE HEALER

MOVE YOUR HEALER

After pausing to relax, shake loose the experience of the demon. Become aware of your softness and flexibility... Let go of any residue of tension; make yourself as flowing as possible – breathe freely and move as though your body is weightless. Create the feeling of your own Healer, moving with the greatest ease possible...explore your hands, your limbs, and your breathing.

MOVEMENT WITH HANDS

SELF-PROTECT

Give expression to the sense of protecting yourself, of containing your energy, throwing off an intruder – the practice of T'ai Chi Ch'uan or Chi Kung movements greatly increases the sense of flow of energy and confidence in the ability 'to be'. In the 'Monkey Section'* you walk backwards while attracting to you with your hands what you need, and rejecting that which is harmful, thus balancing yourself.

ONE WOMAN'S RESPONSE

'The Healer gave me a feeling of security, I think that's it, there is a base to be able to heal. I kept going back to different parts of my life. When I was 14, I invited my mother in for tea to talk about things I liked, she liked, instead of the total withdrawal, the draining anguish of hers...'

EXPRESSIVE ARTS

Having explored both polarities, synthesise them as a bridge between the two extremes of your personality. Transfer these experiences to visual arts, sounds, or writing.

RESPONSES

'Women's period, the menstruation is the bridge, the constant renewal – what is the psyche of women who have not been entitled to their own body? All over the world...it's terrible to think about, so much repression... How was religion formed? Christians never had women priests. They pushed the feminine so far away. Who wrote about the Garden of Eden? Was it a man? It must have been, no woman could blame herself like that, condemn her whole sex, carry all the burden...the bag full of rotten apples...girls don't have rights.'

* from T'ai Chi Ch'uan: Yang Style

'This bridge, I have been avoiding the confrontation, of my-self...projecting my needs on my relationships, knowing that it couldn't give me that...that desert, that wilderness which has to be traversed, leaving a heavy pain on my chest. I never felt it like this before...it is like being ill, in your lungs. I went back to my skin, and its very difficult to be in my body...this fear to confront...'

DEMONIC AND HEALING These exercises make us aware of the potential for change between the demonic and healing. Having experienced both sides, we become aware that we have a choice in whether to lift or carry the burden of the scapegoat.

MOVEMENT WITH SHADOW: ANOTHER VARIATION

MOVE WITH EXTERNAL LIGHT SOURCE When available, move in strong sunlight which creates sharp shadows, or use an electric light, such as a spot reflector or torch. Play with your shadow, relate to one or more people... Do you like to co-operate? Or do you feel people intruding on your boundaries when they step on your shadow? Do you fight back, or withdraw?

TRUSTING MOVEMENT

Move with eyes closed or in a dark room.

How do you feel? Are you able to relate to other people...and to touch them?

Are they safe? Or, are they dangerous?

Has the previous movement and the exploration of the 'shadow' changed your ability to relate and to trust?

INTERFERING WITH EACH OTHER'S PATH

CROSS TRACKS Start by walking in defined lines, think of tracks like grooves crossing each other's path, one eliminating the other person's trace. Repeat several times, changing speeds and accents of rhythm. Individually, create movement patterns that feel ne-gative/closed/withdrawn. Experience both your action in relation to the other, and your boundary being invaded...

This cutting of space into another's space, the constant interference, is like a river flow, interrupted by a dam or blocked by sewage. Repeat until you are moved to anger and frustration, and want 'to do something about it'.

RESPONSES 'The non-feeling begins to break down, become integrated with desires...seeking revenge, becoming a very destructive

force.' 'As Whitmont stated in *Return to the Goddess*: aggression cannot be gotten rid of, it is necessary for survival.'

'The lavatory is now so full, because of their neglect, they will soon not be able to avoid the noxious smell...'

EXPLORE EMOTION

When this is done, create a new phrase, based on positive, open-and-relatedness. Explore the emotions of

> sharing
> compassion
> love

These are the transpersonal waters, which flow into individual patterns.

RESPONSES

'The red sore...the red is my transforming mother...in my solar plexus...near the heart chakra, the sacral and the solar plexus chakra.'

'I want to be massaged, there is nothing more I feel now than to be massaged...'

'The guilt that my group planted on me...after I left, they had no scapegoat any more, and the whole group fell apart.'

IMPROVISATION

DEMON AND HEALER AS PARTNERS

Partners now share in movement the feelings of Demon and Healer, the rescuer and victim. Move as victim and supporter...give weight, take weight, give over to your burden...share and support each other...till you are able to free yourself, so becoming self-supporting, self contained and independent.

TRANSFORM

Working as individuals, with a partner's support and alone again, blends the polarities and combines the feeling of demon and healer into a new felt body sense. This transformation will help to integrate 'persona and shadow' into a positive self-image.

RESPONSES

'The abandoned child...being allowed to be in the group healed something in me, it was wonderful to see all those monsters around me becoming caring carers, and really being with me in the way I needed to be... You asked what I need, and I said 'I will take it to a private session'... I usually never know what to ask for, but my body knows what to ask for, only I can't actually verbalise it.'

'It was lovely to watch your total abandon, I actually wanted to hug you, but was embarrassed...'

Body Maps

IN COUPLES One person lies on the floor, the other draws the contours of the body – the person lying on the floor chooses the colours with which to draw his outlines.

FOCUS ON BEING SCAPEGOAT Change roles. Now everyone has a frame of their body. Lie down on your paper, close your eyes and listen to your breathing – focus on the feeling of being a scapegoat. Be aware of what you have taken on from your family, at work, in the community, in the past and in the present.

There are many levels of perception: the 'black sheep' of the family...the responsible 'sensible child', who carries the projections of the parents, the 'sins', guilt and frustrations... Or the person who carries all the ills of society on their shoulders and ends up being ill.

Place the scapegoat in the body. Where does your body hold your burden, your frustrations, your own scapegoat?

- Do you feel it on your shoulders?
- Do you sense it in your back?
- Is your head heavy?
- Do your legs, thighs, hips, ankles or feet ache?

Get a sense of shape and intensity of your body tensions and pains. Stay with this awareness for some time; open your eyes. When the group is ready, get up slowly and each look at the drawing of his or her own body.

TRANSFER FEELINGS ONTO BODY MAP Choose the colours that can express your sensations and mark the places you have identified in your visualisation. Find a way to transfer these qualities onto paper. You may want to draw, write, make a collage or all of these together.

Reflect on your creation; make any changes or additions necessary. This can be continued in a few consecutive sessions, which will deepen the meaning of the process.

TELL YOUR STORY In small or large groups everyone tells the story as a journey undertaken. The following personal stories have evolved in our practise.

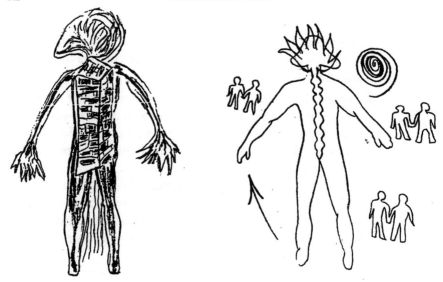

The Body Map: Two stages of energy flow and transformation (Personal story 3)
(Patrizia Diaz)

Participants' Transformations and Personal Stories

One client could dispose of a dress she wore as bridesmaid and felt obliged to keep as a family relic for fifteen years. Another one could let go of twenty large plastic bags full of unnecessary belongings that made her home into a rubbish tip, to clear the space for her writing.

PERSONAL STORY (1)

> I was digging with my hands which were like claws, trying to climb a huge wall...the wall of my creativity... I see a very mature woman there, a wise woman, very beautiful and relaxed. I want to reach the top to meet her, but I haven't yet found a way to scale the wall... It is a very difficult emotion to communicate, since no one can live for me what I am feeling... I am aware of the huge task of climbing, never mind where I am, my relationships with others can't be allowed to define my life... It was particularly difficult with the partners I had – asking for that passion from outside...there is not enough room for all that passion...

PERSONAL STORY (2)

> My scapegoat feeling of being pushed out of my community – I was getting prizes, there was a lot of jealousy around what I was doing... I came out of a circle – I had a surreptitious affair with a white man – I had become *untouchable* – I needed to move out. My parents should have been able to talk to me, but there was never anybody I could talk to. Was I a teenage rebel? I was just autistic, they couldn't get at me...it was such a mixture, complex to extremes, I was in need of help...

Like Joseph in *The Old Testament* I cut off from my community, but I knew something else, I saw my psychic inheritance...that part which is outside and impervious to the social, cultural, or historical process...the light from inside, to be the dreamer of dreams, not becoming servile to skin or creed, or national boundaries – the need to take what is spiritually yours and reject what is not...therein lies the creative spirit which demands and needs to find redemption in the self...that's the only way to change what is outside of oneself: the people and the environment...human nature and nature herself.

PERSONAL STORY (3)

Three Stage Journey:

1st Stage: *The Wall*
Get open is the message like the fire, rising open, open to options...only if I am open I can see the wall, see myself.

2nd Stage: *The Tower*
Rooted, the tower (the wall) has roots, has been built up since childhood – built up in my body – my body has been built up so. The map of my history is my body – the memory of the body. The golden string of my spine rises, moves, dances, sends the energy to the rest of my body.

3rd Stage: *The Fire*
Relating to the outside, the others exchanging energy, sharing fire one self, myself and others meeting in a spiral around the same fire... Passion and Love moves up the spine – making the body vibrant and agile – *star fishes in the air.*

Bricks of the three stages:

'Floating
 but sinking
 become a weight placed on my chest,

flying
 but can't move
 because a wall in my way.

Circulating
 but freely contained
 because a dam in my throat,

throwing out
 but stuck
 because a stone in my mouth.

Floating, Flying, Circulating, Throwing
 but not the wall.

Walls need to be loved
 transformation in my linking
Tower – get to know it,
 the voice near the sky
 sky
 singing
 space.'

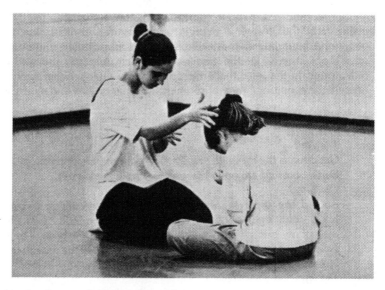

Judgement and surrender (Alicia Sclovich)

Deborah

> And Deborah, a prophetess, the wife of Lappidoth, she judged Israel at
> that time. And she dwelt under the palm tree of Deborah between Rama
> and Beth-El in mount Ephraim, and the children of Israel came up to her
> for judgement.
>
> *Judges* 4: 4–5

Deborah was a judge and prophetess who achieved a state of harmony in
the overall experience of life. With poise and confidence she developed
her inner powers for the good of the whole nation; her spirituality was
rooted and involved in daily life – she was not distanced from her people.

We look at Deborah to cultivate the qualities of wisdom, justice,
leadership, and poetry. When the tribes of Israel were suppressed by the
enemy, it was her foresight which freed them. Deborah called herself 'a
mother in Israel' (*Judges* 5:7).

The palm tree[1] under which Deborah sits has a vertical, extending
trunk; this is a sign of strength symbolising the skilled will needed as a
quality for leadership. The strong trunk grows long, rounded branches
that embrace whoever sits underneath them, providing a feeling of
womb-like security. Sitting between mountains indicates modesty in

contrast to the monumental strength of nature. In contrast to exaggerated confidence and hurried decisions, the combination of the vertical energy of the trunk and the caressing of the branches, balances the two qualities – the female and the male.

Inner Visualisation: Under the Palm Tree

CENTRING Sit on the floor, with closed eyes. Imagine that you are sitting between two poles. Notice your sitting bones at the base of your pelvis... Shift your weight forwards and backwards, very slowly from side to side in circles and spirals... Settle in the place that feels most centred. Become aware of your breathing.

IMAGINE Imagine sitting under a tall palm tree between two mountains. Notice the length of your back, the relationship between head, neck and shoulders...feel the strength and flow of the back. Find a word or phrase that expresses how you feel.

SENSE Now sense the energy that flows from the trunk of the tree... Feel the cooling shade that protects you and the people sharing your space. Think of the nurturing quality of the tree's succulent dates. This is your tree, the place from where you spread wisdom. Find a word or phrase to express how you feel.

Movement Experience: Balancing

Deborah's outstanding quality was a balance between inner and outer worlds; the gift of prophecy and the wisdom to judge. The ancient image of Justice holds a sword in her right hand and scales in her left. In this way she represents the active and passive poles of harmonization. With the sword she cuts away unnecessary matter, and with the scales she rebalances.

BREATHE Listen to your breathing. Breathe in, hold the breath, exhale, hold the outbreath, repeat serveral times...notice what happens in the interchange.

MOVE Stand with legs parallel...shift the weight from side to side, allow the arms to be passive, to be pulled by gravity: i.e., be perpendicular to the ground. Increase the size of the movement, until one leg lifts off the floor. Experiment and alternate between large slow movements and small quick ones. Find variations in the way you use your arms and legs: i.e., bend and stretch them at various angles.

BALANCE Experience ways of being off balance and returning to balance... Pause. Repeat the same ideas with shifting the weight

of the body forward and backward, (be careful not to overbalance backwards)...or diagonally sideways.*

USING LIMBS Bend one arm and one leg towards the centre of the body, then stretch outwards in different directions: closing in and opening out; being in balance and off balance.

Explore the difference between using the same arm and leg and the opposite ones. Repeat many times at varying speeds, rhythm and intensity. What is your experience of losing balance and finding it? What happens in the process?

PARTNERS Balance each other. Experiment with all the previous movements. Mirror each other, then allow your partner to help you keep your balance, and in return support your partner. Nurture each other: make yourself as small as possible, your partner surrounds you, protects you and helps you to open up... Repeat several times, then change roles. One partner takes the role of the extending trunk, the other of holding the branches, contrasting feelings of the straight and curved shapes.

GROUP WORK One person at a time leads the group with movements that create imbalances and balances: representing inner vision and outer reality... Rest.

JUSTICE

VISUALISE Close the eyes. Imagine a sword in one hand and scales in the other. The sword is there to clear space, remove unnecessary clutter, getting rid of what is superfluous to the awareness of clarity and judgement. If you cut away too much, you may mutilate or destroy yourself. To achieve justice you need to cleanse and heal, letting go of unnecessary factors to find the right vision, leading to a correct action. Find an image for your balance. Find an image for your own ability to judge.

We read further from the Bible:

> She sent and summoned Barak the son of Abinoam from Kedesh Naphtali and said to him: 'The Lord, the God of Israel commands you. Go, gather your men at Mount Tabor, taking ten thousand from the tribe of Naphtali and the tribe of Zebulun, and I will draw out Sisera the General of Jabin's army, to meet you by the river Kishon with his chariots and his troops; and I will give him into your hand' *(Judges* 4: 6–7)

* Eshol-Wachman (1958) Movement notation: directions (2) & (6); or (0)& (4); (1) & (5); or (7)& (3).

Barak said to her: 'If you will go with me, I will go, but
if you do not go with me, I will not go.' (*Judges* 4:8)
And she replied: 'I will surely go with you,
nevertheless, the road on which you are going will not
lead to your glory, for the Lord will sell Sisera into the
hand of a woman.' (*Judges* 4:9)
Then Deborah arose and went with Barak to Kedesh.
And Barak summoned Zebulun and Napthali to
Kedesh; and ten thousand went up at his heels; and
Deborah went up with him.
And Deborah said to Barak: 'Up! For this is the day in
which the Lord has given Sisera into your hand. Does
not the Lord go out before you?'
So Barak went down from Mount Tabor with ten
thousand men following him.' (*Judges* 4:14)

Movement Experience: Strength and Weakness

After we read about Deborah's conversation with Barak, we are ready to
work with our issues of strength and weakness, inner and outer power.
We begin simply by looking at the way we walk, sit and stand. The way
we feel about ourselves and the world is revealed in our – the body's –
basic movements.

OPENING

Walk and stop...repeat several times. Change the speed of progression.
Pay attention to what you notice. Find out where the tensions are located
in your body. Listen to your breathing. Is it interrupted by stopping your
walk? Gradually stop for longer periods of time.

Find a space that feels right for you. Stand with eyes closed. Shift the
weight of your body forward and backward, from side to side, in circles…
Return each time to your centre. Become aware of your breathing.

SIT AND
STAND
Open your eyes...start to put the palms of your hands on the
floor, touching with different parts of the hand… Beat the floor
in different rhythms, with varying degrees of energy; change
the rhythm from fast to slow, strong to soft, staccato, legato.
Be aware of how much strength you get from the floor. Try to
put different parts of your foot onto the floor, change the
dynamics and change rhythm. Use the floor as a large drum.
Sense your own strength by stamping on the ground, keeping
the knees flexible.

STANDING

STRENGTH
Stand, bend your legs, focus on your pelvis, your centre, the
'Tan T'ien'. Shift the pelvis in different directions. Move slow-

ly. Taste your strength and the quality of the movement. Sense your power in the centre of the body. Shift the torso, shoulders, and pelvis...in the same direction and opposite, in turn... Sense the flow of your energy. Lift one leg at a time, bend the knee, flex the foot, and kick in different directions and on different levels. Try to feel your strength in different parts of the body... How do you perceive strength? Where in your body do you feel the most power?

CIRCLE OF STRENGTH AND WEAKNESS

EXPRESS FEELINGS
Form a circle. Everyone in the group says 'I am strong', with a suitable movement, taking a shape and holding it. Allow sufficient time and space between the participants so everyone can find their own expression. Alternate between moving and staying with one shape. After everyone has experienced their strength, begin to explore feelings of weakness.

WEAKNESS
Everyone takes a turn to go around the circle, saying 'I am weak', accompanied by a suitable movement.

RETURN TO STRENGTH
After feelings of weakness have been acknowledged and released, return to strength. On this round repeat the shapes of 'I am strong' without the words, using movement by itself.

STRENGTH AND WEAKNESS IN RELATIONSHIP

Express your feelings of strength and weakness in your body through movement and drama.

Working in pairs express two opposite sensations. When one is expressing strength, the other embodies feelings of weakness. Relate these dynamics to current life situations. Can you find weakness in your strength, strength in your weakness?

DELEGATION OF RESPONSIBILITY

Deborah had the strength and the ability to delegate responsibility. She did not feel any need to be at the head of an army. She found a man to be military commander; her own task was to inspire, to judge, and foresee coming events which enabled her to gather many tribes to face and fight off a great danger to her people, threatening their survival. She rightfully gained for herself a name in history, because she had the vision of a united nation: a group soul.

VISUALISE
Close the eyes.

- Find an image for your sense of survival with foresight.

- Find an image for your own masculine and feminine qualities and their boundaries: your survival is conditioned by your ability to see clearly into these dual aspects of yourself.
- Find an image for your ability to delegate responsibility in your family, at work, socially.
- Find an image for your ability to gather a group, unite a team and protect a project you believe in.

EXPRESSIVE ARTS Transfer the feelings into painting and words.

KNOWLEDGE AND WISDOM LEADING TO SELF-DISCOVERY

Deborah was appreciated for her knowledge and respected for her wisdom. People came to see her from far away. Her power was intuitive. Deborah was courageous, decisive and honest.She is the image of an ideal woman, rooted in life, fully in touch with her intuitive and imaginary faculties: unafraid to express herself.

SYMBOLIC IMAGES FOR SELF-DISCOVERY

To facilitate the process of identifying with Deborah, we suggest a number of questions designed to elicit symbolic images. Choose a few, whichever you wish. Each one of the emerging metaphors may be expressed in movement, drawing, writing, or discussion.

Find your own space, close your eyes, connect to your strength.

- What part of you is strong?
- Do you like your strength?
- How do you make decisions?
- How do you plan an action?
- Do you like to take responsibility?
- Whom would you like to protect?
- How do you protect yourself?
- How afraid are you of danger?
- What part of you needs to win?
- Do you know your own value?

See how much you can identify with Deborah:

- Her vision, her inspiration, and spirituality
- Her compassion and sensitivity
- Her courage, power, weakness, and joy
- Her ability to care and take responsibility
- Her feminine and masculine qualities.

Can you see a way to bring this experience into your daily life?

Deborah is a symbol of the leader and the judge who brings peace to a conflict or quarrel. Imagine someone you admire as a wise person; or see yourself acting wisely. Remember a time when you or someone you admired perceived the right strategy to negotiate a difficult situation at home or school or work. Become a leader, or remember your having been a leader in a specific situation. Or, think of someone else you admired for a specific quality of leadership.

The figure/symbol of Deborah is near to the description of the ideal woman. What is your vision of your own inner ideal woman?

Draw the image, share the experience, and consider any problems you encountered.

Conclusion

'The Song of Deborah' tells of the social background of war, the actual battle and the celebrations after the battle.

> Then sang Deborah and Barak the son of Abinoam on that day:
> That the leaders took the lead in Israel,
> That the people offered themselves willingly,
> bless the Lord!
> Hear me you kings,
> Listen you barons;
> to the Lord I will sing
> and will chant to the God of Israel.

Judges 5: 1–3

> In the days of Shamgar, son of Anath,
> in the days of Yael, caravans ceased
> and travellers kept to the byways.
> The peasantry ceased in Israel,
> they ceased until you arose Deborah,
> arose as a mother in Israel.

Judges 5: 6–7

> Awake, awake, Deborah!
> Awake, awake, to sing your song!
> Arise Barak, lead away your captives,
> O son of Abinoam.
> Then down marched the remaining nobles;
> the people of the Lord
> marched down for him against the mighty.

Judges 5: 12–13

To conclude our work with Deborah, we suggest creating a group impro-
visation, praising a wise leader expressing leadership, uniting different
groups, delegating responsibility.

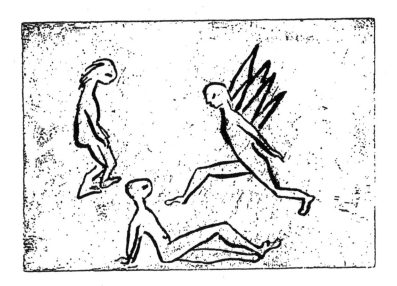

You are free to walk, run and jump (Leah Bartal)

Dry Bones – Ezekiel's Dream

Ezekiel was a prophet of doom during the Babylonian Exile.

He was called by God to express his wrath and foretell the destruction
of the temple, and the scattering of the rebellious nation. After the fall of
Jerusalem he sees a vision of the rebuilt kingdom and the renewed
nationhood of Israel.

We show here the possibility of 'Play' with the theme of the Dry Bones
being brought back to life. Ezekiel's dream illustrates the creative connec-
tion between individual dream and collective experience. It also considers
the relationship between individuals and the groups in which they live
and function.

Our objective is to experience the confidence that comes from stripping
away everything but the essential structure of the personality, to find the
centre and build satisfactory human relationships. It is also a matrix for
renewal and change.

A Personal Vision
A sudden vision, a cripple comes
two wooden stumps hobbling past,
where are the crutches, how can I walk?
I need support – a helping hand.
Just then appears the 'Wise Old Man'
'You have two legs now, on your way!'
The skeleton came out of hiding,
'You're free to walk, run, and jump, Hurray.
My feet are made of bones, moving bones
Dry bones – my dream, Ezekiel's dream
My choreography with young boys and girls
Black costumes, painted with white bones, spread out on the floor.'

GOD'S ACTION

'...and *he* set me down in the midst of the valley, it was full of bones.
And...behold, there were many upon the valley and they were very
dry...and behold, a rattling and the bones came together, bone to its
bone.' (*Ezekiel 37:1–4*)

Movement Experience

INSTRUCTION TO THE GROUP

SENSING THE BODY — Spread out on the floor; lie on your back, side or front. In staccato rhythm move your limbs, hands, arms, feet, and legs as dry bone. Feel your limbs as bone only, move them...how does it feel? How heavy or light? What is the quality of the movement? What is your preferred rhythm? Get the sense of the dryness, and deadness of bones.

GOD'S INSTRUCTIONS

'He said to me, prophesy to these bones and say to them, I will cause
breath to enter you and you shall live – and I will lay sinews upon you,
and will cause flesh to come upon you.' (*Ezekiel 37:5–6*)

SENSORY PERCEPTION — Imagine sinews and muscles to cover the bones...how would that change your movements? Would it change the rhythm? Would it change the quality? How does it affect your sense of weight?

SKIN COVERING

'...and cover you with skin.' (*Ezekiel 37:6*)
Imagine the skin, get the sense of skin covering your bones, limb by limb. Imagine your whole outer shape like a glove, slide it onto your body...surround the sinews, muscles, and bones. How does it feel?

LIFE GIVING BREATH

'...and the breath came into them and they lived.'
(*Ezekiel 37:10*)

EXPERIENCE BREATHING
Imagine breath entering your skeleton, and moving you... Allow time for this sensation.

Imagine the breath entering each leg separately on an even in and out breath. Let the breath come into each of the arms separately on an even in and out breath... Let breath enter the spine from the base, up and over the head, down under the chin, return to the spine and down and out again... Allow the breath to envelop the torso like a blanket, moving in and out... Let the breath enter your joints, as air is blown into a balloon. What is the sensation? Let the air move your whole body...while still on the floor: slide, turn, roll, as you like.

THE RISING OF THE BONES
'... Come from the four winds, o breath and breathe upon these slain, that they may live.' (*Ezekiel* 37:9)

'...and they stood upon their feet an exceeding host.' (*Ezekiel* 37:10)

Rise off the floor slowly...really get the sense that your body is being breathed.

OPENING OF THE GRAVE: RESURRECTION
'... And I will open your graves and raise you from your graves and I will bring you home into the land of Israel.' (*Ezekiel* 37:12)

GROUP INTERACTION
Start moving in space, one after the other. Build an interaction as if each person breathes life into the *action*... The group then follows one leader at a time.

IMPROVISATION

The idea can be developed into a longer group improvisation on the theme of the gathering of the tribes or any other group of people. A larger group can be subdivided and each follows one leader, which is a good way to observe movement and try to echo another person, as well as being responsible for a group of people.

RITUAL CONCLUSION

From T'ai Chi, the section of going into the four corners of the earth may be taught here as a ritual conclusion. This ritual symbolizes going out into the world but returning to the self between each direction. It is necessary to be connected to your centre if you want to go outside and still retain your wholeness.

INDIVIDUAL AND GROUP
The theme of alienation and communication, the individual and the group, is another way to follow up. Explore the relationship of various groups, the sense of separation, going in different directions, or co-operating with each other, seeking a common role.

Personal Story

IMAGERY: THREE PHASES OF DEATH AND REBIRTH EXPLAINING HER DRAWINGS.

1st Phase: My hand, I was struggling in the womb to stay alive –
 the strongest feeling was before I was born, stretching out physi-
 cally...

2nd Phase: My family died, the system died, the mouth was screaming each
 time.

3rd Phase: the final death occured when I was 35, when I met Roy, emotionally,
 physically, sexually, death and life... Leo's sex was his pleasure, his
 inability to express himself, he couldn't love me the way I needed to
 be loved...he was physically selfish... Roy was teaching me how to
 make love, death and life at the same time – death of the ego – the
 feeling that something was dying wrapped up death in life... Hands
 are crucial to a relationship, I can create and I can destroy...all three
 phases are one creation, reaching out...
 This mess isn't my life, but it's touching me... Bones are
 basics, are all in bits, we're all broken up in pieces,
 deformed. I fell this flat feeling, my social fabric was all in bits and
 pieces...
 The arched skeleton's head is cracked but has not fallen
 apart – the female figure has come out of the bones – they're blown
 in that direction, like threads, all going in different directions –
 emerging from what is the female figure, looking happy, light, re-
 leased, free – it's simple, basic, just *being* a light in her legs – she is
 touching, bones are not part of her...she is very clear – like me get-
 ting rid of all the rubbish...
 It was very important for me to look at the skeleton. Now I
 am willing to let the threads flow, being aware of being awoken
 from the death I had experienced before.

From this session we developed our partnership over 18 months. It turned out that the most relevant of her experiences – the 'burning issue' – was the hurt in the womb. Once we homed in on this, it became the central core, or vehicle, of her expression from which links evolved to all other feelings.

Resources of the Mythological Body II
Greek Myths

Aphrodite – Queen of Heaven
The Tasks of Psyche

Embracing her, it is all the riches of life that the lover would possess.

Simone de Beauvoir

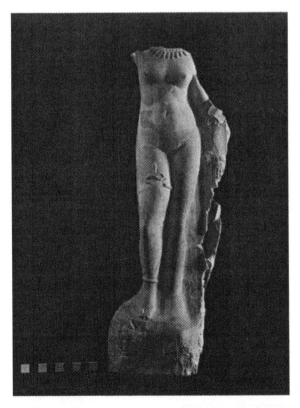

Statuette of Aphrodite, 1st Century. Roman period Mt. Carmel – Israel Museum

Aphrodite is the Greek equivalent of the Sumerian Innana, Assyrian Ishtar and the Canaanite Anath; in Rome she became Venus. In all of these cultures she is the Queen of Heaven, the Golden One, the primal archetype of love and creativity.

To re-own the Goddess(es) in ourselves is part of our way to wholeness, to Self: through descent, submission, death and rebirth. Openness to being acted upon is the essence of the experience of the human soul faced with the transpersonal. This requires not a passive, but an active willingness to receive and transform – to recognise the potential for growth by way of submitting to personal trial.

According to Hesiod's version of Aphrodite's birth, she was conceived of the sea off Cyprus, into which Cronos threw the genitals he had cut off his father, Uranus. She emerged from the foam that surrounded the sperm – the maternal lap of the sea giving birth to the most beautiful of the Greek goddesses. She was so graceful and alluring that the seasons rushed to meet her at Paphos in Cyprus, imploring her to stay forever. Every morning she kissed the earth with morning dew wherever she went. Each spring she returned with her doves to Cyprus for her sacred bath at

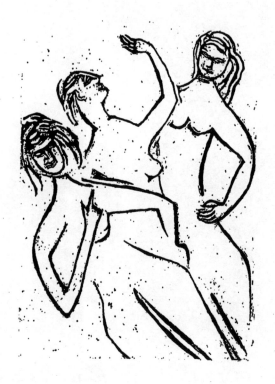

Three faces of the goddess (Leah Bartal)

Paphos – to become a 'virgin' again, and to bless female wombs.[1] Thus her work would never be complete, yet eternally regenerated. Her Graces – flowering, growth, beauty, joy and radiance – greeted her with myrtle and spread a carpet of rose petals for her feet. Aphrodite's other side, her negative shadow side, could be vindictive, destructive and jealous.

In Aphrodite, opposites are reunited to become a whole. She is an independent Goddess, affecting the enjoyment of love and beauty, sexuality and sensuality. She inspires women in their creative work as well as in their procreative function. She can be a tremendous force for change – her gift is to impregnate a woman with passion, be it for a man or her creative work. While under Aphrodite's influence, a woman may give birth to a child, paint and sculpt, choreograph a dance, or compose a poem or musical offering.

In patriarchal cultures she was degraded as a temptress or whore. In Biblical times she would have been stoned, in the Middle Ages she would have been burnt at the stake; in Islamic countries the penalty for passionate involvement outside male control is death.

According to Homer, she was the wife of Hephæistos, the lame god of craftsmen, the Roman Vulcan. They had no children of their own, but their marriage united beauty and craft, the two ingredients necessary to produce works of art.[2]

But Aphrodite is said to have had many affairs, the most important ones with Ares, god of war, and Hermes, messenger and transformer of the wishes of the gods and goddesses. Her union with Ares resulted in the birth of the beautiful Harmonia and two sons Phobos (fear) and Deimos (Terror) who went to war with their father. These offspring clearly indicate the potential of the marriage of those two most uncontrollable passions, love and aggression, which can only produce harmony when in equilibrium. To further highlight her loving gifts, the offspring of Aphrodite's relationship with Hermes was called Hermaphrodite, inheriting the sexual characteristics of both parents, male and female, and implying androgyny.

Aphrodite

To introduce the process we bring poetry and cuttings, from magazines, and other sources, and postcards, and so forth, all relating to Aphrodite. The following poem by Sappho was our first choice:

> God's stunning daughter deathless Aphrodite,
> A whittled perplexity your bright abstruse hair,
> Don't blunt my stubborn eye with breathlessness, lady,
> to tame my heart.

> But come down to me as you came before,
> For if ever I cried, and you heard and came,
> Come now, of all times, leaving
> Your father's golden house.

Many statues and paintings exist from pre-classical and classical times, to inspire the sensual aspect of the Aphrodite figure.

Movement Experience

TACTILE EXPERIENCE We look at the visual material, and subsequently touch our own bodies to discover the curves, the roundness – feel the shapes, the contact with the skin, the softness and malleability of the muscles and the flesh.

SOFTNESS/ FLOW Change the shape of your body accordingly, shift the weight to allow the pelvis to lead the movement... use the shoulders, arms, and chest, to feel particularly feminine... Move on the spot, and move around the room to relate to others around you in a feminine way... Allow the body to move fluently in space, on many levels: on the ground; off the ground but still close to it; more vertical and upright; then moving slowly, fast, changing from one to the other like a stream of water.

Movement Improvisation

POWER AND VULNERA-BILITY As a person imagine yourself to be in the limelight, attractive, beautiful, vibrant, confident – Aphrodite-like.

Be at your most seductive... whom would you like to seduce? What kind of person would you like to seduce? How do you present yourself?

Imagine a specific place and time, a dramatic situation in which you are powerful... Which part(s) of the body feel most activated?

Now imagine the opposite, being very vulnerable, dependent... Where is that feeling in your body?

REFLECT On what beauty, creativity and power mean to you.

BIRTH AND DISCOVERY OF ISLAND – METAPHOR

VISUALISE Imagine being like the foam on the waves... play with the idea of foam, light, bubbling, eventually solidifying... becoming a

* If this is done with an inexperienced group, we suggest to precede the work with exercises from the earlier sections 'Pelvis, Back, and Skeleton'.

person...discovering an island, and walking onto solid ground.

With closed eyes, imagine being in the water, like the foam of the sea...allow any image to come into the mind while identifying with this. Alight on an island, visualise the shore, the inland. What island do you imagine, and what does it mean to you?

Go deeper into the island...what image emerges there? Follow a path that ends in a sanctuary, a temple or a hut...

There you will find a person or a symbol, object of passion and beauty, representing Aphrodite. You can ask her or the symbol anything you wish at this moment.

Creative Process

Upon completion of the four stages to deepen and sharpen the process of the visualisation, open your eyes, move and draw the experience on paper. Write anything you wish to express in words.

CONTEXTUAL- Share in the group – relate your experience and possible
ISING/ relevance to your present life situation – the experience needs
SHARE to be grounded and balanced, so to find equilibrium in daily life: fantasy needs to be brought back into reality. It is this process of fantasising which helps us run our lives.

RESPONSES 'I asked the goddess to be my guide into the depth and to the mysterious, rather a lot to take on, and I paused for a long time before I asked.'

'This lady comes from the bottom of the sea only when the sound and the sea are together. The sound is just blowing, the waves start coming up, very gently; and she is very light and very beautiful, so beautiful that she is frightening. She is listening to the song of the wind caressing the sea – she discovers the land, it is solid, it stops her: it is the 'The Old Man of Hoy', the highest crag on the island. He is a challenge for everyone to climb him... and she says to him: 'You are the secret and the fulfiller, and I ask for *peace*'.'

Of the many examples we have chosen to highlight one, describing the Tadpole:

'I had a strong sense of being this quivering tadpole, ready for anything, with a lot of energy, it wriggled and swarmed in the dark blue sea... it changed into a woman with a long flowing dress... the shore had become my kingdom... I went to

Aphrodite's temple and asked for power... the power for survival.

It reminds me that as a child we went to the country and brought frog-spawn home and put it into the garden. We watched the stages of the tadpoles becoming creatures with tongues, limbs started to grow, and then suddenly there were tiny frogs.

I think the tadpole says something about Aphrodite, because she came out of the foam... and the frog-spawn bubbles, lies on top of the water, you can scoop it off quite easily. And like Aphrodite their skin needs constant moisturising – there is something about Aphrodite who bathed every morning and renewed her virginity. (This is what happened in the Paphos celebrations. It was used in Tennessee Williams' play *Camino Real*, where the gypsy woman's daughter becomes a virgin again with each New Moon.)

The frogs can live on land and in water... when they are tadpoles they are herbivorous, when they grow up they become carnivorous... it is the survival of the fittest.'

RITUAL CLOSING

We use a candle which we found in the shape of Aphrodite. We light it at the end of each session and we also usually serve wine or juice to celebrate the Goddess.

We read:

> For what the centre brings
> Must obviously be
> That which remains to the end
> And was there from eternity.

<div align="right">Goethe, <i>Westoestlicher Diwan</i></div>

The Tasks of Psyche

According to the legend (Neumann 1973), the mortal Psyche was admired as the second Aphrodite. She was in love with Eros, Aphrodite's son.[3] Aphrodite tried to destroy Psyche, but was willing to allow her to return to Eros, if she fulfilled a number of 'impossible tasks'.

The task of Psyche[4] is the process of differentiation on both mental and emotional planes so as to give rise to the spiritual – how to train the mind to develop the human faculty and how to deal with passion and beauty, and the dangers it can lead to as experienced in possessiveness and jealousy.

One needs to practise one's own process before being able to help others attain theirs – and through it we cultivate *discernment, patience, a sense of overview, and delving into the deep* in order to define one's boundaries and be able to *say no* when it is required of us. These are the four stages of Psyche which lead one to define One's Self.

We used the imagery to present a sample process for personal growth. Psyche's four stages of initiation, each lead her to the threshold of despair. Gradually she becomes stronger and attains maturity while protecting her caring nature. This is a way for men and women to become aware of the archetypal inner voice.

The First Task – Sifting

To sort out a jumble of seeds in one day. Psyche is brought into a room filled with a huge pile of corn, barley, millet, poppy seeds, chick peas, lentils and beans. At first she is overwhelmed but a host of ants appear from nowhere and help to separate the grains into individual mounds.

Movement Experience

IMPROVISATION – METAPHORIC ANTS

CHAOS AND ORDER
Start with 'jumbled' movements, vague and inarticulate. Move in space in a chaotic manner... bump into other people, be as disorganised as possible...

On a given command – in form of sound or words, symbolic of the entrance of the ants – change your movement to become very disciplined and organised, mapping out definite directions to walk in, taking definite types of steps.

Move the arms in a specific way...use separate finger movements...likewise separate toes. Make definite differences between stillness and movement...start and stop, listen to the breath... In the beginning anxious, agitated and restless; becoming calm, full, regular and smooth.

Reflect on the difference in quality – chaos versus order, insecurity versus confidence.

VISUALISATION

WITH CLOSED EYES
Imagine a real life situation with conflicting 'jumbled' feelings: in the family, in a relationship or with friends, at work or any other place or situation. Look at the emotion involved and find an image for this confusion.

Identify with the confusion and its image. Stay with it. Now trust the 'ants': your intuitive quality. What does it say to you? Does it change anything? Let the previous image go to the back

of your mind. Sift through your emotions... how does it feel
to sort things out? Try to focus on what it is you need most.

- What is the meaning of it?
- What are the values that are most important in your
 life?
- Can you see your life in a clearer picture?
- What is your 'ant' quality, your intuition?
- How developed is it, how much do you trust it to
 help you?

**EXPRESSIVE
ARTS** Transfer your feelings into paint or words.

REFLECTIONS 'Academic qualifications can really kill creativity, the tasks of
Psyche are the opposite, full of fertility and not sterility.'

'I refuse to give exams to dance students; I lose them because
of their parents' ambitions. A few years later some return of
their own accord, asking 'can I come back to dance?' We have
conformity and compulsion educated into us... we need to
learn to trust that the right thing will appear at the right time
if we are focused on our tasks.'

'Often in class a child that asks questions is considered a rebel.'

'I haven't lived my life...things happen and I think 'where do
they come from?' The beginning of this workshop has already
created a more conscious attitude within myself.'

'I found Helen 1 the nurse, and Helen 2 the creative person.
As Helen 1 I feel anger and frustration to do with work, since
my real values are creativity and novelty. On one hand I feel
a chest that is blocked and my motive is to make something
positive, so my image was a tulip bulb, like an onion with lots
and lots of layers, simple green leaves, one stem with a simple
red tulip, petals with the stamens in the middle; it is a symbol
of self confidence.'

'I wrote my first poem in English:

> The joy of being
> being a seed of myself
> the joy of being
> being as a play of my butt.
> Play as being without motives
> but a necessity of truth
> oh, how I wished that it always be true
> this play
> work as I play
> play as a joy
> that is a true being

but what does it mean completely
I don't know,
I play for the joy of the unknown.
Me giving birth to myself – how selfish I am,
I always feel like that, do I have the right to be?

The Second Task – Patience and Foresight – Metaphoric Reed

Aphrodite demands that Psyche bring her coils from the golden fleece of the terrifying rams of the sun. They are very aggressive creatures, who fight each other and hit out with their horns. The task is very dangerous, and Psyche is desperate – but a green reed comes to her rescue, advising her to wait until sunset, when the rams disappear so that she could approach the bushes. After sunset she could collect as much as she needed of the fleece left on bushes by the rams.

Having discovered the powers of sifting in the previous task, she now acquires the quality of patience, knowing how to approach a task in the right frame of mind. 'Wait, be patient. Time brings counsel.' And also the way to deal with an overpowering situation – hence patience and foresight are incorporated in the second task.

Movement Experience

CHANNEL-
LING
AGGRESSION
This is to experience how one can become trapped and destroyed by external aggressive elements, if one is not aware of the danger and how to avoid it.

Move around the room, mingling with each other... Pass between two others who are trying to prevent you from getting through... Start slowly, gradually increasing the speed. Pause... Rest by standing in one place, bend your legs until you can squat: make yourself comfortable and reflect on how you experienced both trying to prevent people from moving between you and a partner, and you trying to get through.

TIMING
Repeat the experience and move in a more conscious way; maybe you need to become more skilful to find the right time for passing, without rushing too much; maybe you need to focus more on your aim...

- Are you too tense? Or too determined to get through?
- Can you be in tune with yourself, catch just the right moment, to pass without endangering yourself?

Pause... Rest and reflect on the qualities of your movement: were they different from your first experience?

MOVE ON THE GROUND Move with the pelvis touching the floor... keep in tune with your breathing: roll around, soften the hip joints, allow the rest of the body to flow in coordination. Alternate between movement and stillness... Whenever you pause observe what is going on around you.

Divide the group in two. One half moves around the room as before, interacting, also encouraging aggression. The other half watches and observes. The two groups reflect on how you feel about the other's actions and interaction. Change groups.

VISUALISATION

WITH CLOSED EYES Listen to your breathing. Reflect on what waiting means for you.

- Are you likely to rush into any situation whatever the consequences?
- Do you hesitate unnecessarily? Do you have a sense of the right moment, at the right time?
- Was there a time when you felt like rushing into a situation, but something – your intuition – said: 'Wait... it does not feel right'?
- Do you regret things and blame yourself for being too hasty?
- Can you wait silently, patiently, like an animal lying in wait?
- Can you find inside yourself a state of 'dynamic relaxation': being relaxed but aware or alert at the same time?
- Have you got the sense of the right timing to avoid being trapped?
- Can you sit and wait while watching a dangerous situation, without getting involved in it?

EXPRESSIVE ARTS Transfer your feelings into paint or writing.

REFLECTIONS 'As a symbol of patience and waiting I thought of the heels, the roundness, the part that is in touch with the ground. Thinking of nursing, that's where you first develop the bedsores. I saw the sun setting, the terrific force – I saw the deer, when they are hurt and carry each other... my symbol of anger was in my lungs, how one swallows one's anger, holding the breath. The collecting of the fleece is like a floating figure in white and gold, a dainty fairy, and as a symbol of the whole I thought of the uterus being pear shaped, waiting for something to grow.'

'Some women give birth to babies, some to their own child. Before my period started I kept on reading children's books, now my period is coming to an end, I am not interested.'

'I felt the waiting within my pelvis, my symbol, we had a cat at home. It would always sit under the bird's nest, and it would invariably get them. They would either fall out of their nest, or it would climb the tree up to the nest and hook them out, he was so calm and poised and together about it. My anger and my needs were like a Chinese dragon in flight, turbulent with red eyes. The achievement of waiting was like the crown of a king, holding something responsible.'

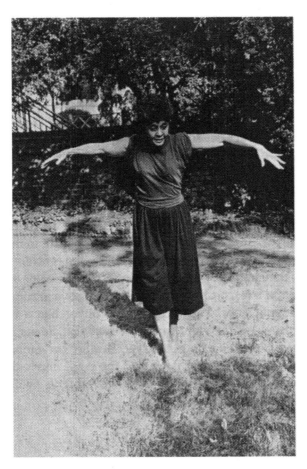

Hovering eagle (Eliyahu Ne'eman)

Third Task – Overview – Metaphoric Eagle

Psyche needs to fill a small crystal flask with water from a forbidding stream. This stream cascades from a high cliff to the lowest depth of the underworld, and up again to re-emerge from a spring.

Metaphorically this stream represents the circular flow of life into which Psyche has to dip, in order to fill the flask. As Psyche looks at the jagged edges of the cliffs and into the mouth of the dragons guarding it she is terrified. An eagle, as a spirit force, appears, to help her out of her predicament. The eagle symbolises the ability to look at the landscape from a far distance, an 'overview', to understand the structures below.

When one knows the structures, one can act efficiently. When sitting inside a landscape or a building, one has no concept of the pattern, the pitfalls and the possibilities. The qualities developed here are the ability to 'disidentify' from a difficult situation and thus find a way of gaining distance and objective perspective.

Movement Experience

HOVERING AND TARGETING

Move around in space, become aware of how that space becomes divided by the way you walk... Do you create dense patterns; can you see the spaces you create? Walk in a straight line...in curves...soft lines, sharp angles.

Notice the relationships created by sectioning the space. Create different rhythmic patterns. Look at the group from close quarters and from far away.

Improvising on the Tai-Chi phrase 'Going into the four corners of the Earth', with its emphasis on returning to the centre before each change of direction, walk to the corners of the room, and return from there into the centre.

Spread your imaginary wings, like the eagle who came to Psyche's rescue. Become this spirit...move around, dive from a height and be carried on air...hover like a bird of prey waiting for the right moment to attack...focus precisely on your target and do not waver. Explore the mobility of your shoulders, head and neck, and the eyes...move the head forward and backward on a horizontal line, while the arms remain spread eagle-like.

VISUALISATION

CLOSE THE
EYES

Your task is to find a container to fill with water from the spring.

- What does it look like? What is it made of? Where does it come from? Is it one you have seen before? Has it any personal meaning for you?
- See the stream of water in front of your eyes... how does it flow? Where does it enter the ground? Where does it come out? What is the colour of its water?
- What are the banks like? What is the shape of the cliffs surrounding the spring?
- What is the dragon like who guards the spring?

EXPRESSIVE
ARTS

Write, move and share the experience. What do you learn about yourself in relation to your present life? Are you aware of an on-going process throughout this series of changes in yourself? Has the focus on life issues been affected, or caused any changes?

REFLECTIONS 'I felt the river went down through the heart, dark and hurt and underground, it returned through my back and went down again. I felt the eagle was my whole body, the light here felt stability.'

'My waterstream was very strong, like a watergun in a car washing place, the eagle is a tiny speck and all the water is hidden in the jungle and that is the lungs. My container was a cauldron in gold yellow metal. The eagle scoops down, grabs it in his talons and soars once more to its heights. When I associate it with the psyche, I put the soaring like a speck of dust in the sky, floating with the air currents, some hot and some cold: it is for me the freedom to choose between the earth, the sky, and the ocean. The part of my body was the controlling hand reaching out, rich with bracelets and jewellery.'

'I feel the whole thing is about birth, mine is strongly connected with the river of life.'

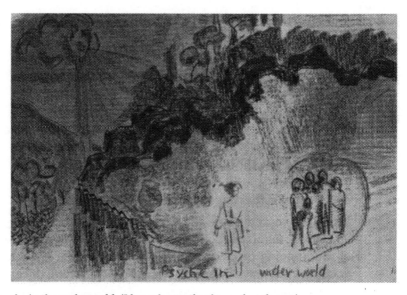

Psyche in the underworld. 'I have drawn the shape of my breast'
(The artist was a woman with breast cancer)

Fourth Task – Metaphoric Speaking Tower
UNAVOIDABLE CONTACT WITH THE UNDERWORLD: TRUSTING THE
SUBCONSCIOUS AND LEARNING TO SAY 'NO'

Lastly Psyche is ordered to descend to the underworld with a small box,
to be filled with the beauty ointment of Persephone. In all the other tasks
she was guided by helpers from the plant and animal world. In the last
one she herself needs to come in contact with the central feminine prin-
ciple: Aphrodite-Persephone. This task is equal to death in, or submission
to, the underworld.

She is saved by a far-seeing tower, which breaks out into speech, telling
her she will encounter pathetic people who will beg for her help. Three
times she will need to say '*no*' to their pleas for help, otherwise she would
be doomed to remain for ever in the underworld. It also forewarns her
that the woman of the deep will offer her seductive fruits and comforts,
all pleasures to try to tempt Psyche away from her task; but if she manages
to avoid the seductions, then her box will magically fill up of itself without
any further action from her.

This task relates to personal boundaries, when in the delicate state of
delving into one's own creative depths, and the need to say '*no*' when
necessary, in order to determine one's own life direction. Most people find
this the hardest task of the four, particularly when brought up in the

Judaic/Christian culture of having to 'do good' and 'be charitable'. It also emphasises the need to trust the unconscious, where all our vital energies are stored, and not to be distracted by gratuitous pleasure, which at the final hurdle endangers the whole process.[5]

Movement Experience

PERSONAL BOUNDARIES
Move around in space, relate to each other by saying 'yes' or 'no', using any part of the body you wish...

Now use only the head and neck... then one hand, two arms, and other parts. Move closer to each other... now further away... How much personal space do you need? When does the distance feel right?

WALK AND LIE
Imagine walking 'in the underworld' – unknown territory:

- Is it dark or light?
- How much space is there for you?
- What kind of ground do you walk on?

Lie on the floor: become aware of your own personal space. Make contact with the ground, and scan the body for contact points... What parts feel secure?

Move closer to each other, and then further away... Reach out and touch each other. What kind of contact is comfortable? What feels an intrusion?

Finally, make contact of a demanding nature, asking for help. What is your spontaneous reaction?

VISUALISATION

CLOSE THE EYES
Find yourself on a path leading to the underworld, carrying a small box for the ointment.

- What shape and size and material is the small box made of? Is it a familiar object?
- And the path, what does it look like? What is it made of: rock, sand, mud, grass...anything else?

You enter the cavern, the underworld... Do you need anything for support or sustenance: like a torch, food, clothing? You are going to meet three people who are in need of help, and you will need to refuse them, otherwise you become doomed yourself. What do you feel and think about this situation? Now you come to meet the dark woman, who will offer you sweet seductive pleasures, but your task is only to humble yourself at her feet, and concentrate on securing the ointment which, if

you do not deviate from your aim, will magically pour itself into your little box.

Finally, you will return to earth, to the shining light above, much more nimbly than you came in... now refreshed.

EXPRESSIVE ART

Transfer your feelings. Reflect on the experience: drawing, writing and sharing the experience. What is the relevant meaning of it, in your home, work, and social life situation, as they are today?

RESPONSES

'My underworld was a snakey path, an enormous cavern... I came across a child, an ex-boyfriend, and another past friend. I said 'no' to all of them and got the ointment without any problems; coming out with a sense of achievement. When I returned, I thought, why is it so hard for me to say 'no' to all these people, but then I realised: why did they ask me? I became conscious of how people have used me in the past.'

'I went down a spiral staircase in my left leg to the underworld, which was filled with many people and shadows. I was able to say 'no' to my father, and 'no' to my mother. I don't want to have to ask other people, I want to do things for myself.

I went on to meet Persephone, who was sitting on her throne dressed in crimson and purple. There was also another throne next to it, draped with the same robes and crown she wore, and she offered me the seat beside herself. But no, I refused, asking only to receive what I came for, and then there was no longer any resistance, and I came out of the underworld as if a wind was blowing me back, a whirling wind blowing me round the spiral staircase...

It made a lot of sense to me in terms of my present life. I cannot be pushed around by outside forces, only my own wind motivates me now that I have made a conscious choice. My father had a very powerful intellect and very strong emotions, and he married my mother, who is the most sublimely unaware person on the face of this earth. I said to her once during one of his crises: 'Of course he is frightened'...and she replied: 'Your father, frightened? I don't believe it?'...i.e., this demi-god I married can't possibly have such a peculiar emotion as fear, because if he is frightened he can't possibly protect me... so they are caught in a real double bind, which I can only distance myself from if I don't want to repeat and be caught in the same coils as them.'

Aphrodite and Psyche – Summary

Reflect and share the experience of growth to maturity and becoming whole.

How did the four stages affect you? Remember the Ants, the Reed, the Eagle, the Tower, your ability to remain strong and say 'no'. Listen to the archetypal inner voice, to Psyche's progress. She matures by becoming more discriminating, summoning the right helpers and learning by the process of descent into her inner nature. Therefore she does not sacrifice herself to other people's destructive tendencies, but rather to her own priorities. This becomes her greatest strength in being able, ultimately, to help in a more perceptive, positive and healing manner; aiding those who cannot help themselves out of their own depth and despair.

By these labours Psyche regains Eros / Amor, risking everything to gain a loving non-destructive relationship. This is a very desirable, almost 'godlike' quality, leading to the birth of Joy.

PARTICIPANTS' TRANSFORMATIONS

'I have learnt that anger can be creative and nobody can live out only one aspect of their personality. I feel more secure in the aspect of survival, no longer a fugitive; perhaps it is not so much a question of saying 'No', but saying 'Yes'. We need to become conscious of what archetype we manifest at any one time, and develop new qualities according to where we are on our individual journey.'

'Aphrodite and Psyche quite simply expanded beyond all recognition my awareness of choices. Before, I used to think of choices in a limiting capacity, but now I feel them to be as a breath of fresh air, pouring into my being, giving me unlimited powers and possibilities.'

'Do you remember how we started these workshops just after the earth showed us her power in the form of the hurricane? We really developed a sense of celebration and reverence for mother nature, through experiencing Aphrodite... But all that was undifferentiated primal energy, becoming euphoric amongst the Group Soul... Then we experienced Psyche, and all that externalised energy started to penetrate on a much more personal level during the course of which I have gained a new understanding of the relationship between science and art – I never asked myself before whether I wanted to be a doctor with a successful University career. Now I can visualise myself approaching Sociology in a more creative way.'

APHRODITE IN MY LIFE

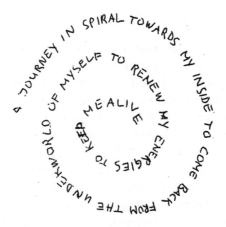

A JOURNEY IN SPIRAL TOWARDS MY INSIDE TO COME BACK FROM THE UNDERWORLD OF MYSELF TO RENEW MY ENERGIES TO KEEP ME ALIVE

APHRODITE

> to unfold my covered third eye
> to shake my spine
> to feel my skin
> to re-shape my own image
> to celebrate this life
> that had happened to me
> to discover a painful truth:
> I'm at the beginning of my journey...
> and there is no end to it.
> So, I will alleviate my sorrow
> invocating your name, Aphrodite.

APHRODITE

> Goddess of Creation
> nourish my dream.
> I will need your whisper at my ear
> when I will be creating.
> Allow me to build up my images
> and to enter the painful process
> of construction and destruction
> of a blossoming creativity.

I have a dream, and I hope my dream will come true, that one day I will feel your presence in my life so strongly that the people who will love me will be able to perceive your energy on myself.

I am finishing this piece sitting in my room. I looked at the sky through the window. There is Venus, the first star of the evening shining in the deep blue... an image that has fascinated me since my childhood.

Final Hymn – Celebration

We felt in most of these workshops the presence of the *goddess*, another dimension became tangible, without losing sight of real life issues.

Now you are ready to become self possessed, rather than possessed externally by so many conflicts. In this way becoming a loving and inspiring *Aphrodite*, ready to meet *Hermes*... the *Dionysian* principle of the Mystical Marriage, in the following Workshop.

Third Hymn to Aphrodite

The Cytherean
 born at Cyprus
 is who I shall sing,
she who presents
 humans
 with such nice presents.
That seductive face of hers
 is always smiling, always
 carrying its seductive flower.
Hello, goddess,
 sovereign of Salamis
 with its good buildings,
 and of the sea place, Cyprus.
Give me the kind of song
 that seduces, please,
 and I will remember you
 in another one.'

(The Homeric Hymns, translated by Charles Boer)

If appropriate, arrange a small exhibition of all the drawings. Allow the written products to be read, and perform a dance movement.

Create an atmosphere to celebrate beauty and creativity – allow the group to be as inventive as possible.

Oedipus – the Classic Tragedy of Understanding One's Own Fate

'We cannot end the war between nations unless we end the war in the heart of men.'

U. Thant

The Oracle of Apollo had prophesied that the son of King Laius and Jocasta would kill his father and marry his mother. The curse had been placed upon Laius for having sodomised the son of a long time friend Pelops, which caused the boy, Chrysippos, to kill himself. Pelops in revenge cursed Laius himself never to beget a son, or if he did, then to be slain by that offspring. The curse was implemented on behalf of Hera, protectress of children, and Apollo the protector of young boys.

To avoid this disaster, guilty Laius arranges for his infant son to be abandoned on a hillside in mid-winter, with his feet pierced and tied; and for this reason the boy is later called Oedipus 'swollen foot'. He is rescued by a shepherd, and taken to Corinth, and adopted by Polybus and Merope, king and queen of Corinth. Growing up in ignorance of his history, he is insulted one night by a drunken guest at a banquet, who mocks him for his lack of resemblance to his parents, and accuses him of being a foster child. So he secretly sets off for Delphi to learn the truth from the Oracle about his parents. He is told that he is doomed to murder his father and marry his mother. Afraid to return to Corinth, he sets off in another direction.

At the same time, the Sphinx is sent by Hera to torment Thebes because Laius had refused to heed Tiresias, to sacrifice to her. On a mountain path Oedipus and Laius meet and quarrel over the right of way and in the ensuing struggle, Oedipus slays the other who is, unknown to him, his father.

When he arrives in Thebes, the Sphinx still terrorises the city. After the murder of Laius is discovered, the kingdom passes to Oedipus, when he, like none other, is able to outriddle the Sphinx and destroy her power. He becomes a wise and gifted ruler of the once again peaceful city. Creon, the queen's brother, had decreed that he who slayed the Sphinx should gain the kingdom and the queen. Oedipus begets four children with Jocasta.

Then a new calamity strikes: a plague breaks out, threatening to bring Thebes to extinction. The oracle insists that the culprit lives in their midst, and that the 'Murderer of Laius be expelled'. Through the intermediary of Tiresias, the past events come to light, and Oedipus discovers the

hidden secret of his unconscious crimes. When Jocasta learns the truth she hangs herself; and Oedipus, to assuage his guilt, blinds himself.

The blind wounded one vanishes from Thebes. He wanders for many years accompanied by Antigone, the eldest of his daughter-sisters, and pursued in his dreams by the Erinyes the 'dogs of Hades', female spirits of vengeance who, punish those who have shed familial blood or broken oaths.

His sons meanwhile murder each other, and the house of Laius is drowned in blood. When Oedipus hears of it he cries in despair. Finally, Antigone leads him to Poseidon's rocky hill, at one of the entrances to the underworld. And there, at the grove of the Erinyes, the earth opens up to finally forgive and receive him.[1]

In our workshops we deal with the main figures of the myth; and explore the perception of 'primitive' people, related to Ted Hughes' version of Seneca's play: primitive figures, 'spider people scuttling among hot stones'. And having experienced all the characters, it will be possible to put together an improvisation, based on Ted Hughes' magnificent adaptation, to bring out the meaning of the legend as a whole and its relationship to the individual.[*]

Movement Experience: 'Spider People on Rocks'

To introduce the process we bring books, pictures and cuttings relating to primitive cultures, such as cave and rock drawings.

EARTHBOUND MOVEMENT To begin the process of identification with 'primitive' earthbound people, close to nature and well grounded, sit on the floor, with open hip joints, legs apart, and feet touching the ground, knees bent.

Move around the floor... Sit beside your legs, and move from side to side. If possible, sit between your legs, very carefully, without the use of force... Move easily, without straining and without holding your breath...help yourself by supporting your weight on your arms... Experiment with as many different ways of moving the pelvis on the floor as you can. Rest.

Sit on the 'sitting bones' with your legs together or separate. Arch your back and bend forward... move from the pelvis and allow the curves to unfold slowly... knees bent or straight. Move on the floor until the body is warmed up.

[*] All quotes in this section are from Ted Hughes' *Oedipus* (1969).

Get up slowly onto your feet... place your legs apart and bend the knees slowly, progressively increasing the size of the movement: soften the hip joints until you can *crouch*... lift your heels if necessary. Rest.

When ready, start walking, running, and jumping over imaginary rocks... Run on hands and feet. Change between being upright and down on the ground.

HUNTING Play with imaginary hunting movements.
MOVEMENT Make percussive movements with your hands and feet on the ground...use the floor like a drum. Move in groups, tribes...create different rhythms for each group. (Use drumming music, live or recorded).

IMAGE The specific image of 'spider people' can be evoked by the following:

Lie on one side of the body... Bend the arms and legs at right-angles to the body on the floor.

Lengthen the upper arm parallel to the ground, and return to starting position... Repeat many times. Rest on the back.

Notice the changes in perception of your contact with the ground... Compare the sensation of one side to the other.

Return to the same side. Shorten the upper arm, parallel to the ground, and return to starting position... Repeat many times. Rest on the back.

Notice the changes in the perception of your contact with the ground.

Return to the same side. Lengthen and shorten the upper arm: notice the gain in freedom of movement. Repeat a similar process with the upper leg... i.e., lengthen the upper leg and return to starting position; shorten upper leg, and return to starting position. Lengthen and shorten alternately the upper leg. When both arms and legs have been 'lengthened', the joints have become free...

Extend the upper arm and leg simultaneously parallel to the ground... lift them vertically into the air, without bending knees or elbows... Return to the ground. Repeat many times until the movement is free and easy. Rest.

Lift again the upper arm and leg vertically into the air... roll over to the other side... Repeat the procedure several times until both sides feel equal. Rest.

Play with the movement, roll from side to side without forcing and without falling, in a 'reversible manner' (Bartal – Ne'eman, 1975). Movement can be stopped and reversed instantaneously at every stage...

After this experience of 'spider-like movement', get up slowly, and move around the room in a similar way: bending and stretching...turning, alternating between slow and fast, sudden and sustained movements.

AGGRESSOR/ DEFENDER Develop group improvisations: leaders and followers, aggressors and defenders.

Expressions of fear and rejoycing can be evoked, accompanied by rhythmic movements of legs; and sounds made by the group and accompanying music.

Laius

Laius is the perpetrator of the tragedy, and is the symbol of patrilineal inheritance, as Jocasta is of matrilineal. We all carry our parents' heritage, their wounds and scars, as well as gifts. 'The sins of the fathers are visited upon the children'. Our inheritance can be material, physical, genetic, and psychological.

VISUALISE
- How much are you aware of your inheritance?
- How do you see your parents' influence in your own life?
- Are you aware of any crossroad in your life, coming face to face with the experience? Think of an event that may have influenced your whole life.
- Do you keep any family secrets? Have you covered up any that you know of?
- Do you expect answers to come from an outside source?
- Are you willing to go through the pain of discovering your own truth, and therefore be responsible for your own joy?

The Sphinx

The Sphinx is the mythical beast, part human part animal. She is the symbol of the negative mother and represents instinctual nature. At first she appears as an expression of Hera's curse, which affects both the individual and the group soul, and attacks the whole community. The

riddle she sets relates to the intellect, a level on which Oedipus excels: this level relates to the conscious Ego, and does not reveal unconscious influences.

Our own exploration begins at the physical level.

The riddle of the Sphinx is an analogy of the life process:

What has four legs at dawn,
 two legs at noon,
 three legs at dusk,
and is weakest when it has most?

As a baby we move on all four, as grownups on two legs, in old age we use a stick to support us and are weakest at extreme old age.

Inspired by the riddle of the Sphinx we experience various forms of growth and decay; tension and relaxation; independence and dependence.

Movement Experience

Lie on the floor on the back. Bend both arms and legs to allow the knees and elbows to face the ceiling: the upper arms and thighs are parallel, vertical to the ground, and the lower arms and legs hang freely, able to bounce...

BABY MOVEMENT — Roll gently from side to side... focus on one side at a time. Roll to the right until the right arm and leg touch the ground; return to centre... Repeat many times. Do not keep arms or legs in a rigid position, allow them to move freely and at the same time lengthen the spine and let the head and neck move without tension. Gradually the movement becomes softer, the body becomes more supple, baby-like.

Experiment with the shift of weight from the back to the limbs and return, until the movement is very easy and flowing, and the left arm and leg touches the ground as well... Now you are ready for your first attempts at crawling!

THE CAT POSITION — Move into a 'Cat Position': the weight distributed on hands, lower legs and feet...

Rock forward and backward, soften the ankles, the hip joints and shoulders. Bend the toes to allow the balls of the feet to take the weight... Continue to rock until you can stand up.

STANDING — Lower your weight and return to the floor... Find different ways of getting up and lying down.

Feel the sense of growing... the transition between weakness and strength. Sense the support of the ground in both a physical and emotional sense. Experience growth from dependence to independence.

BODY RIDDLE

BALANCE
YOUR
WEIGHT
To experience the sense of balancing the body in different ways, analogous to the Sphinx's questions, put the body weight on:
- Two arms and two legs
- Two arms and one leg
- Two legs and one arm
- The sitting bones of the pelvis only
- The side of the pelvis and one hand.

Find as many variations as possible.

Stand up on two feet... Experience the shift of weight from one leg to the other in various positions. Become conscious how you transfer the weight.

Where is the weight on the feet? (It should be divided between the heel, the big toe and the small toe).

Start walking...

LIFE STAGES
Increase the speed, become more energetic. Walk like a young person... think and feel young.

Gradually imagine yourself becoming older, the joints losing flexibility... become heavier needing support. Lean on other people. Lean on a stick or crutches (real or imagined).

REFLECTION
What thoughts and feelings do you have of the relationship between youth and maturity, youth and old age?

VISUALISATION

CLOSE
THE EYES
Have you been faced with a potentially dangerous situation, and pretended it did not exist?

Find an image for an impasse, a cul-de-sac.

What were your feelings? (e.g. frustration, despair...?)

Find an image for your reaction or non-action, and its consequences. Have you experienced a relationship in which you felt instinctively that something was wrong, but let it drag on? What did you do to finally clear the situation?

EXPRESSIVE
ARTS
Transfer your feelings into paint or writing.

Jocasta (Leah Bartal)

Jocasta

Jocasta represents a woman unable to control her own destiny. She is not attuned to the powers of the unconscious and therefore becomes a victim of circumstance, blown by the wind of fate. She adapts to reality, offering her love unconditionally, pure in her self but doomed by her allegiances to the men she allows to father her children.

Jocasta represents the calling to women, to reflect carefully upon their position in life, beyond external appearances.

PHYSICAL LEVEL

At the physical level the figure of Jocasta is explored from many sides. Her roles as: *wife, mother,* and *queen.*

Movement Experience

Begin by sitting, on the floor or on a chair. Experiment with ways of moving the pelvis: forward, backward, sideways... Soften the centre of the body. Make a whole circle, allow the rest of the body to follow, to flow 'in tune'... the torso, head, neck, and shoulders follow without being held in any rigid position...

- Get up and sit down in different ways. Soften the body and allow it to breathe and 'be breathed'.[*]

[*] See Resources of the Physical Body I Sections: 'Pelvis, and Back'.

- You will deal with the feeling of growth, development, opening up, letting go, and creating another human being.
- Improvise on the birth process in movement...
- Imagine giving birth to a baby
- Allow the group to 'give birth' as a collective creation
- Find suitable sounds to be made by members of the group, or accompanying instruments.

Movement Improvisation – Mistress/Mother/Queen
Experience various aspects of a woman...

- As Mistress and Wife: Temptress – Frivolous – Companion
- As Mother: Nurturing – Containing – Supporting
- As Queen: Distinguished – Regal – Domineering.

Practise these aspects with different ways of walking... Find various ways of using the hips, the torso, the head and neck, in relationship to each other. Experience the expressiveness of the arms, the eyes, the way the feet touch the ground.

Whole Woman: 'The whole is more than the sum of its parts'. Explore and experience different aspects of woman/man and their relationship to the whole person.

VISUALISATION

CLOSE
THE EYES
Identify three different aspects of yourself or 'subpersonalities', that are related to your exploration of Wife, Mother, Queen. They can relate to real or spiritual life, or both, or it could be someone you identify with as a mother figure.

- Find an image for your understanding of 'Wife' – to your real husband alive or dead, or your spiritual spouse.
- Find an image for your Mothering aspect – mother to your children; mother to your own inner child; or your spiritual dimension.
- Find an image for your sense of being Queen – ruler, leader, and responsible.

REFLECT
Reflect on the following: Grounding and Reality

- Have you felt that you were not in control of a situation, in relation to any of the above roles? If so, focus on one instance.
- What were the consequences? Reflect on paper in words or drawings.

- Imagine a solution in which you would be more in control, and better attuned to your intuition.

EXPRESSIVE Reflect on paper: in words or drawings.
ARTS

Oedipus

The insult of Oedipus at the banquet can be seen as 'a rude awakening', or as a 'shock' which precedes a search for the hidden motives of something crucial regarding one's life. It symbolises the start of his search into the unconscious; at the end of which he punishes himself and becomes the victim. It is his choice to do this rather than to forgive himself.

By blinding himself, Oedipus forsakes his extrovert lifestyle, in preference for the path of inner sight on which he is accompanied by his daughter-sister Antigone, his *Anima*.

PHYSICAL LEVEL
The figure of Oedipus is explored on the levels of: *Warrior*, *King* and *Father*.

To symbolise his initial abandonment, use objects: string to tie the feet; and two stones per person.

Movement Experience

Begin by lying on the ground. Your feet are tied at the ankles by real or imaginary string. Experience yourself as an isolated entity – a unit separate from the environment. Feel abandoned, as the baby Oedipus...

Try to move in that state. Move your arms, the head and neck, the torso, the pelvis, the thighs, and the feet. Experiment with moving with all or some parts of the body... How does the restriction of the ties affect you?

MOVING Remain with tied feet. Lie on your back. Put a stone into the
WITH STONE palm of each hand...extend the arms – lift one at a time... Then
 both at the same time. If the stones feel very heavy in your
 hand (remember to put them inside the palm), don't hold them
 with the fingers alone.

 Try to find ways to make them feel light. This can be
 achieved by lengthening the arms, supporting the torso, spine
 and pelvis on the ground in a way that allows this to happen.
 Listen to your breathing... are you holding it?

 Let go of the stones. Lift the arms without the weight: how
 is it now? What changes has this experience made in the
 opening of your shoulders? (The area between shoulder and
 breast bone, in some ancient teachings, is known as 'The Gates
 of Heaven'.)

Untie and remove the string from the ankles. Get up slowly, deliberately in a flowing movement, and without holding your breath.

STANDING Allow the arms to rise at the sides of the body. Notice the expansion, the opening of the upper part of the torso... This creates a way of feeling 'regal': a weightlessness, and natural way of being confident, possessing a natural 'mobility'.[*]

Movement Improvisation – Warrior/King/Father

EXPLORE The figure of Oedipus is explored from many sides. He begins by being abandoned and wounded – and is nurtured later on. We examine his role as...

- Warrior: Fighting – Handling Weapons – Fierce
- King: Regal – Distinguished – Commanding
- Father: Protecting – Defending Boundaries.

WARRIOR Find various ways of expressing with your body aspects of the Warrior... through handling weapons, fighting attitudes, and defensive movement.

Notice your feelings of courage, anxiety, resistance... Allow participants to relate to each other in 'combat' – making sure to keep within agreed boundaries for safety's sake.

KING Experience in your body many ways of being a King... Walk in a regal manner.

MOVING IN Feel in control of the group, tribe, the mass of people. Allow
GROUPS the group to develop an improvisation around leadership.

Experience the opposites of being in command and being a subordinate... Reflect on your feelings in relationship to the actions taken. Be very much aware of how much the use of your body expresses feelings and thoughts: who or what gives you the power of the king?

- How do you feel about the responsibility a king carries? Are you comfortable with it? Do you enjoy the power?
- Or would you rather share the power? And if so, with whom?
- How do you relate to the Queen as a power holder? Are the powers equal? Do they complement or conflict?

[*] See Resources of the Physical Body I: Section on 'Skeleton']

FATHER Identify and experience in your body the sense of being a
 Father:
 - how do you relate to your children?
 - How do you protect them?
 - Are you able to defend their boundaries?
 - Do you have their respect?
 - Do you love them? And does it matter to you if they
 are a boy or a girl? If so, in what ways does it matter?
 - Do you feel threatened by them?
 - What do you expect from your sons?
 - What do you expect from your daughters?

REFLECT Reflect on the experiences.

VISUALISATION

VISUALISE Identify three aspects of yourself or 'subpersonalities' that are
CLOSE THE most related to your inner exploration of Warrior, King, and
EYES Father: these can relate to your real life, or your spiritual father,
 or both. Or it could be someone whom you see as a father
 figure.
 - Find an image for your meaning of Warrior – your
 own heroic aspect.
 - Find an image for your meaning of King – your own
 regal, noble and aristocratic, or responsible, aspect.
 - Find an image for your meaning of Father – to your
 own children or as a spiritual father in relation to
 yourself.
 - With what part do you most identify?

REFLECT On paper, reflect on the following: Grounding and Reality
 - Have you ever covered up unpalatable facts?
 - Do you believe yourself to be a good father, husband,
 and a good lover?
 - Do you deny certain aspects of yourself? And in
 relation to your family?

EXPRESSIVE Share and reflect on paper: in words or drawings.
ARTS

The Plague

The plague represents the continuation of the 'rot', festering through the
body. The body is Thebes. In the context of the Group Soul, its decay
through the curse put upon it represents the state of the 'Wasteland'.

The curse is the consequence of the continuing narcissism of the intellect, unable to delve into deeper perceptions. And on the level of the Group Soul it means: 'One rotten apple spoils the whole crate', and soon spreads its decay.

VISUALISATION

CLOSE THE EYES – SOCIAL IMPLICAT- IONS
What situations or stresses produce in you physical symptoms?

- How do you deal with them?
- Are you prone to denying them, or shrugging them off?
- Do you associate other people with these discomforts? Or do you feel they are only of your own making? Or both?
- What do these discomforts mean to you?

Now apply these perceptions to a group you feel connected with. It can be a social group, your work situation, or the community at large.

How does it function? Do you spot dangers that you think the group at large 'turns a blind eye to'? And if so, what do you feel would be the long term consequences of such blindness?

Reflect on paper: in words or drawings.

Creon

Creon represents the Matrilineal Uncle... He is a link in the chain, and ensures that the unresolved problem passes on to its rightful owner, Oedipus.

The role of the uncle on the mother's side, in Oedipus' case serves to underline that the issue was of a feminine nature, the mother's line of descent.

PHYSICAL LEVEL
The Queen's brother is explored as a character who is the upholder of the Law. He is rigid, authoritarian, and takes on the responsibility for his society.

Useful props: sticks, chairs, ladders, tables, and fences.

Movement Experience

Create a physical space to impose limitations on the movement of individuals, (with the help of the above mentioned props).

Give strict instructions to a group, such as:

'Everyone stand still!': using sound to exert one's influence. Then, in military style, without allowing personal freedom for complaints, tell them to bend and stretch, etc. Exercise your authoritarian will.

Allow participants to reflect on their feelings. How would they like to be?

- Do they want to remain within a limited space, and lack of freedom of expression?
- Or do they want to burst out, and rebel?
- Do they feel repressed or secure by the rigid limitations imposed?

IMPROVISATION

AUTHORITY Allow the group to interact and improvise freely. Several members in turn can take the role of the 'Responsible Ruler'.*

We have often experienced that, in reaction to the repressive commands, a playfulness rather than an open rebellion takes place, as if making a mockery of the grandiose one.

VISUALISATION

WITH CLOSED Identify your relationship with society and its hierarchical
EYES structures.

- Find an image of your relationship with people who are outside your immediate family: at work, at play, or with your neighbours.
- Find an image for people you come in contact with on a more remote level: bureaucrats, councillors, members of parliament, or the queen.
- Find an image of yourself in relation to higher authority of a human kind.

EXPRESSIVE Reflect on paper: drawing or writing. And share with the
ARTS group.

Tiresias

The blind prophet and diviner, the mediator of the oracle, represents the 'I and Thou' concept, or The Inner Voice. His communication is with the Deep, since he contains within himself the equilibrium of the masculine and feminine. His is the androgynous soul we strive for.

* See Resources of the Physical Body I: Section on 'Individual Space and Boundaries'

Tiresian vision relies on being able to see beyond material and external reality, and gives us understanding of what 'makes us tick'.

PHYSICAL LEVEL
This character gives us the opportunity to explore the physical environment with closed eyes. Use a scarf or any other blindfold.

Movement Experience

LEAD AND BE LED

Close your eyes, or tie a scarf around them.

Move around in space – experience your reaction to objects and people encountered.

Choose a partner. Keep in touch with the other by sound alone, as you move around separately... How acute does your sense of sound become?

One partner open the eyes, and lead the blindfolded other around in space...over obstacles, away from the group; and finally near to other couples.

Reflect on your reactions, let go and rest.

VISUALISATION

CLOSE THE EYES

Lie on the ground. Imagine that you face an obstacle: let it appear on your 'inner screen'.

How do you interact with the image? As male or female? Or a mix of both?

- Find an image for a time in your life where you had a premonition of an event to come, or a vision.
- Find an image for each of the following: fears, courage, anxiety, and confidence.
- Find an image for your own inner resources, your inner healer.
- How much has your sense of sound and touch changed by working with closed eyes?

EXPRESSIVE ARTS

Reflect on paper: drawing or writing. And share with group.

SURRENDER TO FATE: GROUP IMPROVISATION
The 'surrender to fate' is the surrender to life's trials. It involves the acceptance of the shadow aspect of oneself: on the one hand recognising the power of unconscious forces and, on the other, speculating that if Oedipus had not been abandoned, there would be no story.

Alternatively, by becoming conscious of the unconscious forces being played out in one's life, one can become the creator rather than the victim – or monster – of one's life and fantasies. But if one is unconscious, one cannot make informed choices. If Oedipus had intuited the truth about his 'parents'' identity, he would not have needed to succumb to the prophecy.

Jocasta – As the mother of Oedipus:

> 'I knew the thing in my womb was going to have to
> pay for the whole past,
> I knew the future was waiting for him like a greedy
> god a maneater in a cave...
> ...I carried him for this
> for pain and for fear.'

- How do you perceive your own fear and pain? How do you sense it in your body?
- How do you feel your parents' fears? Do you accept or reject them?
- Have you adopted your parents' gestures, or emotional expressions in any way?

Oedipus – As king:

> 'have I turned back whatever there is that frightens
> men in this world whatever shape terror pain and
> death can come in it cannot turn me back not
> even Fate frightens me'

- What happens to you, your body, mind and feelings, when you have to express and experience death, war, or persecution? Our generation has been suffering on a worldwide scale. How can we deal with it?
- If one is to survive, how can we contain and express, integrate and transform these experiences?
- Is it simply part of mankind's legacy, or can we face up to the shadow?

The Plague

The Plague has arrived: Oedipus is helpless and asks to die. His fear has followed him, his shadow pursues him.

'...fear
came with me...
 ...I stand in it like a blind man in
darkness...
...you high gods
 ...give me death'

To which Jocasta replies:

> '...you are the man we rely on you are the
> King the strength if we have strength
> the heavier the threat the stronger we should find you
> to bear the threat'

- Where does our responsibility lie? Where does it begin and end?
 Or is there a beginning and an end? Are we not parts of the
 continuous evolution of humanity, and the Earth we have
 inherited is our responsibility for those to come?
- What is the value of our lives?
- How do we perceive truth?

Tiresias

> 'if I am slow to speak Oedipus if I ask for time
> be patient...
> ...I am here to
> search this thing to the bottom...
> ...we must look at the omens...
> ...a king's
> eyes are for this world they must be kept well clear
> of the fouling shadows of that other world'

- How is the window we look out on the world?
- Is it clear, stained, polished, cracked, or completely smashed?

The window can also be translated as a mirror.

A Slave

> 'When Oedipus grasped his fate and saw the full
> depth of wrong where he had lost himself he
> understood the oracle now he's condemned himself...

A slave by nature is he who suffers the cruelty of others. His position in
life is against his will, and so serves as a reflection of his master's sickness:
the painful soul.

- Are we slaves to our natures?
- How much do we feel the suppression of others, their sickness
 inflicted on us?

This is very relevant in a modern world that finds the majority helpless in the face of the whims of a minority which holds great powers to inflict potential disasters on the whole planet, whether through nuclear energy or pollution of the planet.

Oedipus (at the end)

<div align="center">'...I</div>

am going away I am taking my curse off you
now you can hope again lift your faces now you
will see the skies alter..
<div align="center">...if you can breathe</div>
suck in this new air it will cure all the sickness'

Oedipus has blinded himself, to have access to his inner vision, the unconscious, the Third Eye. He asks the offspring of his despair to be his guide – a way towards transformation and renewal. And she will remain with him until his enlightenment.

We always have a chance, but we must grasp our chances, and not delay what we must do to heal ourselves.

Tiresias

'while we reach into death and call out the dead let the
men sing let them sing against the dead'

Chorus to Bacchus

'OOO-AI-EE...KA...
CHANT 3 times
REPLY 3 times

DANCE DEATH INTO ITS HOLE
DANCE DEATH INTO ITS HOLE
INTO ITS HOLE
ITS HOLE
ITS HOLE
ITS HOLE
HOLE

LET IT CLIMB
LET IT COME UP
LET IT COME UP
LET IT CLIMB
LET IT LIVE
OPEN THE GATE
OPEN THE GATE
LET IT LIVE
TEAR THE BLOOD
OPEN ITS MOUTH
LET IT CRY

WHILE THE WIND
CROSSES THE STONES

WHILE THE STARS TURN
WHILE THE MOON TURNS
WHILE THE SEA TURNS

WHILE THE SUN STANDS AT THE DOORWAY
YOU YOU YOU
YOU UNDER THE LEAF
YOU UNDER THE STONE
YOU UNDER BLOOD UNDER THE SEA
YOU UNDER THE EARTH

UNDER THE LEAF
UNDER THE STONE
UNDER THE BLOOD
UNDER THE SEA
UNDER THE EARTH

YOU YOU YOU YOU
YOU YOU YOU YOU

UNDER BLOOD
UNDER THE EARTH

YOU

The Marriage of Ariadne and Dionysus

'Appear, appear, whatsoever thy shape or name,
O Mountain Bull, Snake of the Hundred Heads,
Lion of the Burning Flame!
O God, Beast, Mystery, Come.'

Euripides, *The Bacchae*

Introduction

At the heart of its meaning, the marriage of Dionysus and Ariadne patterns the relationship of life and death. Fierz-David (1988) states: 'life becomes death and death becomes life, the human becomes godlike and the divine shows itself in human form.' To beget 'life' a person needs to descend into primaeval depth where force of life dwells, whether in a physical or psychic form.

The Story of Ariadne and Dionysus

Ariadne, the daughter of king Minos and queen Pacifae, fell in love with the heroic Theseus. When her father made a false sacrifice to Poseidon, the god punished him by causing Pacifae to fall passionately in love with a white bull, through whom she gave birth to the Minotaur – half bull and half man. The Minotaur is Ariadne's half-brother. The creature was kept inside a Labyrinth built by Daedalus.

Theseus was asked by Minos to attempt the slaying of the devouring creature. Ariadne offered her help with a ball of string – the thread through life – which she tied to the entrance of the Labyrinth. Theseus succeeded in slaying the Minotaur and promised to marry her. They set sail for Athens; but he abandoned her on Naxos. In her despair she fell asleep: the sleep of the Underworld or 'The Realm of the Shadow', from where she was awoken and transformed by Dionysus.[1]

Dionysus needs to be approached with extreme reverence, since to get in touch with him is to recognise a chthonic destructive power: a crucial factor underlying the creative and transformative process. To open oneself to a painful experience requires placing faith in a power greater than oneself, and coming to terms with duality or paradox.

Jung said the Dionysian Mysteries brought people back to the pre-conscious level: to the 'animal within'. His is divine madness, the wild spirit

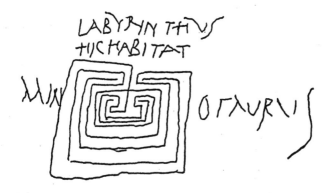

The Labyrinthos hic habitat Minotaurus (The Mystic Spiral)

of paradox, encountered through his 'immediate presence and complete remoteness, bliss and horror, infinite vitality and cruel destruction' (Otto, 1986).

Dionysus lives inside all of us, most of the time rather asleep. His undomesticated presence lies bound in winter, underground, and is released through the stirring of the spring, where all nature appears to explode into life, as miraculous acts of seasonal renewal.

He appears draped in vine leaves, carrying a thirsus, or in a varying number of animal spirits. We shall experience him at different stages and in different guises.

He is also closely related to the Maenads, who accompany and enact his rites. The Maenads are his muses, who are concerned with 'wild' things. They are called the 'Rushing, Raging, Trembling Ones and the Ones Who's Heart Beat Excitedly Under Strong Emotion' (Hall, 1988). Fear mingles musically with excitement; anticipation rises. Dionysus is the heart, and the Maenads who surround him, are the 'gamut of feelings; from the bittersweet of heart-rending passion...to rejoicing with and having sympathy for all living creatures' (Fierz-David, 1988). In this way one opens oneself to the possibility of being transformed and redeemed.

Breaking boundaries, whether of family, work, education, language, style, is a most threatening experience and we need much preparation, much courage; but the potential benefits are of leading a more creative life. This creative process is a harmony of masculine and feminine energy, of which Ariadne and Dionysus are the central archetypal figures.

To explore the depth of feeling, we need someone there to hold the thread. Ariadne as a female spirit represents three aspects: the Anima in men; woman in a crisis of abandonment; and the Soul aspect, the bride ready to be married to Dionysus.

Ariadne, unconsciously 'allowed' herself to be abandoned. She had gone as far as she could with Theseus, without receiving anything in return. She needed to be honest with herself, realising that at a certain point she needed to separate and 'let go', in order to reclaim herself. In this way Ariadne reveals herself to herself in the course of her journey. Her being abandoned looks like disaster, the end! But, as a matter of fact it was a beginning, a rebirth, giving birth to herself. The process which she symbolises is a demanding one, to go into oneself, in order to find a new depth, another meaning, born out of the unknown: making the unknown known to oneself.

What Ariadne rejects when she is abandoned by Theseus is the heroic-mortal lover, with his preference for external-material deeds. Instead, she submits to a greater calling, to become a bride of the underworld.

REFLECTIONS 'Ariadne, is the mistress, the Maestra, the gifted female teacher.'

She had yet to meet her true potent lover, Dionysus, whom she did not yet know.

Another participant: 'Dionysus is such a powerful energy, not a person, he frees us to feel ecstasy... and for this reason he is very complex: being torn, dismembered... madness, mystery, visual and visionary eroticism... he is a turn-on!'

He turns us on to a mini-death, which allows us to give birth to a new aspect of ourself. Dionysus brought Ariadne into the realm of gods and goddesses; and by such fusing of two archetypal energies, each person can give birth to a more individual self. The marriage of the two is a submission to Nature, and to one's own nature.

STAGES OF THE SOUL JOURNEY
- We explore the Labyrinth and its symbols.
- Ariadne's ball of string which she gave to her lover Theseus, and the confrontation with and slaying of the Minotaur within the Labyrinth.
- Ariadne's abandonment and sleep of death.
- Her re-awakening through meeting Dionysus, Lord of the Dance, Soul of Nature, or Divine Madness – the masculine spirit, as a fertilizing, fructifying principle in the service of the Great Goddess.[2]

The Labyrinthian Journey

The *Labyrinth* is the 'unseen' world, the place where the inner process unfolds itself, the womb, or underworld, realm of the unconscious. It can also be related to the process which unfolds during a lifetime. It is the route to maturity of the individual.[3]

Through movement experience we explore the physical aspect of going into a labyrinth.

Movement Experience

SPIRAL
Begin by walking curved, spiral paths, diminishing and expanding circles. Experiment with walking on the spot and moving in space. When moving on a spot bend one or both legs...be aware of the spiral path the body creates... Add one or both arms, hands, shoulders... Notice the contraction and expansion of the body in relationship to itself and to its surroundings. Move close to the ground, then away from it, from one extreme to the other. Listen to your breathing...

Do you like to travel alone or with someone else?

TURNING
Move on one spot with increasing speed, until you start whirling, the weight of the body supported on one foot, which should be the axis around which you turn... Change directions if you feel dizzy.

Do you enjoy the feeling of just turning without feeling the weight of your body? Try to be conscious of your arms.

Now repeat the above experience with closed eyes. Are you more aware of your feelings with eyes opened or closed? Which do you prefer?

The *String* is the guiding energy, or the umbilical cord which nourishes the 'unborn' consciousness in its period of gestation. Internally it is intuition, externally as a learning process, an unfolding of one's own development.

GUIDED
IMAGERY
CLOSE EYES
Entering the Labyrinth – Prepare yourself for entering the Labyrinth on an imaginary path. Focus your attention inside. You are now going on a dangerous journey. Reflect for a moment on any similar event in your life.

- How do you prepare your entry?
- Do you dress up for the occasion?
- Do you want to have a guiding principle?
- Are you afraid?

- Do you wish to carry any object with you for assistance: like a weapon, a torch, a talisman, a musical instrument?
- Have you got a specific quest, or can you allow yourself the experience of 'Being'?
- What are your expectations? Or don't you have any?
- Is there anything you want to ask from your soul, the Ariadne-Anima?

VARIATION Work with a partner: one holds a ball of string – real or imaginary. Tell your partner what you need of them, while you are going deep into the underworld...

- How is the journey? Is it smooth or are there any obstacles in the way, any dead ends?
- Do you need to retrace your steps at all, or are they sure? Is your centre of gravity heavy or light?

EXPRESSIVE Relay to paper your feelings and experience, drawing or writ-
ARTS ing.

The Minotaur

We view the *Minotaur* as a figure full of contradictions, dimensions, and as a non-flowing energy. He is a tragic figure, caught and distorted, trapped in the Labyrinth from which he cannot escape. He is a 'trapped' figure, as when one says 'I feel trapped...'.

The Minotaur is the Monster within us, our darkest, destructive fears and desires. These need to be 'confronted' and 'conquered'. However, the slaying of the Minotaur should not be perceived as a 'killing', but rather as a way to resolve emotional or physical conflict. For example, Orpheus at the Gates of Hell tamed Cerberus, the dog of Hell, with his lyre.

Try and locate in your body your own disharmonious parts, your own distortions, the parts, that if not acknowledged could potentially be extremely destructive.

EXPERIENCE THE MINOTAUR

Listen to your breathing. Collect your inner resources as you come now to the centre of the Labyrinthian experience... How are you going to meet the Minotaur, half-man and half-beast?

- What part of you do you consider human?
- How much of the animal consciousness do you allow yourself?
- Is the animal part, the beast, acceptable? Or is it unacceptable, and/or destructive?

- Is it dangerous, exciting or both? Is it inert and docile? And does it acknowledge you, or is it insensitive to your presence?
- Seek and identify the elements to which it relates, as well as the thoughts and emotions it triggers off.
- How do you meet it? Do you confront it as part of yourself or outside of you?
- Is the beast male or female, neither or both?
- Can you see it clearly, or does it hide behind a mist, or is it veiled?
- Do you feel it? If so which organs are most affected? And does its presence make you move differently?
- Does it freeze and petrify you? Or does it bring out feelings of anger, or childhood tantrums?
- Does it master you, or can you guide and tame it?

EXPRESSIVE ARTS
Reflect on paper in drawings, words, or both.
Share your experience in small groups or one large group, relating it to your present-day life experience.

RESPONSES
Personal Stories: *Going Into the Labyrinth...*

'I was reminded of a terrifying dream, I went down to a basement in my old college. It was full of bats and I was terrified. In the corner was an old man with a gun, I ran away from him. He shouted after me: 'Do you want anything?' I replied: 'No...' and instead I sang and took some golden streamers. Eventually I took the old man and danced with him, which I enjoyed and didn't want to stop, or leave him.'

'I fed the Minotaur with fruit, he was tame, I took him by the horns, and rode out of the Labyrinth on his back.'

'My Minotaur was not frightening, I could easily get past him – and looking at my drawing, it is really benign – and for years I have been afraid of it – how stupid!'

Ariadne

Now we are ready for the next stage. In fleeing with Theseus, Ariadne still worships her heroic lover.

Her being abandoned is symbolic of a separation/individuation, the 'parting of the waves', the end of a relationship. Like many women coming out of an unfulfilling relationship she needs time to be without a mortal man to get in touch with her own individual nature. She needs to get in touch with the divine masculine: a fertilising phallus. Her feeling of being lost can be said to be a spiritual death.

Ariadne on Naxos goes into a cold storage, as the isolated vine fermenting during the process of wine making, which prepares her for the divine Dionysus, Lord of the Bacchae... According to legend, on Naxos wine gushed forth from a spring, for the first time, at the marriage of Ariadne and Dionysus. So, the soul opened itself up to the fructifying principle, representing the psyche animated by the dawn of a new light from the sea of the unconscious. In this way Ariadne faced the unknown in a receptive mood, opening up to the spirit, while sleeping the sleep of death.

Movement Experience – Abandonment

To prepare for Ariadne's abandonment, lie down and listen to your breathing. Imagine your physical boundaries, the shape of your body, the enveloping skin and what it means to be separated by the skin from anything else around you.

Experience Ariadne being abandoned. She wakes up and finds herself alone. Have you any analogous experience in your own life, being left, abandoned, uncared for? Has anyone broken what you felt to be a sacred promise?

Experience the coldness of being abandoned on an island... Feel the dewy limbs, feel the seabreeze sweeping through your hair...sense the ocean waves breaking...hear the sound of the waves gushing in and returning to the sea, only to rise once more...again and again: can you give way, to become part of the natural dance of the elements?

- How do you feel about being there, being alone on the rocks? What emotions does it raise in you?
- Can you look for the face you had before the world began?
- Do you have a glimpse, a rare moment of recognising something old or new in yourself?
- How do you wake up? How do you meet Dionysus? What is your attraction for him?
- Do you trust him, or not?

EXPRESSIVE ARTS Reflect on your experiences, convey it to paper: drawing or writing, or both.

RESPONSES Share with other members of the group.

'One client started to wail and burst into a flood of tears. She'd had a tragic life experience, losing one son in a motoring accident, while the other two sons went their own way abandoning her; her husband had long before married someone else, and she contracted leukemia... Suddenly the pain hit her

like never before, she experienced it by tying her heart to her womb with Ariadne's red thread... and now she was able to talk and share her pain without having to mould her heart into an enclosed and invisible mound, as she had done before in her dreams.'

'I can get far more done by staying depressed and accepting and realising it's there. A lot of depression is correcting an imbalance. It's as if I have been terribly outwardly focussed for a while and I need a period when I am not and it is diffuse for a while. And I nearly always find a book or a series of books that are like the lights.'

AN EXCHANGE BETWEEN FOUR WOMEN

A: 'Just take the pills deary'...when doctors and husbands say 'It is normal'. They can't conceive that antidepressants block off the path to the unconscious, and so eventually destroy the will to live.'

B: 'I think for men the underworld is particularly terrifying. Their structured, patterned existence is disrupted.'

C: 'Our society encourages in men the macho image, that's why they find these moods in women so overwhelming.'

D: 'We women get a monthly booster, we go down each month before we menstruate, men go on forever until a big wave comes to knock them flat, and they are really frightened.'

The Dionysian Experience

'Through the Dionysian the body may be re-appreciated as a metaphorical field. Dionysus was called Lysios, the loosener. Lysis means loosening, setting free, deliverance, dissolution, collapse, breaking bonds and laws and a final unravelling...'[4]

Hillman, 1984

Dionysus needs to be approached with reverence and a sense of the sacred. We highlight him as a Universal Model – an archetype – based on traditional Mystical Ceremonies.*

We work both inside and outdoors, as befits his Mystery. Inside we sanction the room as an initiation chamber, a place of sacred transformations... The Dionysus Cult could boil over, and so the structure of the Mystery offered a sanctuary where the boiling emotions could be transformed. Outdoors, we incorporate the natural world that is his habitat, where we can call up the undomesticated presence of Dionysus.

* The Eleusian Mysteries were the Greek form of the Descent of Inanna, the Sumerian Goddess.

His is libidinal love that initiates the impulse to create, and procreate and frees the soul from the confines of strictures. It is also symbolic of the religious experience of assimilating a god into the human body.

Movement Experience

CHANNEL-
LING ENERGY

Begin by rolling on the floor until you find a place where you can lie comfortably.

Lie on your back, change to either side, change to the front of the body... In search of the positions bend the legs and move the pelvis as freely as possible.

On the back, bend the legs, put the feet on the ground, pelvis width apart, so that the spine can be pushed or pulled, and you can feel the movement of the spine between the shoulders: the connection of the pelvis with the chest and the head... Feel the flow of energy through the whole skeleton.

Lie on the side in an embryo position... move the pelvis forward and backward in relationship to the body... Allow this movement to flow right through the body... contract and expand to allow maximum movement, from complete contraction to extreme expansion and stretching.

Sit on the pelvic bones, the sitting bones... move the torso forward, side and back... and in a circle clockwise and anticlockwise, allowing the body as much freedom as possible... Let the movement flow... Increase the movement until you touch the floor with hands and arms.

Crawl across the floor with as much freedom as you can... Allow arms and legs to find their own rhythm and coordination.

GUIDED
IMAGERY

Find your own Dionysian energy here in a safe and caring environment, as something ongoing, a changing dynamic process, which is part of you and you are part of it... Your creativity is there to serve not only yourselves but life itself.

- What is your most cherished sense of being creative?
- What steps can you take to allow your own creativity to be nurtured?
- What are you willing to sacrifice to a higher purpose, to a creative venture, whether individual or collective?

- What have you avoided, because of lack of confidence or your non-belief in your own power? Which boundaries would you like to break?

Remember your own path – what experience was most important, most relevant to your present life?

Movement Experience with Symbolic Objects

From the ancient Dionysian Mysteries we use: the *Thirsus*, twigs, vine leaves, Kista Mistika, and meet Dionysus in the guises of *Bull*, *Goat* and *Snake*. We also use masks and pieces of chiffon or gauze to enhance the movement.

Each of the participants is to have a stick to symbolise the *Thirsus*.

Play and dance with the stick, experience your relationship with it; guide it, and be guided by it; meet others with it, greeting, separating, creating boundaries, overstepping other people's boundaries.[5]

EXPRESSIVE ARTS — Reflect on your experience physically and emotionally.

REFLECT-IONS — One client, a film maker, talked of the film she had just finished, 'The Hidden Wisdom', in which: *the staff is the symbol of transformation and emigration of black women...*

'The staff becomes the symbol of empowerment through the Goddess, a youthful maiden signifying her eternal nature – she throws the staff, joining images of forestland, sea and air, while emitting a scream from the fire of her belly... from the past, like a rebellion.

The black older women shown in the documentary are alive because in their memory they express these ancient unconscious manifestations. They relate and recall the memory in their presence, of the ancient Goddess who has accompanied them on their physical emigrations, from Africa, to the Carribean, and lately to England. This then becomes their internal journey, the one that binds them together through all their historical movements.'

The 'Kista Mistika', symbol of the mother, was a sacred container for the divine. It served to protect a potent energy, that needs to be approached with reverence. In the classical initiation ceremonies the god would be symbolised as a snake, and placed in a box.

Movement Experience

<div>

WORK WITH
REAL OR
IMAGINARY
BOXES

Finding the Kista Mistika, open yourself up to the experience.
How do you perceive the energy contained in it?
Can you open the box, or do you need to keep it closed?

</div>

RESPONSES One who opened, suddenly lost all the tensions that she had
held throughout the workshop, commenting immediately:
'Like Pandora's box, when I opened it, I felt an elation of hope,
of possibility once more...'

MEETING DIONYSUS

As instruments of transformation, Dionysus will be met in different
shapes and guises: the *Bull*, the *Goat*, and the *Snake*.

GUIDED
IMAGERY

Meet Dionysus in your imagination in the form of a bull: wild
generating power. He can be still as well as powerful, frenzied
or dangerous. The bull exhibits the duality of giver of life and
destroyer.

Meet Dionysus as a goat. According to the legends he
changed into a black goat while being in flight from the terrible
Typhon.

> How do you perceive the goat?
> As a he-goat, or a she-goat?
> Earthbound, nimble footed, lecherous, eating the vine
> shoots?
> Meet Dionysus as a snake: it can be the contained
> snake energy embedded in the Kista Mistika; or a free
> snake, living in nature.

How do you perceive the snake? Do you befriend it? Are you
frightened of it? Can you relate to it, or do you flee and leave
it by the wayside?

EXPRESSIVE
ARTS

Reflect on your experience, translate it into drawing, writing
or any other physical manifestation... Share the experience
with your partner, or group.

The Maenads

'The mystery is always of the body,
The mystery is always of the body of a woman,
The mystery of the mystery is being woman.'

Hall, 1988

Having experienced the Labyrinth, the Minotaur, Ariadne's abandonment, Dionysus's various disguises, can you express in movement, voice, on paper: in three dimensions *'the Call'*? Your feelings of a Maenad accompanying Dionysus, being part of a Dionysian Mystery? Seek Dionysus, call him into you, search for him on your own, and then within the group.

Often the call of the Maenads can come to women who have been restricted, suppressed, undervalued and who lived removed from nature, in cities... The great question is when a woman is faced with The Call, to nature or to her own nature, will she respond to it?[5]

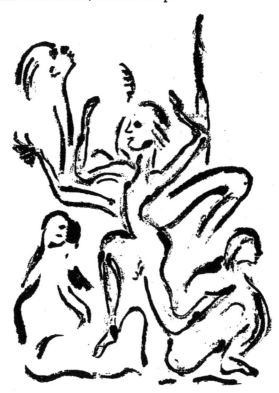

Dionysus (Leah Bartal)

Personal Stories

'There was one rock like a statue of a man, sitting on a chair. I imagined him to be Dionysus, a primaeval meaning of the vitality of life...'

'The extreme example of 'riding your anger' is Jimmy Boyle, who harnessed his anger from being a murderer, he became a sculptor and created a social centre in Edinburgh.'

'There is sadness and fear that holds me back, these things have to be worked through...'

'I circled closer and closer to the black hole, after a few years I could suddenly stand inside it.'

'Adapting everything around me would lead me to death... I need to step into creativity, otherwise it would really mean death for me.'

'One needs to lose speech to discover another aspect of the Self... I lost words completely and a little later I erupted, and at Christmas I was able to face something for the first time in my life.'

'Dismembering, dis-remembering, letting go, being reborn – no longer attached to the discomforts.'

'I discovered the parts in me that are fragmented, but I can recognise them now as something bigger than myself... my own rhythm is often not in tune with society and it is difficult to listen to my own nature... I tried to solve relationships with people through my head and then suddenly the emotions took over... I need to take things in my heart first and in the head only after...'

'The feeling of bubbling ecstasy is something completely new for me.'

'Dionysus has arrived and it is a matter of finding the energy to do something... not to stay underground.'

'The moment Dionysus and Ariadne met the energy started flowing; we started to dance and the energy came from the dance...'

Epilogue

Allowing your breath
Looking back on your path

> 'How do I know the way of all things
> at the beginning?
> By what is within me.'

<div align="right">(Lao Tzu)</div>

Having shared your journey with us
You will have discovered more of yourself –
The ME that is the real ME within YOU.

> 'The wide pond expands like a mirror
> The heavenly light and cloud shadows play upon it.
> How does such clarity occur?
> It is because it contains the living stream from the Fountain.'

<div align="right">(Chu Hsi)</div>

Resources to the 'Mythic Journey'

The following notes serve as complement to the book. They focus upon archetypal symbols, and offer sources that link the two primary states of human existence – the physical and metaphoric, or body and soul, at the heart of body/mind/spirit consciousness.

These sources concentrate on the metaphoric or 'mythic journey', and cover the main themes we explore – such as the need to harmonise and integrate both personal and universal polarities, shadow, masculine and feminine consciousness.

Throughout human history the 'mythic journey' has been recognised and well documented as something unseen, yet real and present, affecting the individual and society. However, its non-material and seemingly invisible nature offers a deeper meaning of life – one not readily accessible at the surface of day-to-day existence – which has made it vulnerable in the face of more tangible and material explanations. Hence, the practice of ignoring the relevance and harmonising qualities of the 'mythic journey' as something ancient and irrelevant; and which has led to its relegation to the back- shelves of human consciousness – can be perceived as the root of the contemporary crisis facing humanity, both itself and in its relationship with planet Earth.

Introduction

1 'LECH-LECHA' – THE CALL TO TRANSFORM ONE'S CONSCIOUSNESS

Suares (1985, pp.149 and 290), commenting upon The Call found in Genesis 12:1, states: 'The words ascribed to YHWH when assigning his mission to Abram, "Lekh-Lecha", have great significance'. Expanding on the verse: 'Lekh-Lecha Min Artsekha' – 'literally "towards you, into you (away) from your earth"...' he points out that 'The Call' has been misrepresented by the canonical translation 'go from your country'. Hence, 'The Call', instead of confirming the need to transfer one's place of habitat, stresses the need to transform one's state of being or consciousness – encouraging us to move away from purely physical and material concerns to those of a spiritual and creative nature. Halevi underlines the intention clearly: 'The challenge of the human soul is to understand its physical and spiritual bondage in incarnation and find the way to "The Promised Land" of the spirit'.

2. SYMBOLIC DIFFERENCES BETWEEN EAST AND WEST

For a symbolic interpretation of the two cultures, see the Wheel card in Sallie Nichols, *Jung and Tarot* (1980, p.188). Eastern culture, located close to the Wheel's centre, represents 'a world of archetypal principle slow to change'. Western culture, located 'near the Wheel's periphery', expresses that the realm of archetypes has 'been spun out into objective reality'. Hence, 'The introverted Easterner is con-

cerned with general principles, eternals, unity, stability, and pure being. The extroverted Westerner is more caught up in worldly objects and experiences. His is a world of motion, freedom, diversification, and specialization'.

THE WEST'S BURIED TRADITION

Suares, like Jung, discourages Westerners from wholesale adoption and embrace of Eastern techniques at the expense of overlooking the West's own buried esoteric and spiritual tradition. One of the earliest roots of this tradition is found at the heart of the ancient Hebraic consciousness known as Qabala.

The Qabalist tradition is bound in the Bible, with *Genesis, Exodus,* and the *Song of Songs,* the leading lights of its deeper wisdom and understanding. Two recommendations are Carlo Suares' *The Qabala Trilogy,* and *Kabbalah and Exodus* by Z'ev ben Shimon Halevi. These outline a spiritual journey as profound and instructive, with the same potential for healing and transformation, as any to be found in Eastern traditions.

THE 'BERESHYT' TEXT – TREATISE OF CONSCIOUSNESS

Carlo Suares spent 40 years deciphering the original Hebrew text *Bereshyt* (known as *Genesis*). His Qabalist method utilises the ancient letter–number principles inherently built into the Hebrew alphabet, i.e.: Aleph (A) = 1; Bet (B)= 2, etc. As Suares states (1985, p.41): 'Nothing is important except the knowledge that the key to the Revelation is to be found in the letter–numbers'. Each letter–number is symbolic on one of three levels or 'states of energy'. These three levels are the physical, psychological and spiritual: or, as expressed in *The Metaphoric Body,* Body–Mind–Spirit.

Suares presents *Bereshyt* as a 'Treatise on Consciousness' and thereby gives recognition to the manner by which the Ancients perceived the workings of nature in relation to the human condition. As such, 'The Cipher' reveals both the scientific and esoteric understandings of the ancient mind. The *Bereshyt* text describes the workings of the human mind contemporary with the major innovations of western civilization: the wheel, the alphabet, astronomy, monotheism, etc. The text, unveiled correctly, ultimately presents us with the evolution of consciousness at the base of all these transformations, which issued out of the Mesopotamian 'Fertile Crescent, The Cradle of Civilization'.

Suares highlights this tradition as having spread not only West but also Eastwards. The revelations of Abraham and Brahma (the Sanskrit God of Creation), seen in light of Consciousness, are essentially one and the same at their source. Not only do the names suggest this link, but also, all the markings of Eastern philosophies: Yoga, 'Kundalini Serpent', Meditation,'Tao' 'Shiva-Shakti', 'Lingum-Yoni', 'Yin-Yang', are to be found within the Abrahamic Enlightenment, simply with different terminologies, which in the East are manifest, but in the West have been obscured.

The name Abram makes reference to this union of East and West. Ab-Ram (literally 'Father of High' or 'Father of the Exalted'), in Qabala, implies 'He or She who contains or possesses the universal essence within the self'. Ram is well known all the way from Egypt to India-Tibet as the 'Basis of all Life' (Suares 1985, pp.14–15).

3. THE QABALISTIC ALEPH, and A-DAM = ALEPH in 'BLOOD'

Suares, (1985, pp.20–21, 26) states: 'The Qabala insists on the significance of the name Adam: "dam" in Hebrew means blood. With-in it is the hidden Aleph'. Aleph can be substituted for Goethe's 'inscrutable', or mysterious enigmatic Spirit, that energises all life and consciousness. In the context of our work, if we allow Aleph,

the transformative spirit, to energise us, we become its vehicle and are able to perceive our Metaphoric Body in its embryonic form. In so doing, we are encouraged to open, explore and develop our own creative potential. Suares underlines both the origin and universal notion of the metaphoric characters: 'archetypes are in us prior even to the formation of our psyches. Whatever their names, they exist in every human being. In some parts of the world they may be called Vishnu and Shiva, or Yin and Yang, or other wise' (ibid, p.126).

Rebekah – Initiation + Choice

1. Rebekah comprehends the meaning of the two nations – or duality – inside her, and initiates Isaac's choice of Jacob over Esau (Suares 1985, p.171). Rebekah is the symbol of accomplished and transfigured womanhood [ibid p.165]. Her attributes are Initiative, Action, Freedom, and Self-Reliance. The episode where King Abimelek sees Isaac and Rebekah freely associating (*Gen.* 26:8), expresses a recognition of the feminine or woman as adult and free companion of the male, seen openly to be able to express her feelings and emotions. Suares decodes her name to mean 'A projection of the Universal (200) into the Individual (2), and the individual may emit (put forth) the cosmic Aleph (100), alive (5)!' (ibid, p.163) In other words, she allows the power of Aleph to take effect within her, and thereby knows how to transmit its hidden or veiled meaning to those around her. In this way she represents a person not fooled by illusionary or vain concerns.

Scapegoat

1. AZA'ZEL

The name 'Azazel' is a composite of 'Ez' a goat, and 'Azal' which can mean to go/to escape. Perera states, 'Azazel was a goat god of pre-Hebraic herdsman connected to the feminine, sensuous beauty and to nature religions' (Perera 1986, pp.18–19).

The first goat was killed for blood atonement and purification, while the one dedicated to Azazel carried away evil to the desert of the collective unconscious. The distortion of the original intention has led to the threats of desertification of both the human soul through alienation, and the planet earth through pollution/war. The old ideal of the wilderness was as a place of preservation of the remembrance of things lost: a deep point of reflection – where 'Israel' found itself in the process of Exodus, and where Jesus faced the Temptations.

2. MYTHOLOGICAL ANIMAL OF GODS OF TRANSFORMATION – ENKI/PAN/HERMES/WITCHES' SABBATH

It is further interesting to note the mythic role of the goat as a sacred animal of gods who rule the Realm of the Shadow, such as Sumerian Enki, Greek Pan, Hermes and Dionysius; all of whom personify the element of transformation, through wisdom and ecstatic ritual.

3. SUFFERING SERVANT/SGOAT PHENOMENA

'The Scapegoat phenomenon is a particular expression, along with Cain, Ishmael, Satan, witch-hunting, minority persecution and war, of the general problem of shadow projection. It is, as we know from anthropological data, an almost universal phenomenon. In cultures where conscious connection to the transpersonal source has not been lost, the one identified with the scapegoat serves the community by returning evil to its archetypal source through sacrifice, carrying back to the gods a burden too great for the human collective to bear. In Western culture, those who

suffer identification with the archetype share the burden of the central divinity of our eon, for the archetype of the Messiah as Suffering Servant is at the core of the Western psyche. We all feel its power and share its effects to some extent'. (Perera 1986, p.98)

4. SWASTIKA

For a detailed interpretation and historical–mythological background, see Campbell *Primitive Mythology* (1987, pp.141–143, 232–233). It appears in all parts of the world, from the Far East, to North American Indians, and the Ancient Near Eastern sites of Halaf and Samarra.

The swastika whirls in two directions:

(i) Clockwise – referring to what Campbell calls 'conjuring up' or 'making visible' the godhead: the process of Western Culture and Civilization.

(ii) Anticlockwise – referring to the 'conjuring away' of the godhead, as in the Buddhist tradition of the attainment of Nirvana.

See also Cooper *An Illustrated Encyclopedia of Traditional Symbols* (1978, p.165–6), which states: 'In all circumstances it is a symbol of good luck; good augury; good wishes; blessing; longevity; fecundity; health and life'.

'It is also suggested that the swastika is a conventionalized human form of two arms and legs or the union of the male and female principles; the dynamic and static; mobility and immobility; harmony and balance; the two complementary phases of movement, centrifugal and centripetal, in breathing out breathing, going out from and returning to the centre, beginning and end. Again, it is suggested as a version of the labyrinth; of water in movement... Or the Qabalistic Aleph symbolic of the primaeval motion of the Great Breath whirling chaos into the creative centre'.

THE SERPENT, SATAN, AND THE DEVIL – EXAMINING THE NATURE OF EVIL

The misconceptions surrounding the swastika can likewise be highlighted in the original ideals concerning the corrupting motif and the corrupting figure at its base. Hence, the Serpent, Satan, and the Devil, are often misguidedly identified as one and the same. Rather, they are most simply equated:

I　Serpent – The Agent of Transformation

II　Satan – The Teacher in Adversary

III　Devil – The Confuser: Agent of Manipulation and Evil.

I. The Serpent originally was a symbol for the libido and transformation – responsible 'to make one wise' (*Gen*. 3:6). Suares (pp.116–117) calls the serpent's energys a 'fire' that is 'initiatory and becomes knowledge through transmutation of sex into creative intelligence'. As such it is the 'carrier of all memories of forgotten wisdom to new beings...who must consume the past and be its fruition'.

The serpent's action upon Eve, leading to the plucking of the fruit, has been crucially misinterpreted in the translated words which we we have come to know as 'beguile' or 'seduce'. Suares (p.121) relates: 'What the true reading gives is far more significant. The Hebrew phrase (*Gen*. III.13) 'Hanahhash Hashayiny (Hissiany)' as is often true in the most beautiful passages, is impossible to translate in two or three words. It has to do with the letter Sheen...which stands for the cosmic breath of life [or Spirit]. Now Hanahhash Hashayiny (Hissiany) simply means that Nahhash, the serpent,

'Sheens' her' – in other words, the serpent's fire enflames Eve, which is an ancient metaphor for the libido's enflaming or initiation of the psyche.

The Edenic serpent directly correlates to the action of the Kundalini serpent upon the chakras in Yogic Consciousness. The letter Sheen, shaped as a Trident, may be likened to Shiva's symbol, or correlated with Chinese 'Chi'; the breath of life animating the human being.

This initiation is the key to the Eden Mystery – wherein the human, Adam, who was created 'male and female' (*Gen.* 1:27), undergoes a transformation – from simply existing to be 'fruitful and multiply' in order 'to replenish the earth' (*Gen.* 1:28) as all other creatures, into an intelligent and spiritually aware being, able to break nature's round of breeding and feeding in order to conceive and give birth to its own ideas and creations, and so become a Civilized being.

II. Satan, as is well known in Semitic traditions, is the 'adversary or accuser', that manifests when we face our deepest conflicts and stubbornness. The satanic influence manifests as static unmoving authoritarian energies. As Suares states, the satanic energy is 'a confinement in structure...a continuity in existence which resists its own necessary destruction'. [p.185].

III. The Devil's influence, as stated in '*Jung and Tarot*' (p.262): is referred to as confusing, 'the Devil is confusing because he himself is confused'. Hence, the Devil represents manipulative energies opposed to transformative ones, and as such breeds evil and destruction.

THE CADUCEUS

The Caduceus, symbol of Western medicine, identifies initiation through the serpent as based on a duality – These being the healing and destructive forces. Identified with Hermes, the Alchemical Mercurius figure of transformation, the duality is also at the base of the archetype of the Trickster.

TRICKSTER/LOKI/JESTER

The Trickster is the shapeshifter. If mistreated, he becomes like Loki, the leader of the Host of Hell in the Norse myth of *The Twilight of the Gods*. But, if approached correctly, he can be said to be the teacher of mankind, or the bringer of fire (as he is in one form or another, e.g.: Coyote, of the North American Indians). The fate of Prometheus alerts us to the potential of the Trickster, but also reminds us 'of the tragic patterns of man's relationship to the governing powers of the natural universe'. The Trickster effect can also be recognised in the story of Job. As Jung points out in his 'Answer to Job', even the godhead is portrayed as having an Alter-Ego, a dark unconscious side to its meaning. God embraces all opposition, including that of consciousness and unconsciousness. This is the process of *The Way* in the Chinese tradition, which embraces the light-dark of the Yin-Yang. The Trickster in Europe can be identified with Raynard the Fox, and in the Grail Legend, in his positive outlook, as the Holy Fool (Perceval), or the role of the jester, and modern clowns such as Charlie Chaplin, or the Marx Brothers.

Deborah
THE HULUPPU TREE – PROTOTYPE OF THE TREE IN EDEN
The mythical tree associated with the Sumerian Creation story is identified as a date palm. Its influence on Mesopotamian mythology is likewise recounted in the Hebrew tradition: 'The Hebrew story of creation parallels the Sumerian account of "The Huluppu-Tree"...(Wolkstein and Kramer 1983, p.144) While the tree itself also provides for both cultures a configuration of the forces of life and death, and consciousness and lack of knowledge' (p.145). (For full detail and description of Huluppu poem see pp.137–145.)

THE IMPORTANCE OF THE DATE PALM FOR THE MESOPOTAMIANS
'The date palm was also an important economic source for the ancient Mesopotamians. It's fruit is of great nutritional value and can be preserved and stored; its leaves, fiber, and timber provide numerous by-products; and it survives easily in the salty soil and water of Mesopotamia. These factors, together with the fact that the date palm requires the services of a horticulturist in pollination if a substantial crop of dates is to be harvested, must explain its frequent appearance in Mesopotamian texts and art...In Sumerian art, the date palm stands before deities and is the focus of libations and, perhaps, symbolic ritual fertilizations'. (ibid, p.178)

DATE PALM AS SYMBOL OF FERTILIZATION
'Inanna herself...is called 'Lady of the Date Clusters' and represents the numen [spirit] of the communal storehouse for the dates. Her spouse, Dumuzi, called Amaushumgalanna: 'The one great source of the date clusters' is personified in the enormous bud that the date palm sprouts each year-the source of the leaves, flowers, and fruit'. (ibid, p.178)

In light of these definitions, the fact that Deborah is to be found seated under the palm tree (*Judges* 4:5) would seem to link her with the more ancient tradition. Now that we have re-discovered the influence of 'The Descent of Inanna', we can imagine that Deborah – or the Age in which her story is told – was familiar with this myth and symbolism, at an historical moment in time not so distant from the recordings of the legend. (This Age, c.1700 BC can be calculated to as little as 300 years after the Mesopotamian record, dating to c. 2000 BC.)

THE TREE OF THE ANCIENTS – SYMBOL OF INTERNAL AND SPIRITUAL GROWTH
The tree has long been identified with spiritual growth, leading to personal and group consciousness. Wherever we look, whether in the ancient Near and Middle East, Norse Myth (Tree of Woden), American Indian (Totem), Hindu-Buddhist (Buddha Tree), etc; its symbology is consistent within the collective unconscious.

THE TREE IN QABALA
The Qabalist tree is a well known and popular symbol. Its roots may be perceived in the Eden story.

It is little realised that no mention of an apple tree is contained in the Hebrew text. Indeed, the two unique Trees of Life and Knowledge are distinctly separate from 'every tree that is pleasant to the sight, and good for food' (Gen. 2:9). In other words, to equate the Tree of Knowledge with any of nature's organic species goes against the text's basic principle. A similar mistake of interpretation characterises the image of God: whereas in Greek and Latin cultures there is an image of an old man in the sky, there is no such concrete image in the Hebrew tradition

The word for tree, 'Etz' symbolises growth. As such the 'Tree of Life' and 'Knowledge' imply internal growth – of psychological, emotional, and spiritual faculties – in the struggle of maturity of what we term 'Body-Mind-Spirit' Awareness and Consciousness. The projection of the apple tree is an addition, probably popularised at the time of the Greek translation, drawing upon the Hesperides Myth of the 'Garden of the Golden Apple in the Island of the Blessed' – as found, for example, in the 'Trial of Paris' preceding the Trojan War, and the 'Labours of Hercules'.

This growth initiates one to the existence of a duality, or alternating currents in life, and represents the rise of consciousness and the responsibility associated with it.

THE EDENIC FIG LEAVES – METAPHOR FOR DEEP EMOTIONAL EXPRESSION

As a further example of the symbolic and metaphoric use of trees in Genesis, we can briefly turn our attention to the 'fig leaves' found in the Eden Myth, (*Gen.* 3:7).

Fabre D'Olivet, in *The Hebraic Tongue Restored*, (Samuel Weiser 1976 – originally published in French, 1815 – Part II, pp.102–4;) offers an illuminating insight into the linguistic rooting and symbolic meaning of the fig leaves which is further underlined in context of the given Hebrew dictionary meaning of 'camouflage'. D'Olivet expresses the idea of the 'camouflage' where the word for 'leaf' gives rise to a 'shadowy elevation, a veil; a thing elevated above another to cover and protect it'; the word for 'fig' is revealed to be 'an expression of grief not only in Hebrew, but in Samaritan, Chaldic, Syriac, Arabic and Ehiopic'. He summarizes the meaning so: 'to be plunged in grief, to cry out with lamentations, thence, sorrow, affliction: and finally deep and concentrated grief that one shares or communicates'. He further states: 'It is presumable that the fig-tree has received the metaphorical name on account of the mournfulness of its foliage, from which lactescent tears appear to flow from its fruits'. In the context of Fabre D'Olivet, the popular conception of the fig leaves as symbolic of emotional suppression and shyness is misrepresentative. Instead, we see within them the ancient Middle and Near East's concern to express one's veiled or deepest emotions.

Aphrodite/ Psyche

1. See Esther Harding *Woman's Mysteries* re: 'virgin'. As virgin she belongs to herself alone, she is 'one-in-herself'.

2. The marriage of Archetypes can be likened to the union of energies, masculine and feminine, positive and negative, which govern all life. See *The Rabbi's Tarot*, for unions of Venus/Aphrodite. Harmony is born of this union when allowed to be active in us: Joy/Pleasure is the offshoot of Psyche and Amor, leading to creative splendours, while terrors and distortions take root if they are unassimilated.

3. Neumann calls the love of psyche and amor 'a *psychology* of encounter'. Further, he differentiates between Aphrodite and Psyche: 'Aphrodite represents the union of the anonymous powers of Above and Below; in uniting the masculine and feminine she operates as a universal and anonymous power. With Psyche, an earthly, human realization of the same Aphrodisian principle has come into being on a higher plane' (*Amor & Psyche*, p.90).

Suares, highlighting the importance of the feminine in the scriptures, likens the role of eve to psyche. 'The role of the development of the feminine is one of the

principle elements in the whole of Hebraic-Christian mythology. We have seen it represented by Ischah (Woman) in Eden, by Mary of Magdala (Magdalene), and we find it again in other myths, for example, under the name of Psyche' (1985, p.424).

The role of Eve as the psychic rather than biological mother, can be further clarified. *Gen.* 1 describes the evolutionary function, at the conclusion of which Adam is created 'male and female' (*Gen.* 1:27); *Gen.* 2 manifests Adam's 'living soul' and its offshoot psyche – revealed as the 'Shadow Eye', rather than 'rib' (see p.221 for 'play on words'). Thus the Eden myth (*Gen.* 2–3) deals with an involutionary or internal function. Suares highlights human beings as subject to a 'double reality' – of 'external existence' and 'internal life'. Hence 'Adam and Eve' = the formula 'Homo + Sapiens', only when, as intended, the original value of 'Homo' signifies both genders, and Eve 'the mother of all living' (*Gen.* 3:20) identifies her as the 'Mother of all Knowledge or Wisdom': Gnostic Sophia.

4. Eve's labour pains and sorrows – the hebraic 'tasks of psyche': The 'Tasks of Psyche' or psychological tasks that give birth to a new idea following trial and tribulation, is likewise recounted in the Hebrew text. However, its location and relevance in *Genesis*, is obscured by the biological rather than psychological role attributed to Eve. D'Olivet, (1991 Part II p.112–3] reveals that the so called 'curse' upon woman to 'multiply' her 'sorrows and conceptions' (*Gen.* 3:16) expresses the difficulty of bringing mental or psychic conceptions to fruition. Eve's travails as Psyche's, will experience: 'obstacles of all sorts' while resistance to them 'shall be overcome, only by dint of labour and of time'. This Qabalist reference, paralleling physical and mental conception, as in Tao, reflects upon a symbiosis between natural and psychological phenomenon. In this case, the birth of a child and birth of an idea are seen to follow a similar course of fertilisation, lengthy gestation and a painful birth. This relationship is revered as the most profound and pure reflection of the act of creation. The travails of psychic labour and creativity is also the theme of Halevi's *Kabbalah and Exodus*.

See Campbell's *Creative Mythology* (1976) and Von Franz and Emma Jung (1986), for the Grail ideal of 'The Transformed Heart' as result of successfully undertaking the tasks of the psyche. Likewise, Scherazad plays the same archetypal role of the Anima in '1001 Nights', transforming the heart of the tyrant.

5. The inherent dangers of failing to complete the final task is revealed in the fate of Moses, who was not permitted to enter the Promised Land, because he struck the rock to unleash a torrent of water out of his own Will rather than of God's: as the Lord states 'in order to sanctify me in the eyes of the children of Israel' (*Numbers* 20: 12). Hence Moses transgressed in fulfilling his Psychic task of merely being the vessel of the Divine, the guide and not the redeemer of Israel. Both these points are covered in *Kabbalah and Exodus*.

Oedipus: Reflections on the Myth
1. THE SIN OF THE HOUSE OF LAIUS
Laius provokes Oedipus by running over his lame foot at the cross roads, thus striking at the heart of both a personal and familial wound. While Oedipus believes himself to be on a corrective journey or healing path, he has not yet realised or come to grips with the crisis at hand – 'the tragedy waiting to happen'. Laius's denial of Hera and his refusal to listen to Tiresias, at once symbolises denial of both (a) the feminine, and (b) the shadow – or internal, non-material, dream-induced aspect of

one's personality. Hence Tiresias's external blindness veils hidden psychic vision – through which is revealed a deeper meaning of life not visible to the naked eye. He sees through what is known as 'The Third Eye' (the 'Eye of Horus' in Egyptian myth).

To the ancients this subterranean vision revealed the 'Realm of the Shadow' or 'Soul' – whereby the godhead was perceived to reside inside each one as an internal voice, and not as a mystic external other: hence the Delphic inscription 'Know Thy Self'. The tragedy of Oedipus is the abandonment of oracular or psychic consciousness, as is the fate of Theseus in the Minotaur myth. The danger of refusing to assimilate the intuitive powers is indicated in the story as leading potentially to an evil fate for the individual, and causing disease of the social collective, and the environment, as symbolised by the plague. We are encouraged to gain Tiresian insights, thereby avert a tragedy-in-waiting. In this way we gain joy and reward by working towards a new level of consciousness and awareness regarding oneself, society, the environment, and nature at large.

REKINDLING ANCIENT CONSCIOUSNESS OF FEMININE AND SHADOW REALM

Oedipus inherits a twin conflict of which he is initially a victim, although, through his struggles and final catharthis, he becomes a symbol of its redemption.

The tragedy touches humanity's individual and tribal consciousness, which Freud outlined as the bridge between personal psychology and the collective Taboo or moral. We see that Oedipus kills the father who symbolizes the dominant masculine order, and marries the mother, the ruling feminine principle. This represents Oedipus identifying with the feminine or matrilineal order rather than the masculine patrilineal one. Matrilineal societies did not concern themselves with paternity rights, and hence not with the associated guilt feelings attached to patriarchal values of heritage. Patrilineal concern suppressed female rights, in order to engender its own lineage.

The Oedipal guilt is here diagnosed as mistreatment of the goddess principle or Jungian 'Anima', and the cyclic laws of nature and the feminine. The consequence of her mistreatment is a metamorphosis in physical symptoms of illness and moral dilemma that lead to both disturbing and tragic human behaviour, and the wrath of nature. Hence Oedipus seeks redemption of the feminine.

The myth offers us an understanding – that if on the individual and collective level we attune ourselves to assimilate the feminine psychic principle, then we are likely to see differing personal, interpersonal, familial, social and environmental ties developing. These ties we explore in our work.

THE FEMALE CHARACTERS: ASPECTS OF THE 'ANIMA'

Through all the feminine characters in this myth reverberates the denial of the feminine–Yin principle. They reflect both the wrath and redemptive/transformative powers of the feminine upon the individual and collective.

The Erinyes:

Usually three in number, the Erinyes manifest as a kind of noxious swarm, inflicting a punishment of madness. They can be likened to nightmares.

For a parallel or prototype of these Hellish creatures in ancient Mesopotamia, see Perera's *Descent to the Goddess*, and *Inanna, Queen of Heaven* by Kramer and Wolkstein (p.68). From the poem of Inanna:

'The galla, the demon of the underworld, clung to her side.
The galla were demons who know no food, who know no drink,
Who eat no offerings, who drink no libations
Who accept no gifts.
They enjoy no lovemaking.
They have no sweet children to kiss'...

These nightmarish demons are the destructive opposites of the potential ecstatic vision represented by the Maenads. (See 'Dionysus and Ariadne'.)

The Sphinx

Von Franz in *The Problem of the Puer Aeternus* warns against a linear, festering intellectual relation with the sphynx that denies or is unable to react with the powers of intuition: 'One can't free creative energies with mental gymnastics, nor out wit human fate by clever answers. Likewise, it is no good to be philosophical at the moment one needs to react with instinctual behaviour' (p.11).

The theme of the conflict between intellect and psychic powers is presented in Bika Reed's *Rebel In The Soul – A Dialogue between Doubt and Mystical Knowledge* ('Inner Traditions International', 1979). Deciphering an ancient Egyptian text, it reveals the prototype of Apulieus's *The Golden Ass*.

Jocasta

Robert Graves translates Jocasta's name as 'Shining Moon'. Developing this theme, Bleakley states in *Earth's Embrace* (p.153) 'Iocassitere: Cassiterite is the most common ore of tin, stannous oxide, so the shining moon is the gleam of tin, and Oedipus is of the family of tin miners, who work the mother Earth's metals, and are in her service. Like Hephasestus himself, who also has crippled feet, Oedipus is said to be edgy, grumpy, bad tempered. In the smith's lingo, he is ill-tempered, has not been hardened properly, has clear faults in his metal/mettle, his quality of temperament...The heroic Bronze Age which spawned the Greek Heroic myths was dependent literally upon large quantities of tin for smelting with copper to make bronze'.

Antigone

Antigone is symbolic of the mistreated Anima, who is still faithful to the individual if one wants such guidance. And she stays throughout one's life, as with Oedipus, until his final release from material-external illusion.

THE PLAGUE – PERSONAL, SOCIAL, AND ENVIRONMENTAL DISASTER: - 'THE WASTELAND' IN GRAIL LEGEND, & BIBLICAL PLAGUES & FLOOD

The consequence of individual behaviour affecting the social fabric is highlighted by the plague on Thebes as is the plagues in 'Exodus'. See also *Kabbalah & Exodus* (p.70–102) for definition of the ten plagues of Egypt.

The Wasteland

These ill symptoms are to be found in the theme of the Wasteland within the Grail Legends. The Wasteland is a territory of repression which comes about due to the consequences of an unhealed wound. In the legend it is the wound of the Grail King, Anfortas, whose name comes from old French 'Enfertez' meaning 'infirmary'.

See Campbell's *Creative Mythology* and Emma Jung and Von Franz' *The Grail Legend*, for further psychological and spiritual implications of the Grail Legends, as well as for their historic and social significance. Campbell describes the danger of ignoring the link between spiritual and material concerns, as: 'the life-desolating effects of this separation of the reigns of nature (Earthly Paradise) and the spirit (the Castle of the Grail)'.

FAMILY TIES AND INCEST IN MYTH

See *The Grail Legend*: Emma Jung & Von Franz, p.177–178, re:

(a) The Wounded King being the matrilineal uncle of Perceval.

(b) The role of incest within the physical and psychological processes of the individual and group soul.

Dionysus–Ariadne

1. SLEEP IN THE UNDERWORLD – THE REALM OF THE SOUL & 'VEILED EYE'

This idea of the sleep in the underworld, is likewise to be found in the Eden myth – although in Genesis its meaning and significance has been little understood: where the offshoot of Adam's 'living soul' (*Gen.* 2:7) following the'deep sleep' (2:21) leads to the awakening of the 'rib'. The works of Suares [1985, pp.106, 108] and D'Olivet ['H.T.R' Part II, pp.88–9] – illuminate the Hebrew root for 'rib' is 'shadow', and that the word contains a double meaning. The second meaning is 'shadow-eye' or 'a veiling'. The 'shadow-eye' known also as 'The Third Eye' parallels for example, the Eye of Horus in Egyptian myth. Viewed in this light, the ancient Hebrew text corresponds with all the other major contemporary texts of its time (from Egypt, India, China, etc), expressing the workings of the human soul and psyche: the unseen, dream induced, non-material aspect of our personality. That Freud and Jung were seen as major innovators in the twentieth century for exactly this discovery, merely underlines how the ancient understandings have become submerged and neglected in the historical course of Western Civilization. Kramer [1961, p.102–3] underlines the rib as 'one of the most puzzling motifs in the Biblical paradise story'. Further, he determines a Sumerian literary influence upon 'the Hebrew storyteller' that reveals 'one of the most ancient of literary puns...through what may be termed a play of words'.

THE RIB / WOMAN / EVE – PSYCHIC INITIATION

The Egyptian *Book of the Dead* deals with the process of initiation into the 'Underworld' as a guide to the living and not the dead, as does the sleep of Ariadne. The Rib/Woman/Eve plays this same transformative role in the Edenic Mystery.

Below (based on Suares and D'Olivet) are listed the three distinct names associated with the feminine being. And where in English they have been generalised as one and misconceived as a physical biological woman, the Hebrew root of each offers us a distinct insight into Qabalist promptings of Adam's Rib, representing a three-fold psychological awareness of creative energy. This three-fold

enactment is repeated in the Saga of the Patriarchs, and the Christian Trinity. Its active significance most simply describes

(a) Natural phenomenon, and

(b) Psychic or Spiritual awareness of natural phenomenon: hence

(a) The Seed (1) in the Shell (2) Sprouts to Life (3)

(b) Likewise as metaphor, consciousness is revealed three-fold – Awakening (1) – Initiating (2) – Transforming (3)*

ENGLISH	HEBREW	ROOT	METAPHORIC
RIB –	TSALAA –	SHADOW –	AWAKENING (OF PSYCHE FROM SOUL)
WOMAN –	EESHA –	FIRE –	INITIATION OR INFLAMING (OF PSYCHE BY SERPENT)**
EVE –	HHEVA –	LIFE –	TRANSFORMATION (BY PSYCHE OF LIFE)

2. ARIADNE

Ariadne already knew the way of the labyrinth. As the Anima (Soul) she waited outside the Labyrinth while Theseus entered it by himself.

Theseus is an archetypal male hero. His fate links him to male-cycle tragedies, as with Oedipus. However, unlike Oedipus, he fails to achieve transformation.

By abandoning the Anima principle, he abandons her values of instinct and intuition. Ariadne, meanwhile, opens herself up to receive a deeper masculine love, a truly liberating one representing a fully evolved masculine principle. As such, her marriage to Dionysus symbolizes a personality bearing a healthy relationship with the Anima, embodying the Creative Spirit within oneself.

Ariadne's rude and depressing exposure to the underworld may be likened to Inanna's descent into her dark sister's, Ereshkigal's domain where, stripped of her splendours, and seemingly left to rot, she unconditionally must await her redeemer. Inanna's descent is also prototype for Persephone's rape and kidnap by Hades. [See Indexes for Ereshkigal, in: 'Descent To The Goddess'; 'Inanna – Queen of Heaven'; 'The Masks Of God'.]

3. SEE LABYRINTH

See: Von Franz and Emma Jung *The Grail Legend* for a parallel of the Labyrinthian ideal. Campbell also deals fully with the mythic Labyrinth.

4. 'RAA' AS 'LYSIOS' – AND AS PART OF THE 'TREE OF KNOWLEDGE':

The idea of 'Lysios' can also be found in the Hebrew word 'Raa', as presented by (Suares 1985, pp.102 & 120). He states: 'The process of Raa (translated 'evil') is really a loosening of our bonds, a thawing out, an awakening or quickening of the life force'.

The actual nature of 'Evil', Suares [1985, p.312] is found in another Hebrew verb, 'Shed' (Sheen-Dallet). However, he stresses that 'Shed' contains a 'most remarkable' paradox, since it is a root which gives rise to two diametrically opposed meanings. On the one hand: 'Shed' (Devil or demon) and 'Shadad' (plunder, despoil, loot,

* See also Note 5, concerning the importance of the feminine as transformer.
** See 'Scapegoat' Note 2: Serpent as 'Agent of Transformation'.

pillage and rob) – while on the other, there is 'Shad' (a breast) and 'Shadai' (The Almighty).

This inherent paradox can perhaps most clearly be defined in the following metaphor. If the breast represents 'life nurturing', then 'evil' is the negation and manipulation of life-nurturing energies that induces a feeling of intense turmoil in the breast.

5. See Neumann, *The Great Mother* (p.23–25) for the two characteristics of the female: elementary and transformative: the former as 'woman's experience of herself', her body's cycles and powers of birth and the latter as 'man's experience of woman'.

Suares parallels the importance of Neumann's 'Elementary' stage, thus: 'The theme of the necessary transformation of the feminine is very important in the Bible'. Having underlined its importance in the significance of Adam created 'male and female' (p.91 based on Gen. 1:27), he states (p.92): 'We shall meet it again in the feminine types of Esha, Hheva, Sarah, Rebecca and Rachel, etc...up to Mary, the mother of Jesus'.

Bibliography

Arieti, S. (1976) *Creativity the Magic Synthesis*. New York: Basic Books.

Auerbach, E. (1957) *Mimesis, The Representation of Reality in Western Literature*. New York: Doubleday.

Bartal, L. and Ne'eman, N. (1975) *Movement, Awareness & Creativity*. New York: Harper & Row.

Bateson, G. (1979) *Mind and Nature*. New York: Bantam Books.

Bernstein, P.L. and Singer, D.L. (1982) *The Choreography of Object Relations*. Keen, Antioch New England: Graduate School.

The Holy Bible (1971). London: Oxford University Press.

The Holy Bible – King James Version (1809). New York: New York Bible Society.

Bly, R. (1988) *A Little Book on the Human Shadow*. San Francisco: Harper & Row.

Boer, C. (1970) *The Homeric Hymns*. Dallas, TX: Spring Publications.

Bolen, J.S. (1984) *Gods in Every Man*. San Francisco: Harper & Row.

Bolen, J.S. (1989) *Goddesses in Every Woman*. San Francisco: Harper & Row.

Brenner, A. (1988) *Ruth and Naomi*. Israel: Kibbutz Meuchad, Sifriat HaPoalim.

Brooks, C.V.W. (1982) *Sensory Awareness: The Rediscovery of Experiencing*. Santa Barbara: Ross-Erikson Publishers.

Campbell, J. (1972) *Myths to Live By*. New York: Bantam Books.

Campbell, J. (1972) *The Hero with a Thousand Faces*. Bollingen Series XVII. New Jersey: Princeton University Press.

Campbell, J. (1974) *The Mythic Image*. New Jersey: Princeton University Press.

Campbell, J. (1987) *Primitive Mythology ('The Masks of God')*. Harmondsworth: Penguin.

Campbell, J. (1988) *The Power of Myth* (with Bill Moyers). New York: Doubleday.

Capra, F. (1975) *The Tao of Physics*. Boston, MA: Shambhala Publications.

Capra, F. (1982) *The Turning Point*. New York: Bantam Books.

Capra, F. (1989) *Uncommon Wisdom*. New York: Bantam Books.

Capy, M. (1982) *Compendium Abstract*. 17th Annual ADTA Conference: New York.

Capy, M. (1991) *Improvisation Story Telling for the Special Child in Arts with Special Need Students, from Theory to Practise.* Kansas City: Accessible Arts Inc.

Chaiklin, H. (1975) (ed.) *Marian Chace: Her Papers.* Columbia, MD: American Dance Therapy Association.

Chaiklin, S. (1975) Dance Therapy. In S. Arieti (ed.) *American Handbook of Psychiatry, 2nd edition.* New York: Basic Books.

Chuang, T. (1974) *Inner Chapter* (translated by Gia-Fu Geng and J. English). New York: Vintage Books.

Chung Yua (1963) *Creativity and Taoism.* New York: Julian Press Inc.

Cirlot, J.E. (1963) *A Dictionary of Symbols.* New York: New York Philosophical Library.

Cook, R. (1974) *The Tree of Life.* New York: Thames & Hudson.

Cooper, J.C. (1972) *Taoism, The Way of the Mystic.* Wellingborough: Aquarian Press.

Cooper, J.C. (1978) *An Illustrated Encyclopedia of Traditional Symbols.* New York: Thames & Hudson.

Da Liu (1974) *Taoist Health Exercise Book.* New York: Harper & Row.

Da Liu (1986) *Tai Chi Chu'an and Meditation.* New York: Schocken Books.

Dreifuss, G. (1971) Paper on the archetype of sacrifice: Isaac, the sacrificial lamb. *Journal of Analytic Psychology,* 16, 1.

Eliade, M. (1952) *Images Et Symboles.* Paris: Cirlot.

Erikson, E.H. (1963) *Childhood & Society* (2nd ed.). New York: North & Co.

Eshkol, N. (1986) *Movement Notation, A Comparative Study of Labanotation and Eshkol Wachman Notation* (with M. Shoshani). Tel-Aviv: Research Centre for Movement Notation, Tel-Aviv University.

Eshkol, N. and Wachman, A. (1958) *Movement Notation.* London: Weidenfield and Nicholson.

Euripides. V (1968) *The Bacchae* (translated by W. Arrowsmith). Chicago: University of Chicago Press.

von Franz, M.L. (1972) *Creation Myths.* Dallas, TX: New York: Spring Publications.

von Franz, M.L. (1978) *Interpretation of Fairy Tales.* Dallas, TX: Spring Publications.

Feldenkrais, M. (1972) *Awareness Through Movement.* New York: Harper & Row.

Feldenkrais, M. (1981) *The Elusive Obvious.* Cupertino, CA: Meta Publication.

Fierz-David, L. (1988) *Women's Dionysian Initiation.* Dallas, TX: Spring Publications.

Frederich, P. (1978) *The Meaning of Aphrodite.* Chicago: University of Chicago Press.

Fung Yu-Lan (1948) *A Short History of Chinese Philosophy.* New York: Macmillan.

Geddes, G. (1991) *Looking for the Golden Needle: An Allegorical Journey.* London: Manna Media Publications.

Gendlin, E. (1981) *Focusing:* New York: Bantam.

Graves, R. and Patai, R. (1983) *Hebrew Myths.* New York: Greenwich House.

Halevi, Z.S. (1988) *Kabbalah and Exodus.* Bath: Gateway Books.

Hall, N. (1980) *The Moon and the Virgin.* London: The Women's Press.

Hall, N. (1988) *Those Women.* Dallas, TX: Spring Publications.

Harding, E. (1955) *Women's Mysteries.* London: Rider Company.

Hillman, J. (ed.) (1980) *Facing the Gods.* Dallas, TX: Spring Publications.

Hillman, J. (1985) *Archetypal Psychology.* Dallas, TX: Spring Publications.

Hobson, R.F. (1985) *Forms of Feeling: The Art of Psychotherapy.* London/New York: Tavistock Publications.

Houston, J. (1982) *The Possible Human.* Los Angeles: J.P. Tarcher.

Huang, A.C.L. (1973) *Embrace Tiger, Return to Mountain – The Essence of T'ai Chi.* Moah, Utah: Real People Press.

Hughes, T. (1969) *Oedipus.* London: Faber & Faber.

Huizinga, J. (1949) *Homo Ludens.* London: Routledge & Kegan Paul.

Jacobi, J. (1973) *The Psychology of Jung.* New Haven, CT: Yale University Press.

Jacobi, J. (1974) *Complex/Archetypes/Symbols in Psychology of Jung.* Bollingen Series LVII. New Jersey: Princeton University Press.

Jacobi, J. (1976) *Masks of the Soul.* London: Darton, Longman, & Todd.

Johnston, C.M. (1986) *The Creative Imperative.* Berkley, CA: Celestial Arts.

Jung, C.G. (1961) *Memories, Dreams and Reflections.* New York: Vintage.

Jung, C.G. (1962) *The Secret of the Golden Flower.* New York: Harcourt Brace Jovanovich.

Jung, C.G. (1964) *Man and His Symbols.* London: Aldus Books.

Jung, C.G. (1968) *The Psychology of the Child Archetype* Volume 9. New Jersey: Princeton University Press.

Jung, C.G. (1974) *Four Archetypes.* London: Routledge & Kegan Paul.

Kalff, D. (1980) *Sandplay: A Psychotherapeutic Approach to the Psyche.* Santa Monica: Sigo Press.

Kerenyi, C. (1985) *The Gods of the Greeks.* London: Thames & Hudson.

Koltuv-Black, B. (1986) *Book of Lilith.* York Beach, Maine: Nicholas-Hays Inc.

Laing, R.D. (1970) *Knots.* Harmondsworth: Penguin.

Lao Tzu (1972) *Tao Te Ching* (translated by Gia-fu Feng and J. English). New York: Vintage.

Lao Tzu (1985) *Tao Chi Ching* (translated by Richard Wilhelm). London: Routledge and Kegan Paul.

Lawson-Wood, D. and J. (1973) *Five Elements of Acupuncture & Chinese Massage.* Wellingborough: Health Science Press.

Legeza, L. (1975) *Tao Magic, The Secret Language of Diagrams & Calligraphy.* London: Thames & Hudson.

Leibowitz, N. (1975) *Iyunim Besefer Bereshyt* (Hebrew). Jerusalem: World Zionist Federation.

Libai, Y. (1991) *Teaching Secular Values Through the Bible.* Haifa: Haifa University, Oranim Kibbutz School of Education (unpublished).

Mann, F. (1973) *Acupuncture, The Ancient Chinese Art of Healing & How it Works Scientifically* (Revised edition). New York: Vintage.

Mazar, B. (1962) *Biblical Enclyclopedia Vol. IV.* Tel-Aviv: Mossad Bialik.

Middendorf, I. (1990) *The Perceptible Breath.* Pederborn, Germany: Junferman Verlag.

Miller, A. (1990) *The Untouched Key.* London: Virago Press.

Nei Ching (1949) *The Yellow Emperor's Classic of Internal Medicine* (translated by I.Veith). Baltimore: Williams & Wilkins.

Neumann, E. (1973) *Amor and Psyche: The Psychic Development of the Feminine: A Commentary on the Tale by Apuleius.* New Jersey: Princeton University Press.

Nichols, S. (1980) *Jung and Tarot: An Archetypal Journey.* York Beach, Maine: Samuel Weiser.

Oda, M. (1988) *Goddesses.* Volcano, CA: Volcano Press.

Otto, W. (1986) *Dionysus, Myth and Cult.* Dallas, TX: Spring Publications.

Perera, S.B. (1981) *Descent to the Goddess.* Toronto: Inner City Books.

Perera, S.B. (1986) *The Scapegoat Complex.* Toronto: Inner City Books.

Piaget, J. (1973) *Play Dream and Initiation in Childhood.* New York: Norton.

Purce, J. (1974) *The Mystic Spiral.* London: Thames & Hudson.

Rilke, R.M. (1984) *Letters to a Young Poet.* New York: Random House.

Samples, B. (1981) *The Metaphoric Mind.* Reading, Mass.: Addison Wesley.

Schilder, P. (1970) *The Image and Appearance of the Human Body.* New York: International University Press.

Schoop, T. (1974) *Won't You Join the Dance.* Mountain View, CA: Mayfield Publications.

Schoop, T. (1979) Reflection and projection: The Schoop approach to dance therapy. In P.L. Bernstein (ed.) *Eight Theoretical Approaches in Dance Movement Therapy.* Dubuques, IA: Kendall/Hunt.

Schwenk, T. (1965) *Sensitive Chaos.* London: Rudolf Steiner Press.

Steinman, L. (1986) *The Knowing Body.* Boston, MA: Shambhala Publications.

Steinsaltz, A. (1984) *Men and Women of the Book.* New York: Basic Books.

Stevens, A. (1983) *Archetypes, A Natural History of the Self.* New York: Quill.

Sutherland, J.D. (1980) The British Object Relations Theorists: Balint, Winnicott, Fairbairn, Guntrip. *Journal of the American Psychoanalytic Association*, Vol.28, No.4.

The Torah. (1962) Philadelphia: Jewish Publication Society of America.

Tsung Hwa, J. (1980) *The Tao of Tai Chi Chuan*. Warwick, NY: Tai Chi Foundation.

Veith, I. (trans)(1972) *The Yellow Emperor's Classic of Internal Medicine* (Huang Ti Nei Ching Su Wên).

Whitehouse, M. (1958) *The Tao of the Body*. Paper presented at the Analytical Psychology Club of Los Angeles.

Whitehouse, M. (1963) *Physical Movement & Personality*. Paper presented at the Analytical Psychology Club of Los Angeles.

Whitehouse, M. (1979) C.G. Jung and dance therapy. In P.L. Bernstein (ed.) *Eight Approaches In Dance Movement Therapy*. Dubuque, IA: Kendall/Hunt.

Whitmont, E. (1983) *Return of the Goddess*. London: Routledge & Kegan Paul.

Wilber, K. (1985) *The Holographic Paradigm, Other Paradoxes*. Boston, MA: Shambhala.

Wilhelm, R. (trans)(1962) *The Secret of the Golden Flower*. New York: Harcourt Brace Jovanovich.

Wilhelm, R. (trans)(1967) *The I Ching or Book of Changes*. New Jersey: Princeton University.

Wilhelm, R. (1974) *I Ching* 3rd Edition (translated by C. F. Baynes). London: Routledge.

Winnicott, D.W. (1964) *The Child, The Family, and the Outside World*. Harmondsworth: Penguin.

Winnicott, D.W. (1971) *Playing and Reality*. London: Tavistock.

Wolkstein, D. and Kramer, S. N. (1983) *Inanna: Queen of Heaven and Earth*. London: HarperCollins.

Appendix Notes

Bleakley, A. (1989) *Earth's Embrace*. Bath: Gateway Books.

Campbell, J. (1976) *Creative Mythology ('Masks of God')*. Harmondsworth: Penguin.

Campbell, J. (1987) *Primitive Mythology ('The Masks of God')*. Harmondsworth: Penguin.

Cirlot, J.E. (1962) *A Dictionary of Symbols*. New York: Philosophical Library.

Cooper, J.C. (1978) *An Illustrated Encyclopedia of Traditional Symbols*. London: Thames & Hudson.

D'Olivet, F. (1991) *The Hebraic Tongue Restored*. (Originally published in French, 1815; English translated by N. L. Redfield, 1921). York Beach, Maine: Samuel Weiser.

Halevi, Z.S. (1988) *Kabbalah and Exodus*. Bath: Gateway Books.

Harding, E. (1955) *Women's Mysteries*. Rider Company.

Jung, E. and Von Franz, M.L. (1986) *The Grail Legend*. Boston: Sigo Press.

Kramer, S.N. (1961) *Mythologies of the Ancient World*. Anchor.

Moore, D. (1989) *The Rabbi's Tarot*. St Paul, MN: Llewellyn.

Neumann, E. (1955) *The Great Mother*. London: Routledge & Kegan Paul.

Nichols, S. (1980) *Jung and Tarot: An Archetypal Journey*. York Beach, Maine: Samuel Weiser.

Perera, S.B. (1981) *Descent to the Goddess*. Toronto: Inner City Books.

Perera, S.B. (1986) *The Scapegoat Complex*. Toronto: Inner City Books.

Reed, B. (1978) *Rebel in the Soul: A Dialogue Between Doubt and Mystical Knowledge*. Rochester, VT: Inner Traditions International.

Suares, C. (1985a) *Sepher Yetsira ('The Qabala Trilogy')* (translated by V. Stuart and J.M. Watkins). Boston, MA: Shambhala Publications.

Suares, C. (1985) *Cipher of Genesis ('The Qabala Trilogy')* (translated by V. Stuart and J.M. Watkins). Boston, MA: Shambhala Publications.

Von Franz, M.L. (1970) *Problem of the Puer Aeternus*. Dallas, TX: Spring Publications.

Wolkstein, D. and Kramer, S.N. (1983) *Inanna: Queen of Heaven & Earth*. New York: HarperCollins.

Additional Readings

Ankori, M. (1989) *'Veze Hayaar Eiyn Lo Sof'* (Hebrew). Ramat Hasharon, Israel: Gevel Publications.

Arnheim, R. (1974) *Art and Visual Perception*: Berkley: University of California.

Assagioli, R.(1986) *M.D. Psychosynthesis*, Wellingborough: Turnstone Press Ltd.

Bartenieff, I. with Lewis, D. (1980) *Body Movement: Coping with the Environment*. New York: Gordon and Breach Science Publications.

Bernstein, P.L. (1979) (ed.) *Eight Theoretical Approaches in Dance Movement Therapy* Volume I. Dubuque, IA: Kendall/Hunt.

Bernstein, P.L. (1984) (ed.) *Eight Theoretical Approaches in Dance Movement Therapy* Volume II. Dubuque, IA: Kendall/Hunt.

Bialik, H.N. and Ravnitzkiy, Y.H. (1952) *Sefer Ha-agada* (Hebrew). Tel-Aviv: Dvir Publications.

Brodsky, G. (1974) *From Eden to Aquarius*. New York: Bantam Books.

Chen, Y.K. (1979) *Tai-Chi Ch'uan, its Effects and Practical Applications*. North Hollywood: Newcastle Publishing Co.

Chodorov, J. (1991) *Dance Therapy & Depth Psychology*. London: Routledge.

Chuang, T. (1974) *Inner Chapter* (translated by Gia-Fu Geng and J. English). New York: Vintage Books.

Edinger, E.F. (1972) *Ego and Archetype*. New York: Penguin Books.

Eliade, M. (1963) *Myth and Reality*. New York: Harper & Row.

Eliade, M. (1971) *The Forge and the Crucible*. New York: Harper & Row.

Erikson, E. H. (1968) *Identity, Youth & Crisis*. New York: Norton & Co.

Ferrucci, P. (1982) *What We May Be*. Wellingborough: Turnstone Press Ltd.

Gilligan, C. (1982) *In a Different Voice*. Cambridge, MA: Harvard University Press.

Halevi, Z.S. (1979) *Kabbalah: Tradition of Hidden Knowledge*. New York: Thames & Hudson.

Halperin, H. (1979) *Movement Ritual*. San Francisco: San Fransisco Dancers Workshop.

Halprin, L. and Burns, J. (1974) *Taking Part*. Cambridge, MA: MIT Press.

Hampden-Turner, C. (1981) *Maps of the Mind*. New York: Macmillan.

Hannah, B. (1981) *Encounters with the Soul: Active Imagination*. Santa Monica: Sigo Press.

Hardy, J. (1987) *A Psychology with a Soul*. London: Routledge & Kegan Paul.

Hillman, J. (1977) *Re Visioning Psychology*. New York: Harper & Row.

Hillman, J. (1979) *The Dream and the Underworld*. New York: Harper & Row.

Jung, C.G. (1967) *Symbols of Transformation*. Collected Works, Vol 5. New Jersey: Princeton University Press.

Landgarten, H. (1981) *Clinical Art Therapy: A Comprehensive Guide*. New York: Bruner Mazel.

May, R. (1975) *The Courage to Create*. New York: Bantam.

McNiff, S. (1989) *The Arts and Psychotherapy*. Springfield, IL: Charles Thomas.

Metzner, R. (1971) *The Maps of Consciousness*. New York: Macmillan.

Oaklander, V. (1978) *Windows to Our Children*. Moab, UT: Real People.

Pearce, J.C (1985) *Magical Child Matures Magical Child*. New York: E.P. Dutton.

Perls, F.S. (1980) *Gestalt Therapy Verbatim*. New York: Bantam.

Quinn, K. (1991) *Reclaim Your Power*. London: HarperCollins.

Richards, M.C. (1962) *Centering in Pottery, Poetry & Person*. Weleyan.

Richardson, A. (1969) *Mental Imagery*. New York: Springer.

Rilke, R.M. (1984) *Letters to a Young Poet*. New York: Random House.

Rogers, C. R. (1961) *On Becoming a Person*. Boston: Houghton & Mifflin.

Rubin, J. (1984) *Child Art Therapy*. New York: Van Nostrand Reinhold.

Rubin, J. (1986) *The Art of Art Therapy*. New York: Van Nostrand Reinhold.

Sachs, C. (1963) *World History of Dance*. New York: W.W. Norton.

Samuels, M. and N. (1981) *Seeing with the Mind's Eye*. New York: Random House.

Scholem, G. (1965) *On the Kabbalah and its Symbolism* (translated by R. Manheim). New York: Schocken Books.

Spiegelman, J.M. and Jacobson, A. (1986) *A Modern Jew in Search of a Soul*. Phoenix, AZ: Falcon Press.

Stone, M. (1979) *Ancient Mirrors of Womanhood*. Boston: Beacon Press.

Suzuki, S. (1970) *Zen Mind, Beginner's Mind*. New York/Tokyo: Weatherhill.

Takahashi, M. and Brown, S. (1986) *Qi Gong for Healing*. Tokyo/New York: Japan Publications.

Todd, M.E. (1972) *The Thinking Body*. New York: Dance Horizons.

Wallhofer, and Von Rottauscher, (1965) *Chinese Folk Medicine & Acupuncture* (translated by M. Polmedo). New York: Bell.

Watts, A. (1975) *Psychotherapy East & West*. New York: Vintage.

Whitehouse, M. (1978) Reflection on a metamorphosis: In a well of living water. In R. Head, R.E. Rothenberg and D. Wesley (eds.)*Festschrift for Hilde Kirsch* Los Angeles: C.G. Jung Institute.

Wilber, K. (1979) *No Boundary: Eastern and Western Approaches to Personal Growth*. Boston, MA: Shambhala Publications.

Wosien, Maria-Gabriele (1974) *Sacred Dance, Encounter with the God*. London: Thames & Hudson.

Yalom, I. (1976) *The Theory and Practice of Group Psychotherapy*. New York: Basic Books.